Jazz in American Culture

JAZZ IN AMERICAN CULTURE

Burton W. Peretti

The American Ways Series

IVAN R. DEE *Chicago*

Library of Congress Cataloging-in-Publication Data:
Peretti, Burton W. (Burton William), 1961–
 Jazz in American culture / Burton W. Peretti.
 p. cm. — (The American ways series)
 Includes bibliographical references and index.
 ISBN 1-56663-142-4 (cloth : alk. paper). — ISBN 1-56663-143-2
(pbk. : alk. paper)
 1. Jazz—History and criticism. 2. Popular culture—United
States—History—20th century. 3. Music and society. I. Title.
 II. Series.
ML3508.P46 1997
781.65'0973—dc20
 96-35596

For Jenny

Contents

Jazz in American Culture

Introduction

JAZZ MUSIC has long been one of the most widely discussed, admired, and explored creations of the twentieth century. In the United States and around the world jazz is a part of many different settings—in nightclubs, on television commercials, in concert halls, even in subway stations and on sidewalks. Other kinds of music that also surround us in our daily lives, such as country, rock, pop, rap, or classical music, often reflect jazz influences. Early jazz masters are honored in Washington, D.C., and appear on postage stamps. Jazz is often described as "America's classical music" or "the leading American art form." The word *jazzy* has become a common adjective, a term that describes the flair or style of a person, an event, or a manner of speech. "All that jazz" is a general term we use to describe miscellaneous odds and ends in life—a jumble of things that affect us in a dizzying, unsettling way which might resemble jazz music we once heard.

(Jazz music and the references we make to it constitute a fascinating American cultural artifact. The nation's culture is made up of its ideas, institutions, and ways of life—what anthropologists call a people's "shared learned behavior." As we enter the twenty-first century, jazz may seem like a relatively minor part of present-day culture, dominated as it is by computers, video, "pop" music, and political movements. Jazz remains an exciting musical field, but it is certainly small compared to other musical genres or styles: only 4 percent of all CDs sold today contain jazz, and in the United States there are no commercial all-jazz radio stations. The typical Ameri-

can college student probably has never been to a jazz night-
club and cannot name one or more major jazz performers
who are currently active.)

Yet jazz echoes through our lives and is an ingrained ele-
ment of American styles and attitudes. This suggests that jazz
was once a major force in the nation's music and culture. By
looking to the past, we can see that jazz has thrived through-
out the twentieth century. It originated soon after the turn of
the nineteenth century and then evolved during nine decades
of astonishing historical change, during what the publisher
Henry Luce called "the American century." Since 1900 stage-
coaches have given way to air and space travel, gunpowder to
atomic bombs, and postal letters to instant communication via
satellite and electronic mail. The entire culture has struggled
to adapt to these changes. Meanwhile the United States has
launched crusades against totalitarian dictatorships overseas
and poverty, crime, and bigotry at home. Jazz has entertained,
comforted, and inspired Americans throughout these difficult
times. As the historian James Lincoln Collier has suggested,
jazz has been a "theme song" for the American century.

Jazz, in other words, is history, and it is history central to
the development of American culture since 1900. No Ameri-
can music has inspired more praise or more controversy. Only
jazz has lent its name to an entire decade in twentieth-century
history, the "Jazz Age" of the 1920s, or symbolized the rejec-
tion of the Victorian values that dominated nineteenth-
century social life. No music has been so closely associated
with the rise and fall of America's cities, or with the fluctuat-
ing reputation of American culture around the world. And no
music has been more intimately linked with the search by con-
cerned Americans for legal and social equality for all, particu-
larly for African Americans. Harassed and isolated by slavery
and then by segregation, black Americans maintained a rich
and powerful culture of their own. They devised the major el-

ements of jazz music in its formative years as well as important innovations in later decades. The black movement for equality grew up with jazz and affected white Americans' perception of the music too.

This book is a chronicle of how jazz has been a key thread in the tapestry of American culture in the twentieth century. It is a thread woven through many lives and places, with a few persistent characteristics. First there is the music itself. What information can it convey? Music is usually described in detail in the highly technical terminology of musicologists, which can frighten many readers. The general qualities of jazz music, though, can be noted in plain English, especially with the use of musicians' terms such as "swing" and "comping." Straightforward information such as the titles, lyrics, and dimensions (length, size of ensemble, and so forth) of jazz works can tell us important things about the music and its cultural significance. The growth and evolution of the guild of jazz musicians also deserves careful attention. While space limitations prevent me from discussing more than a few of the hundreds of important men and women who have made jazz, even a brief summary reveals that these artists helped build a tradition that joined a powerful memory with a spirit of constant innovation. The shape of jazz ensembles, the places in which jazz was created and performed, and the practices of performance, composing, and arranging all changed significantly over time. Jazz musicians are sensitive and articulate Americans who have been deeply affected by their surroundings and society. Their life stories often provide vignettes or details—involving their education, ethnic background, personal beliefs, and spiritual life—which illuminate the special roles of jazz in American culture.

Beyond this guild of musicians lies the audience. At first—in 1910s New Orleans, for example—jazz audiences were musicians' friends and families, brought up in local and musi-

cal traditions and closely knit against an impersonal and harsh society. These audiences nurtured the music in its infancy. Very quickly, though, paying customers nearby, as well as at stops on band tours, expanded the audience, as did the new electronic media which broadcast music nationwide by the 1920s. The listeners were large cross sections of the American people, and when they responded to jazz they revealed emotions, tastes, prejudices, and hopes that reflected and shaped American culture. For various Americans, jazz at different times expressed their sense of economic prosperity, dread of war, pride in black heritage, multinational musical tastes, fondness for comforting tradition, and hunger for novelty and modernistic innovation. Debates about jazz articulated these concerns among musicians, fans, and critics as well as people who disliked and rejected the music. The audience for jazz, in short, numbered in the millions, and their reactions to the music tell us much about changes in American life since 1910.

Through the music, its players, audience reactions, and critical debates, we can place jazz clearly within the turbulent contexts of American history. Those young people who first played and heard jazz were inheriting a society that was already complex and filled with conflict. By the 1910s some old issues had been settled: slavery and the Confederacy were dead; Native Americans had lost their lands forever and lived on isolated reservations. But industrialization had just begun to dominate the nation's economy. Even the most isolated farmers acquired such new products of industrial inventiveness as telephones and factory-made pianos. Other rural folk abandoned their farms as America organized itself around cities and industry. They joined millions of immigrant newcomers in factory towns and cities and tried to adjust to a new way of life. Dangerous and noisy factories, bustling markets, and cramped city tenements confronted whites, blacks, and immigrants in Northern cities. Social workers and other

middle-class reformers struggled to understand and to remedy the problems of these big new cities and their political machines. Politicians sought to reassure voters with calls to action—for war against Spain and against the evil trusts—but no one knew exactly where the nation and its dynamic economy were heading.

Half a century after the end of slavery, African Americans were still specially disadvantaged. In cities, blacks were discriminated against by factory owners (who hired them for the lowest wages, usually as strikebreakers) and unions (who saw blacks as competition and "scabs"). Black women usually could find work only as domestic servants. Across the nation, most white Americans subscribed to ideas of racial inferiority. Directed in part at the Indians and Filipinos the army had pacified, this racism classified blacks at the lowest level; "coon" stereotypes flourished on the minstrel stage and in popular novels. In the years following Reconstruction, Southern whites adopted "Jim Crow" laws imposing segregation in all public facilities, deprived most black men of the vote, and tolerated discriminatory law enforcement and vigilante violence. Booker T. Washington cautiously urged blacks to practice self-help and pleaded with Southern whites to respect his race; Northern blacks such as W. E. B. Du Bois urged protest and resistance. "Progressive" white leaders such as Theodore Roosevelt and Woodrow Wilson, busy with industrial and labor problems, had little sympathy for the difficulties of African Americans under Jim Crow and did little to ease their plight.

These processes of industrialization and urbanization, as well as African Americans' search for equal treatment, were joined by new cultural trends which would help to launch jazz. By 1910 movie theaters, vaudeville houses, dance halls, and amusement parks such as New York's Coney Island were drawing urban Americans away from the books, parlor

games, and other private leisure they had enjoyed in their homes. Leisure was being redefined as a public activity one enjoyed in the company of a mass of strangers. Because blacks were excluded from most facilities, the mass audience consisted of an all-white mix of economic and ethnic groups. At the same time electricity was illuminating the streets and parks at night, allowing Americans to become more nocturnal in their leisure. The growing popularity of nightclubs and cabarets also brought the mixed white public into enclosed, often more disreputable settings. Here black performers and customers could gain access. For many, the Edison Talking Machine or phonograph brought new types of music into the home as well. Public space, morals, and electric media were evolving along with leisure. Tradition-minded Americans condemned the new leisure and targeted it for legal restriction. The debate over public leisure was intense, and it continues today.

For decades, jazz was a focus of this debate. In the 1910s America began an involvement in overseas wars which would continue for the remainder of the century. Military conflict had a deep influence on jazz musicians and the cultural functions of the music. The two world wars dramatically altered American economics and the lives of young people, and laid bare the forces of violence and conflict always near the surface of modern industrial society. Personal violence, addictions, and psychological disorientation affected musicians and listeners in these decades. After 1945 the United States attempted to use its dominant military and economic power to create peace while simultaneously spreading its culture and leisure styles to nations around the world. Jazz played a leading role in this cold war effort. At home, though, America was becoming a postindustrial and suburban nation. Cities and nightclubs fell into decline, and in the 1950s and 1960s new popular music eclipsed jazz; the future direction of jazz music

became uncertain. As the century came to a close, a diminished economy and the end of the cold war led Americans to ponder their purpose in the world, and jazz too faced similar crises of purpose and identity.

In the midst of this change, the relationship between jazz and the African-American struggle for civil rights remained close and constant. This is not to suggest that jazz was purely an African-American music; since the 1910s all kinds of Americans have played, enjoyed, and debated the value of jazz. Rather, it is to note that the work of some major black jazz innovators was rooted in their neighbors' (and their own) redefinition of themselves. As W. E. B. Du Bois predicted in 1901, the black struggle for equality became the great social drama of the century. Civil rights activists' strategies of resistance, self-help, and black pride worked in tandem with the creativity of black jazz musicians, who increasingly associated themselves with the struggle for equality. Jazz particularly inspired African Americans and others to challenge traditional caution and conservatism and to create a freer and more fluid public leisure—settings for further progress. The nature of American race relations and the racial heritage of jazz remain topics of interest and controversy today.

The ethnic contexts of jazz history remind us that any study of a complex twentieth-century music in its rich social and cultural context will uncover different cultures of expression that vary by class, ethnicity, and generation. Whether played by poor sharecroppers or affluent suburbanites, by ghetto residents or nationally known "stars," jazz has spoken to the diverse situations and longings of Americans, to groups that were in conflict and in agreement. Although jazz has often been misrepresented and misused, diluted and abandoned by a mass audience, it has remained vital and popular. It continues to speak to all of us today, in countless direct and indirect ways.

1

From Ragtime to Jazz in the 1910s

AS THE TWENTIETH CENTURY began, the most popular music in the United States was nostalgic in its lyrics and tone. When Americans wanted music they generally turned to songs and pieces that evoked simpler and safer times. Classical performers and audiences relied on the dead European masters for their repertoire. Throngs of immigrants in America's cities performed religious and folk music from their homelands to keep alive their traditions and memories. The earliest recording catalogues advertised Enrico Caruso's operatic renditions as well as Polish, Irish, and German songs. Also numerous were songs that featured racist stereotypes of African Americans—minstrel and "coon" songs sung by blacks (such as the vaudeville star Bert Williams) as well as white performers. These songs often looked back to the "peaceful" days of the Old South, when civil war and racial conflict supposedly had not yet emerged. "Old-time" fiddlers, sea chanters, and storytellers also graced these early Edison and Victor wax-cylinder catalogues.

Nostalgia would remain a strong force in American music and culture throughout the century. Even older jazz fans would yearn for the music of bygone days, just as in our time some older rock music fans long for the sounds of the 1960s or 1970s. Such attractions to the past usually well up because peo-

ple are worried and uncertain about the present and future. In the first two decades of the twentieth century, America was at the crest of a wave of enormous social and economic change that had begun in the 1800s. The Civil War had been fought and slavery had ended, but the South was still wrestling with a backward agricultural economy and violent race relations. Farm families nationwide had lost ground to large-scale agriculture and low crop prices, and millions had fled to the cities. There factories were booming, attracting rural migrants and huge influxes of immigrants—by 1907 more than a million persons a year. Mail-order catalogues and department stores tempted consumers. The United States had seized the Philippines and Puerto Rico as colonies and built the Panama Canal. Telephones, streetcars, the automobile, and aircraft seemed to shrink distances, and electricity transformed home and work life and lit up the night.

Jazz music originated in a spirit that embraced this avalanche of change. In the 1910s millions of Americans saw innovation as far preferable to nostalgia, and yearned to experiment with new sounds, new behavior, and new ideas, to mix with diverse strangers and move to the speed of the machine age. Modernization would not always be positive; in the trenches of World War I and on the home front, many Americans witnessed extraordinary and shocking new violence. Yet they clung to positive, invigorating novelties which helped them to adjust to these changes. Jazz became a defining component of this aggressive, forward-looking, modernizing culture.

Jazz arrived on the heels of a similarly extroverted and brash music which peaked in popularity in the late 1910s— ragtime. The source of the word *ragtime*, like that of *jazz*, remains obscure. Whatever its true root, the important fact is that by 1900 musicians agreed that "ragging" was at the heart of the music. "Ragged" rhythm was the heavy syncopation of

two-step dance melodies. Primarily a piano music, ragtime exploited the contrast between the stiff, steady beat in the left hand and the syncopated jumpiness of the melodic right hand. The melody, in other words, contained many notes that fell between the pulses of the basic beat.

The music itself was also born in obscurity. Some musicians later claimed to have "ragged" in the 1880s, but the style seems to have been defined during the 1893 Columbian Exposition in Chicago. This world's fair attracted millions of visitors as well as dozens of African-American piano "professors" who sought the tourists' business in nearby taverns. In Chicago they shared ideas and solidified ragtime into a piano style. By 1900 Scott Joplin's "Maple Leaf Rag" had sold a million sheet-music copies, and the ragtime rage was on. Hundreds of composers published rags for piano and various instrumental ensembles. Tin Pan Alley, New York City's song publishing industry, seized hold of the new style, and songwriters such as Irving Berlin ("Alexander's Ragtime Band," 1912) made it a staple of vaudeville performance and recording. Ragtime remained the dominant popular music until 1920 and enjoyed numerous popular revivals in later decades.

Two facts about ragtime stand out. First, it was almost entirely a product of America's growing cities. The most popular music in cities of the Civil War era had been songs from the minstrel stage, the staple entertainment for Irish and German immigrants and other working-class urbanites. Minstrel songs such as Stephen Foster's were defined by their mild touches of "colored" syncopation; think, for example, of the accent on the last syllable of the phrase "Oh Susann-*ah*" or the phrases "doo-*dah,* doo-*dah*" in "Camptown Races." Ragtime undoubtedly originated far from the big stages and song publishers, but its creators drew on minstrelsy, or authentic black music, or both, to syncopate melodies to an even greater degree.

Ragtime probably originated among the poorest city estab-

lishments in which pianos and skilled players could be found. While we know that urban blacks had easy access to old military band instruments and to instruction on them, the sources of pianos and piano instruction among poor blacks are less clear. "Blind Tom" Bethune, an 1800s touring virtuoso, learned to play while he was a house slave on a Georgia cotton plantation. In any case, by the 1880s many city saloons, taverns, brothels, and gambling dens hired pianists to create musical moods for their customers. The jobs were usually low-paying, sometimes dangerous or unsanitary, often brief. "Professors" tended to be young, healthy, and always on the move. By 1900 itinerant pianists were crossing one another's paths regularly and forming informal networks, sharing job leads or the newest keyboard tricks. Scott Joplin moved from Sedalia, Missouri, to St. Louis, where he worked with the canny white publisher John Stark, and by 1906 Ferdinand Lemott, or "Jelly Roll Morton" as he billed himself, had left his native New Orleans to play in the taverns of Chicago, Cincinnati, Los Angeles, and other cities.

The second clear fact about ragtime is that almost all its originators belonged to what America called its "Negro" or "colored" population. Ragtime did reflect many "white" or European musical traditions, such as minstrelsy, and of course the piano was of European origin, as were written musical notation, the left-hand ragtime march beat, and ragtime's standard chord progressions. Ragtime's "whiteness" even increased after Tin Pan Alley's composers began to commercialize the style. But the music's defining feature—its complex syncopation—derived from the polyrhythmic traditions of black Africa and America. Recordings of ensemble drumming from equatorial West Africa, Haiti, or even Georgia's Sea Islands illustrate the intricate interweaving and overlaying of many beats. White listeners mistakenly called these polyrhythms "syncopations." Ancient African rhythmic pat-

terns were distantly evoked in ragtime. Just as their ancestors had maintained various African traditions during centuries of slavery, black ragtime pioneers successfully kept alive the African rhythmic heritage in what was primarily a "white" piano music. (It would be left to later generations of black jazz musicians to reconnect the ragtime-jazz tradition to its African rhythmic roots.)

Ragtime's European qualities made it sufficiently traditional for culturally conservative white players and listeners to enjoy. America in 1900 was an empire of pianos. The American middle class, more than any other, embraced the piano as a symbol of nostalgia as well as status. Victorian middle-class values held that women were the guardians of American homes and their culture. The wife and mother was often devoted to her parlor, her children, and the "sweetness and light" of art and morality. At the same time, though, the sprightly syncopations of ragtime—derived from black traditions—epitomized the quickened pace of modern industrial life, the era of the streetcar and the express train. As Joseph Lamb, May Aufderheide, and other white composers joined in the ragtime sheet-music bonanza, they began a cultural balancing act that would typify the attitudes of twentieth-century American whites: balancing recognized and cherished traditions (symbolized by the piano, motherhood, rural life, and the left-hand march rhythm) with new, fast, and sassy modern behavior (represented by the city, black piano "professors," and the ragged syncopation of the right-hand melody). Fun-loving whites in straw hats, seersucker suits, and crinolines "tripped the light fantastic" to a ragtime beat at Coney Island and state fairs, on Broadway and Main Streets across the nation. The music vaguely symbolized the loosening of constraints on white women and courtship, the expansion of lively public space and leisure, and the excitement of diverse urban populations and pleasures.

African Americans also found ragtime to be an expression of the city. Cities were new places to most of them, places filled with stimulation and promise. Beginning in the 1870s, thousands of rural blacks moved to nearby Southern cities, multiplying the black populations of New Orleans, Atlanta, Memphis, Richmond, and Washington, and creating a new strength in numbers. While the jobs they gained were often domestic or common labor, they at least paid wages (unlike sharecropping), and city parks and shops offered more attractive leisure and consumption. Northern cities also saw their black communities grow steadily, though they remained small compared with immigrant and native white populations. In 1910 no large Northern city held a black population greater than 5 percent of the city's total. Northern blacks were free of legal segregation, but custom banned them from many jobs, institutions, and neighborhoods. By 1910, though, they had frequently achieved parity with their white neighbors (and often surpassed immigrants) in terms of education, home ownership, income, and medical care—parity they would generally lose in later decades. In all, cities at the turn of the century offered blacks general poverty and discrimination, but also the possibility of real progress and hope.

In these urban black communities, the few physicians, attorneys, butlers, and chauffeurs created self-conscious "Negro elites" which often shunned the poorer majority of blacks. Black "elites" embraced ragtime as a statement of African-American pride, accomplishment, and assertiveness. The term *Afro-American* was a popular new name for the race, promoted by the leading black intellectual, W. E. B. Du Bois, a former resident of Boston, Philadelphia, and Atlanta who in 1910 moved to New York City. Black composers used ragtime to assert pride in African roots and dark skin. The conductor, singer, and composer Will Marion Cook, slyly exploiting the minstrel and "coon song" genres, created the rag-styled 1898

Broadway production *Clorindy, or the Origins of the Cakewalk,* a celebration of slaves' music and dance. His interest in cultural origins soon led him to an African subject. His fourth stage show, *In Dahomey* (1902), a satire on the colonization of West Africa by free blacks, was imbued with ragtime sensibilities and Cook's interest in mythologizing the Afro-American heritage.

This was an exciting and sometimes dangerous era of cultural experimentation. Blacks and whites openly competed for the theater audience. Cook's and other black stage shows were hits with many whites, but others did not tolerate black success: in 1900 a riot erupted outside a New York theater presenting a Negro revue. Despite these tensions, Cook, John Rosamund Johnson, and other musicians formed friendships with sympathetic whites. In Manhattan these contacts led to a music settlement house in the black San Juan Hill neighborhood (financed by the white entrepreneur David Mannes), increased philanthropy to black colleges nationwide, the formation of the National Association for the Advancement of Colored People (NAACP) in 1909 (in which Rosamund's brother, James Weldon Johnson, was active), and invitations for black ensembles to perform at the most elite stage in the city, Carnegie Hall. In these ways ragtime increased controversial public interaction between the races.

The "King of Ragtime," Scott Joplin, came to New York in 1907 to realize his dream for the music and for black culture: ragtime opera. Joplin, like many black (and white) musicians after him, wished to "elevate" black popular music to the most elite forms and settings possible. He composed a one-act work, *A Guest of Honor,* as well as a full opera, *Treemonisha.* Like Cook's shows, *Treemonisha* also explored origins, in this case the origin (and acceptance) of formal learning in an Arkansas slave community. But just as New York offered benefits for Joplin and other blacks, it also presented stiff chal-

lenges. Expenses were high; income, financing, and promotion were essential; con men and swindlers were everywhere. Unable to handle these pressures, Joplin deserted his family, fell into alcoholism and mental illness, and died in 1917, poor and nearly forgotten. Like some important jazz artists who followed him, Joplin succumbed because he was artistically ahead of his time, too impractical to succeed in a cutthroat profession, prone to addiction and disillusion, and victimized by racial discrimination.

Still, opportunities beckoned for those who could manage to secure and hold on to them. No African-American ragtime musician seized opportunities more eagerly or more successfully than James Reese Europe, who saw ragtime as both a popular entertainment and a concert art. Befitting his family name, Europe's ambitions eventually became international in scope. His success in the 1910s brought the ragtime era to a climax and raised the expressive and commercial stakes for all future African-American popular artists.

Jim Europe's family migrated from Mobile, Alabama, to Washington in the 1890s, then to Manhattan. New York in the 1890s nurtured a special brand of ragtime playing. Every gambling den, tavern, and fancier saloon featured an African-American piano "professor" ragging Tin Pan Alley favorites. New York was also the home of the finest classically trained black musicians, graduates of such schools as the short-lived National Conservatory of Music. In 1893 the Conservatory's first director, the great Czech composer Antonin Dvořák, was so impressed with the black spirituals sung by his pupils Will Marion Cook and Henry T. Burleigh that he proclaimed Negro melodies "the folk songs of America." They contained, he said, "all that is needed for a great and noble school of music." New York's white musical elite, which worshiped German musical models, disdained Dvořák's advocacy and his black students. Because of America's obsession with racial

classification, Cook, Burleigh, Rosamund Johnson, Will
Vodery, and other aspiring classical talents were forced to
write shows for the popular stage, using minstrel and ragtime
models.

Europe was the first black musical innovator to achieve a
sustained popular success in ragtime. In 1905, with other clas-
sically trained black musicians, he joined the songwriter
Ernest Hogan's pioneering ragtime orchestra, featuring more
than two dozen performers. Incongruously named the Mem-
phis Students, the group performed elaborate orchestrations
of ragtime favorites for the next few years. Like all ragtime
artists, the Memphis Students took advantage of the rapid
evolution and growth of New York's nightlife—new restau-
rants, cafés, and semiprivate gathering places (soon called
cabarets or "nightclubs") for well-to-do whites in search of ex-
citement and entertainment after dark. Europe realized that a
ragtime orchestra, properly promoted, would handsomely
complement these activities. By 1910 he operated on a dual ca-
reer path. He built up a corps of talented orchestra musicians
through his Clef Club organization and marketed various
groups to Broadway establishments. At the same time he led
the flagship ensemble, the Clef Club Orchestra, and became a
nightlife celebrity. In 1913 Europe allied the band with Ver-
non and Irene Castle, a married dance team that performed
floor shows, led society dances, and above all demonstrated
hip-shaking black dances such as the shimmy and the turkey
trot (in sanitized forms) for delighted crowds. Europe was a
junior partner in the Castles' rising commercial success. By
carefully grooming his classically trained players and ragtime
music for the tastes of the white public, and by mastering the
lucrative and competitive Manhattan entertainment market,
he succeeded where many others such as Scott Joplin had
failed.

While Europe was paving new avenues of commercial and artistic success for black ragtime in New York, even more dramatic musical innovations were occurring in a city hundreds of miles away. New Orleans was probably more unlike New York than any other American city. Strongly rooted in its French and Spanish colonial origins, its laws based on the Napoleonic Code, New Orleans was in many ways a Caribbean city culturally. Although they were being steadily outnumbered by newcomers after the Civil War, white and "colored" Creoles in New Orleans still maintained Catholicism, the French language, and French musical traditions. Politically the city had implemented few progressive reforms to curb official graft, police abuses, putrid water supplies, shoddy housing, disease, and widespread poverty and unemployment. In other ways, though, New Orleans in the 1910s was becoming more typically American. After Reconstruction many rural whites and blacks had moved to the city, creating an industrial working class and a Protestant majority. Strict segregation laws were in force, relegating Creoles of color (who had previously enjoyed an intermediate social status, as in Caribbean societies) to second-class citizenship with the "American Negroes" they despised.

All these changes helped to propel the growth of New Orleans's own form of ragtime music. The enthusiasm for French music, rich Caribbean influences, highly developed dancing and social traditions, and an abundance of musical instruments and talented music teachers stimulated extraordinary musical activity for decades. Bands formed by children ("spasm" bands), men's clubs, coworkers, neighbors, and Mardi Gras celebrators filled the poverty-stricken streets with a more sensuous, "dragging" instrumental kind of ragtime which featured a great deal of "sliding" between notes. Groups in other Southern cities, especially St. Louis and

Memphis, created similar music, but they could not match the Crescent City's dense and diverse musical traditions or its French-derived love for expressive music and dance.

Compared to Manhattan's ragtimers, those in New Orleans were unpolished and poorly paid; almost none of them could support themselves as musicians. Their revision of standard ragtime, however, was radical and significant. Above all, they incorporated the harmonies and timbres of the Mississippi Delta blues into ragtime. What classical musicians called "flatted" or "blue" notes, along with the sliding between notes, standard twelve-bar harmonic progression and three-line stanzas, and rich vocal-style timbres or instrumental tone qualities typical of the Delta blues made New Orleans ragtime deeply expressive. Players in New Orleans also adapted blues guitarists' improvisational skills to band music. After the whole band played a tune, soloists would take turns making up new versions, using notes of the song's chord progression, while others played the chords underneath the solos. Bands developed devices for connecting solo and ensemble passages—short "breaks" or "stop-time" pauses that provided dramatic contrast. While New Orleans "musicianers" usually called their music "ragtime," some also called it jass, jasz, or jazz. It was a word of unknown Afro-Caribbean origins and meaning, usually vaguely referring to fast movement or sexual relations.

Musicians' testimony conveys the stimulation and exhilaration they felt as they infused ragtime with the musical spirit of New Orleans. The bassist Montudie Garland felt he was an artist—"I likes my own basis for playing jazz music"—while such conservatory-trained musicians as the bandleader Charlie Elgar were proud of their education. The first jazz pioneer to relate his autobiography, the pianist Jelly Roll Morton, was often absent from New Orleans while jazz was being formulated, touring Chicago, Los Angeles, and many other cities as

a piano "professor." Nevertheless, Morton's own rich Creole upbringing and improvisatory genius allowed him to work similar magic as he transformed ragtime. "Jazz," Morton recalled in 1938, "is based on strictly music. You have the finest ideas from the greatest operas, symphonies and overtures in jazz music. There is nothing finer than jazz music because it comes from everything of the finest class music." Morton's 1925–1926 band recordings show how he used the stylistic hallmarks of Chopin and French opera—funeral marches, curtain-raising chord progressions, and transparent instrumentations—to enrich such ragtime standards as "The King Porter Stomp" and "Wolverine Blues."

Throughout his life Morton would be afflicted with the burdens of New Orleans's racial divisions. Born into a "colored Creole" family in 1890, he was socialized by his parents into believing that non-Creole blacks were inferior and that he, in fact, was not even a Negro. New Jim Crow laws had forced Morton and other Creoles of color into a general inferior "Negro" social class, also including the English-speaking Protestant blacks they despised. Like other Creoles, Morton denied his black blood and heritage and adopted racist attitudes to cope with his own victimization.

Within early New Orleans jazz, however, there was considerable diversity. Many Creoles, such as Kid Ory and Charles Elgar, did not hesitate to play music with "American Negroes." Jazz played host to the city's entire racial and ethnic spectrum. The first known jazz cornetist, Charles "Buddy" Bolden, was from a "holy roller" Protestant family from the Delta, while many early instrumentalists, such as Lorenzo "Papa" Tio, were of Caribbean Creole background. While males dominated the musical trade, as they did most other public professions, a number of local women (such as Mamie Desdoumes, Jeanette Salvant, and Billie Pierce) were popular pianists and blues singers. Desdoumes worked as a prostitute,

one of the few vocations for poor New Orleans women that exposed them regularly to trained musicians and paying musical jobs.

According to the 1910 Census, the population of New Orleans was three-quarters white, and part of this population inevitably shared in the creation of jazz. Beginning in the late 1800s white bands, while much less influenced by the blues than black players, also played improvised instrumental ragtime. As with African Americans, white children's bands were common. Like Papa Tio, the jack-of-all-trades "Papa Jack" Laine, a boxer, mechanic, and volunteer fireman, organized spasm bands and found them paying work at picnics, store openings, and public parks. White bands rode wagons to advertise merchandise, played for neighbors' birthdays and homecomings, and tagged along with the Mardi Gras and other parades. White bands eventually gained better-paying hotel and restaurant jobs (for which their wilder syncopations were toned down). They benefited from the assistance of the whites-only musicians' union local and the large Werlein's Music Store, a clearinghouse for jobs and instruments. Blacks' only real employment advantage was on riverboats operated by the Streckfus family, which hired young jazz pioneers for all-black bands that played on trips up the Mississippi.

Black employment in New Orleans was meager and low-paying. Black musicians sometimes depended for jobs on organized crime, which operated many saloons and taverns. In general, violence and deprivation burdened black New Orleanians. Their neighborhoods received little police protection or decent recreational or educational facilities, and many youths were drawn to vice for employment and to the streets for leisure and community. Morton epitomized the musician who consorted with criminals and shared in the "sporting life" of prostitution, gambling, drinking, and narcotics. From the waterfront saloons in New Orleans to Chicago's Midway, and

eventually to Harlem's side streets, Morton and other players worked part time as pimps and dodged the threats of hostile competitors, card sharps, and gangsters. Other jazz pioneers, such as Joe "King" Oliver and Edward "Kid" Ory, fled New Orleans during World War I because of increased violence between rival gangland saloon owners.

Violence was unavoidable in the era. War in Europe and social disruption at home helped bring New York ragtime and New Orleans jazz to world attention and make jazz a musical symbol of the frenetic new modern spirit. Well before 1917, when the United States entered World War I, the nation had begun to experience intensified economic change, human migration, and technological innovation. The 1910s introduced airplanes and automobiles to most Americans. In the cities, skyscrapers began to rise into the clouds, huge assembly lines accelerated factory work, and capitalists used "scientific management" to make the most efficient use of their huge unskilled work forces. Time became an obsession in this fast-moving age; in 1917 Congress even introduced daylight savings time, which compelled everyone to change their clocks by an hour twice a year. The pace and scale of modern industrial life were beyond traditional comprehension.

World War I, begun in 1914, was unlike any war before it. The western front in Belgium and northern France was a huge, new theater of the grotesque, the scene of unending siege and attrition. "Battles" in the traditional sense were replaced by massive assaults by waves of troops flowing from miles of trenches. Their progress was often measured in meters; their often futile maneuvers lasted weeks or months; and casualties were immense. Doctors found that soldiers were as likely to be wounded by their own fears as by their enemies' weapons. "Shell shock," the paralyzing fear of being hit by a shell, took almost as many British troops out of action as did real injuries. On the European home fronts, civilians were en-

listed in unprecedented economic mobilization, and almost every household had to deal with wounded and disillusioned returning veterans. The war changed civilian attitudes and behavior. Younger civilians emulated the troops' world-weary regimen of cigarette smoking, drinking, and bitter humor. The Armistice in November 1918 ended the fighting but failed to restore calm and innocence to Europe. Later events proved that the "Great War" had done little to advance Western civilization. Rather it had crippled economies, made the public and politicians cynical and pessimistic, and revealed technology to be an almost uncontrollable destructive force.

Before the 1910s American popular culture had portrayed gun battles and fistfights as the common currency of heroic masculinity. Violence "regenerated" the energies of white men for larger struggles in war, against the power of nature, and in opposition to "savage" dark-skinned adversaries. When the United States entered the war most young enlisted men endorsed this ideal of masculine violence and looked forward to heroic and "bully" experiences in battle. But the doughboy's training camp was dominated by the Wilson administration's standardizing, efficiency-minded progressive ethos. "General issue" uniforms, safety razors, haircuts, instruction on social diseases, and IQ tests—as well as pressure on immigrant GIs to speak English and "act American"—had the greatest socializing effect on the six million servicemen. The three million who traveled to France also saw a civilization new to them, rich in religion, art, cuisine, and a morality far different from America's. The million soldiers rushed into combat in 1918 also felt the full force of the nightmarish new warfare. In the five months before the Armistice, more than 100,000 Americans died of disease or battle wounds.

Among those who saw combat were segregated African-American regiments, including a volunteer unit from New York that was the core of the 369th Infantry Regiment. James

Europe eagerly enlisted and put together the 369th Hell Fighters band. He became one of only a few hundred black officers to serve in the war, receiving a captain's commission. Traveling to Paris in the spring of 1918, Europe was actually ordered away from the band and to the front lines, where he apparently was the first black officer in the war to lead troops into battle. Meanwhile the band (which Europe soon rejoined) was captivating the French with its suave brand of ragtime. For these listeners the raw "frontier" energy of American culture was a welcome alternative to gentler Old World traditions which seemed quaint and irrelevant in an era of total war.

At home the war caused an economic upheaval with profound political, social, and racial consequences. President Wilson, mobilizing the economy, had no choice but to place industrialists and financiers in charge of the effort. Wilson's antitrust activity and wage and labor regulations were relaxed, enabling big business once again to dominate Washington. In a new reactionary mood, the government prohibited criticism of the war effort. It shut down socialist, pacifist, and other antiwar groups and overlooked attacks against innocent Americans of German descent. A radical left politics arose in response, ranging from free-speech advocates organizing a Civil Liberties Union to two new Communist parties. But a prudish morality dominated. The prohibition of alcohol accelerated, and in 1917 the navy permanently closed Storyville, New Orleans's legal prostitution district, out of concerns for sailor hygiene.

The mobilization caused economic and migratory chaos and conflict. The waning of European immigration and the growth of the armed services forced industrialists to hire millions of applicants they had earlier shunned—including women and African-American men—for well-paying factory jobs. Blacks used the new openness in hiring to make their first great exodus from the South. From 1915 to 1920 half a

million blacks left Jim Crow and sharecropping for new lives in Chicago, Detroit, Pittsburgh, New York, and other Northern cities. White laborers did not welcome their new coworkers and neighbors warmly. African Americans mistrusted the whites-only unions they were now asked to join, and white coworkers harassed and tussled with them in return. White renters and homeowners were angered by the growing number of blacks moving into their neighborhoods (steered by profit-hungry realtors who exploited the migrants' demand for scarce housing). Soon white residents' associations were pushing for the containment of black neighborhoods, and vigilantes were throwing bombs at black residences.

From 1917 to 1919, labor and housing tensions repeatedly led to racial rioting. More than two dozen major street battles broke out between young blacks and whites in East St. Louis, Charleston, Washington, Omaha, Chicago, Longview, Texas, and other cities; overall these waves of riots killed hundreds and burned thousands out of their homes. More than 200,000 African-American men served in the armed forces during the war, but they were segregated and met with white hostility everywhere. After the Armistice the U.S. command refused to allow black soldiers to march in the Paris victory parade, and more than a dozen black veterans were lynched when they returned home—some in their uniforms. The war had been a source of great optimism for African Americans who sought to demonstrate their worth as citizens, but it was clear that the white majority resented their presence and their successes more than ever.

Yet the homecoming of the 369th Hell Fighters in 1919 was a joyous affair. Four hundred thousand New Yorkers welcomed the regiment and other local troops, and when the Hell Fighters reached Harlem, Jim Europe's band led the large new black community in a tumultuous street celebration. Harlem blacks, now almost a quarter-million, enjoyed their

strength in numbers, higher wages, voting, and relatively free daily lives in the North. The rise of the Jamaican immigrant Marcus Garvey, founder of the Universal Negro Improvement Association, and the spirit of Irish independence and Zionism in Palestine, also nurtured black nationalism. Joining the black masses in the North were black (and white) musicians from New Orleans and elsewhere who were playing a strange new kind of ragtime. Everyone, from James Europe to the poorest migrant, took note of the new sound.

New Orleanians had already spent years spreading early forms of jazz across the country. Jelly Roll Morton began touring in 1906; the bassist Bill Johnson had taken a band to Chicago in 1909; and by 1912 others had traveled the usual circuits to that city as well as to Los Angeles. (The first printed reference to "jazz" music appeared in a San Francisco newspaper in 1913.) White New Orleans bands, with their racial advantages, achieved the commercial success that first made jazz famous. Tom Brown, a protégé of Jack Laine, failed to inspire excitement in Chicago in 1915, as did a band headed by Nick LaRocca (another Laine pupil) the following year. In 1917, however, LaRocca's revamped group, the Original Dixieland Jazz Band (ODJB), arrived in New York. James Europe had not yet joined the army, and his Clef Club Orchestra was at the peak of its Broadway fame. (LaRocca, always a racist, later recalled that "nigger" musicians "were everywhere on Broadway.") The African-American vaudevillian Bert Williams was also a major star, and the young immigrant songwriter and lyricist Irving Berlin was scoring hits with his supple, colloquial popular songs. Even with this competition, though, the ODJB and its growling and sliding New Orleans jazz effects became sensations during the band's stint at Reisenweber's restaurant.

At this moment—just when America was poised to enter World War I—new technology quickly transmitted jazz to a

national and global audience. Thomas Edison's sound-record-
ing device, the gramophone, or phonograph, had struggled
through a long infancy, evolving into electrical cylinder and
disk recording and playback technologies, and by the 1910s
large companies were ready to market players and records to
an eager public. Victor recorded the ODJB's rendition of
"Livery Stable Blues" during the band's stay in New York,
and sold tens of thousands of the disk. The ODJB made a suc-
cessful visit to London, and soon a copycat white group, the
Original Memphis Five, formed in New York. Almost in-
stantly jazz became a world music. In Moscow saxophone-
playing members of the tsar's court mimicked the ODJB's
recordings in the weeks before their dynasty was overthrown
by the Bolsheviks.

The ODJB recordings signaled the evolution of popular lis-
tening tastes away from ragtime and toward more novel, un-
usual, and socially daring music and behavior. The ODJB's
energy, outrageous buffoonery, and cacophonous ensemble
playing transported audiences beyond ragtime's syncopations.
Above all, New Orleans jazz allowed dancers to cut ties to the
staid dance steps of yesteryear and to shimmy, wag, and trot
with a marked lack of inhibition to the new (black) steps pop-
ularized by the Castles. Although that couple's national tours
had been limited, and Vernon Castle had met an early death
while serving as an army flight instructor, their popular lesson
books and the explosion of irresistibly danceable music—led
by the ODJB's disks—paved the way for a national revolution
in dance and leisure.

This shift was not simply a lighthearted diversion. The
public fascination with jazz took hold at a time when Ameri-
cans were shaken by the heightened violence of the war era.
James Europe was a notable early victim of this violence.
After returning home in 1919, Europe took note of the
ODJB's new style and sought to explore its artistic and com-

mercial possibilities. His band, once again civilian, toured the nation in triumph. Riding on the ODJB's popularity as well as his own, Europe found himself redefined in the press as a jazz musician. Labels bothered him—he had considered ragtime "a fun name given to Negro rhythm by our Caucasian brother musicians"—but he recognized the exciting possibilities of jazz rhythms. He quickly sought to take advantage of the new attention and to "produce new, peculiar sounds." Europe would not realize his goal. A drummer in his band, Herbert Wright, had developed a jealous hatred of the leader, and on May 9, 1919, after the group had finished performing in Boston, Wright mortally wounded Europe in his dressing room.

Europe was thirty-eight when he died. His passing was a convenient endpoint to the era of ragtime, just as other events of 1919 showed an America suffering from various symptoms of postwar disillusion. Violence wracked the nation that year. New Orleans clubowners' feuds drove Joe Oliver, Kid Ory, and others to black communities outside the South. The worst race riots occurred during the "Red Summer" of 1919, and the Red Scare, widespread labor unrest, baseball's "Black Sox" scandal, and Wilson's failure at the Paris peace table also increased the public's pessimism. Many combat veterans came home emotionally shattered and suffered a bitter alienation from America and its devotion to glorious violence. Others, though, saw "hell as a stimulant" (as the writer John Dos Passos put it) for wiping away an old culture and for embracing new ideas and ways of life. Dos Passos would later see 1919 as the decisive year in which this new outlook emerged, and he chronicled its events in a novel. Combat veterans such as Dos Passos, Ernest Hemingway, and e. e. cummings, as well as soldiers William Faulkner and F. Scott Fitzgerald and civilians Sherwood Anderson, Dorothy Parker, Eugene O'Neill, and H. L. Mencken, wrote angry condemnations of the war, and

some of them were giddily eager to cast off the civilization that had produced it.

In an effort to find an antidote to this "botched civilization," as Ezra Pound called it, writers and other young Americans embraced an alternative form of modern life—a culture of "bohemian" leisure and nonconformity. Already in 1919, urban pioneers lived "the fast life"—heavy drinking, serial sexual activity, and nighttime leisure. White women were the most daring nonconformists. As they advanced rapidly in work, education, and politics (the vote would be theirs in 1920), some of them eagerly sought to look and act like male soldiers. The short bob hairstyle was the female counterpart to the doughboy's crewcut; saloons were patronized as openly by women as by men; and a variety of activities from automobile driving to dancing to unfettered bachelorhood were adopted by many daring "flappers."

After the war the nation thus endured what the historian Henry F. May has called "the end of American innocence." As a new decade dawned, the disciples of Jim Europe, piano "professors" in saloons, innovative New Orleans musicians, and dedicated fans of ODJB records across America were poised to make jazz music the beating heart of a new subculture and worldview. Yet the tugs of nostalgia and modernization would continue to divide Americans' sentiments, and cultural traditionalism would grow. The national prohibition of liquor sales in 1920 signaled that the new decade would feature reactionary popular movements. Americans fearful of bold new behavior condemned jazz as a symbol of the violation of tradition and morality. The 1920s—christened "the Jazz Age" by one of its most gifted interpreters—would be an exciting and contentious time.

2

Hot and Sweet, White and Black: The Jazz Age

FEW NOTIONS about American history are as popular or durable as the concept that the 1920s was one long, roaring party. Since the publication in 1931 of Frederick Lewis Allen's *Only Yesterday,* many analysts have argued that Americans, tired and disillusioned by World War I, cast off Victorian values, experimented with new sex roles and mores, and defied the rule of Prohibition. Also in 1931, F. Scott Fitzgerald echoed Allen's portrait and named the twenties "the Jazz Age." More recently, many observers have suggested that only 1960s rock music symbolized its era as well as jazz did the 1920s. The adventures of jazz musicians and fans in illegal speakeasies (where bootleg gin was sold), their elbowing at the bar with notorious gangsters, the stimulating effect of jazz on college students at "petting parties" and on the wealthy smart set at Gatsby-style parties of the rich—all of this, the argument goes, made it the characteristic music of the time.

Much evidence supports the traditional view of postwar revolt. It applies most accurately to the experiences of white Americans, especially those descendants of Anglo-Saxons in the middle and upper classes. Many Americans used jazz to

grapple with new concepts and ways of life. For them, jazz was a pastime and a stylistic statement—both an element of carefree leisure and a critique of existing American institutions. Younger whites, especially, used the music to champion social experimentation and rebellion, and began an adolescent critique of adult standards which would grow and evolve for at least the next half-century.

But a reexamination of twenties jazz and its white musicians and listeners reveals that the simplistic cliché of the Roaring Twenties hides complex dimensions of American thought and behavior. The Jazz Age defies simple description. Cultural revolt ranged from the radical to the cautious. Much more was on most whites' minds than pure rebellion, and jazz became bound up in the public debate about urban life, gender roles, technology, and race that also helped define the twenties. Brilliant young writers such as Fitzgerald weighed in on these and other issues at a time when America was feverishly seeking to define its identity. A few white performers and observers championed black jazz and thus helped to challenge long-standing racial notions. They also helped to prime jazz for an even more prominent role in the 1930s. African Americans in the North, confined to a separate society in many ways, shared some of these reactions to jazz and the new leisure, but they faced special community dilemmas that added extra dimensions to the music's significance. It was among blacks too that a blues-influenced "hot" style of improvisation from New Orleans emerged to revolutionize the music.

The Original Dixieland Jazz Band's success in 1917 inspired many imitators, bands that would define jazz for the public for the next five years. The Original Memphis Five (from New York) copied the ODJB directly and scored recording successes, as did Art Hickman's California band.

Many of the first jazz stars were Jewish New Yorkers, already proficient in ragtime, who now turned to another indigenous style to help themselves assimilate in the American urban scene. The clarinetist Theodore Friedman, alias Ted Lewis, burst on the scene in 1919 with a highly skilled and innovative band. Dazzling audiences with musical slides, whoops, and syncopation at breakneck speeds, Lewis became the best-known jazz performer. Nightclub singers such as Sophie Tucker and Eddie Cantor featured this style of "happy" or "nut" jazz in their accompaniments, and less genteel "barn-yard dances" (borrowed from blacks) became the rage in New York and beyond. Broadway and Tin Pan Alley songwriters popularized this latest Southern musical style.

The growing jazz business now strove for an image of respectability. Famous bands usually avoided contact with clubs that violated Prohibition, and copyrights, record contracts, and nightclub residencies were carefully policed by managers, record and sheet-music companies, and the musicians' union. Publicists for jazz nonetheless played up the music's alleged association with provocative dances, daring sexuality, and disreputable nightclubs and dance halls. Press agents, entertainment journalists, and soon gossip columnists such as Walter Winchell paired jazz with the nightlife of the idle rich and depicted a daring scene featuring song, dance, and illicit drink.

It was the rotund son of a Denver music teacher who built the most successful jazz band and soon dominated the business. The Paul Whiteman Orchestra's recordings of "Whispering" and "Japanese Sandman" sold a million copies in 1920, and the press soon crowned Whiteman "King of Jazz." He had artistic ambitions that went far beyond those of happy jazz. Like James Europe and Scott Joplin before him, Whiteman believed that good popular music could be as refined an art form as the symphony or opera. His all-white ensemble included some true instrumental virtuosos who shared White-

man's elitist musical philosophy. Ross Gorman, skilled in a dozen reed instruments, and the trumpeter Henry Busse shared Whiteman's Western background and formal musical training, and the pianist Ferde Grofé included polished symphonic touches in his band arrangements.

These players helped to make Tin Pan Alley jazz accessible to white Americans in the heartland. Ignorant of black musical styles and generally new to Eastern city life, Whiteman's artists had been raised on the small-town American traditions of brass bands and music education. Since the early 1800s militia, police, fire, and other community bands had been a staple of small-town musical life. Reverent courses in classical music appreciation usually rounded out the white band student's education. Whiteman's band served as a bridge between the raucous jazz world and that of the small-town brass bands and music teachers. While the official music educators' journal, *The Etude,* associated "jazz at its worst" with "vile surroundings, filthy words, unmentionable dances and obscene plays," the success of Whiteman's polished band inspired many instrumental students to practice and pursue jazz playing. Many clean-cut bandleaders with respectable music backgrounds, men such as Fred Waring from Pittsburgh, Guy Lombardo from Toronto, and Ernest "Red" Nichols from Utah (another music teacher's son), copied Whiteman's recipe. By transforming the booming, Sousa-march-band sound into the smooth, "sweet" jazz that entertained the storied urban "smart set," these bands made a dramatic 1920s musical and cultural adjustment and helped the heartland audience to make it as well.

Leon Bix Beiderbecke joined the Whiteman band in 1927 after a rich apprenticeship. He had known a conventional Midwestern boyhood in Davenport, Iowa, growing up in a community of Lutherans, parlor pianos, and band traditions. But riverboats from St. Louis also brought black ragtime and

the blues to Davenport, where they influenced the young cornetist. Beiderbecke's ill-fated prep school enrollment in Chicago introduced him to jazz improvisation and black New Orleans bands. His remarkable warm solo style blended the spirit of black jazz with a sound that fundamentally remained "white," rich in the rhetoric of nineteenth-century brass band music. Beiderbecke's early work with small Midwestern groups and a popular regional band, the Wolverines, gained him a devoted following. With Whiteman, though, he largely recorded saccharine and novelty numbers, and his most original playing was only occasionally captured on record. Like Whiteman, Beiderbecke yearned to write music in the avant-garde style of European impressionist composers, but he was thwarted by alcoholism and illness, and in 1931 met an early death.

Beiderbecke, Whiteman, and others delighted millions of listeners who shared their background and tastes. Just as the *New Yorker* magazine soon became popular in Iowa (even though it claimed to be published "not for the little old lady in Dubuque"), whites became socialized to "symphonic jazz" through Whiteman's ambitious yet entertaining musical experiments. He hired skilled composers and arrangers to write polished, varied numbers which often incorporated harmonic and instrumental flourishes borrowed from the classical avant-garde. Whiteman appealed to the classical elite in the cities as well. The climax of his efforts was an "experiment in modern music" in February 1924 at New York's Aeolian Hall. The concert included the first performance of the *Rhapsody in Blue*, featuring its twenty-six-year-old composer, the songwriter George Gershwin, as piano soloist, and attracted a large audience of luminaries from classical and popular music. Whiteman's later presentations often fell prey to his bombastic showmanship and taste for flamboyant orchestration, but Gershwin continued to produce symphonic and operatic com-

positions, as well as Broadway scores, that brilliantly show-cased his use of the new jazz sound.

Whiteman's concert efforts helped to launch a stimulating and revealing debate about jazz in American culture. Beginning in 1924 music critics such as Deems Taylor, Sigmund Spaeth, B. H. Haggin, Henrietta Straus, and Carl Engel wrote detailed articles in the popular press examining jazz's intriguing musical innovations. While most of these critics admired jazz's rhythmic vitality and instrumental color, some disapproved of the "happy" bands' jazzing of classical tunes, and others worried about the influence of Tin Pan Alley on youth. Engel, later the music curator at the Library of Congress, wondered about the effects that "Semitic purveyors of Broadway melodies" (such as Gershwin, Irving Berlin, and Jerome Kern) might have on young Anglo-Saxons. (The automaker Henry Ford agreed, arguing in his newspaper that "the abandoned sensuousness of sliding notes" was "of Jewish origin.") A few critics were openly hostile. David Smith, dean of the Yale School of Music, challenged the idea that jazz was an "American folk music" by noting with distaste that it had originated in the "frenzied" culture of the city.

How many readers followed this debate is unclear, but it is certain that jazz as a social phenomenon was a popular concern. Whiteman's concert-hall elitism did not hide the fact that most jazz was aggressively irreverent and often more suggestive and sensuous than symphonic or "sweet." This fact, as well as jazz's appeal to white youth, made it a topic of controversy and a symbol for a decade of cultural debate.

Jazz was condemned by conservatives as the downfall of America's white youth. The revolutionary fires of wartime had cooled in the 1920s, but to middle-class whites no group seemed more rebellious and insolent than their own children. A distinctly adolescent subculture—neither childlike nor adult—a subculture of social experimentation and leisure for

young men and women, had been emerging and gaining attention since the ragtime era, but the Jazz Age marked its controversial national debut. A minister declared that "in 1921–22 jazz had caused the downfall of 1,000 girls in Chicago alone." Henry Ford attacked "the waves upon waves of musical slush that invaded decent parlors and set the young people of this generation imitating the drivel of morons." John McMahon, writing in the *Ladies Home Journal,* condemned "The Jazz Path to Degradation," asked "Is Dance Ruining Our Youth?" and yearned for a return "Back to Pre-War Morals." By mid-decade, however, even middle-aged parents were indulging in petting parties and the turkey trot, and the new leisure was a fascination for all ages. In 1925 Sinclair Lewis's best-selling novel *Babbitt* depicted the fictional paragon of middle-aged conformity. Yet even the realtor George F. Babbitt abandoned bourgeois respectability for a binge of drinking and dancing with his seductive client, Tanis Judique, and her fast "Bunch."

Jazz inspired adolescent white men to create cliques of appreciation and instrument playing, which led many of them to musical careers. Phonograph records and instrument instruction inspired high school boys in such locales as Denver; Spokane; Boston; Austin, Illinois (near Chicago); and Berkeley, California, to form jazz bands. Playing at fraternity parties, Chinese restaurants, and soda shops gave them networks of adolescent male support and communication. Once they became professional musicians, these men remained in close-knit "gangs," living and socializing together—in Austin, in Bix Beiderbecke's cabin in northeast Indiana, in the pianist Art Hodes's Chicago apartment—well into adulthood. Always "the boys" in the band, white jazz musicians formed lasting bonds through shared living quarters and travel. They were by no means revolutionary; not a single early white jazz musician would ever be attracted to political radicalism, and

the resistance of most to female colleagues and homosexual men in nightlife showed their basically conservative tendencies. Still, their behavior demonstrated the welcome allure of the jazz musician's life for twenties adolescents, and they formed the core of what became the much larger swing subculture of white youth in the next decade.

In general the 1920s adolescent revolution in courtship, public behavior, dress, and female behavior had built-in limits and even some socially conservative tendencies. The adolescents (and elders) involved in the revolt were middle-class whites who were drawn to carefully sanitized versions of working-class immigrant nightlife. Dating, petting, shimmies, and even the woman's bob haircut had been pioneered by Catholic, Jewish, and African-American urban revelers. The middle-class rebellion in Muncie, Indiana, as a landmark sociological study by Robert and Helen Lynd showed, took place in dance halls, speakeasies, and nightclubs in "safe" and prosperous urban and suburban districts. The leisure experimentation of white college students rarely violated laws such as Prohibition or challenged their parents' largely Republican political conservatism. The limits of 1920s rebellion can also be noted in the new and wide popularity of a music that epitomized tradition and cultural conservatism. "Old-time" or "hillbilly" music, championed by singers such as Vernon Dalhart, Jimmie Rodgers, and the Carter Family, was a national sensation by 1929, nearly rivaling the mass appeal of jazz.

While moralists might have exaggerated the revolutionary nature of jazz or the new subculture, their concern did draw attention to the real and increasing dominance of leisure in America. Before 1920 nightclubs, cabarets, carnival "midways," and amusement parks had prepared the way for jazz by inviting all whites—rich and poor, male and female—to cast off formerly valued inhibitions. In the mid-1920s "Coolidge prosperity" fueled an enormous growth in

nightlife. Every major and midsized city had its version of Broadway; even Muncie and Dubuque hosted speakeasies, petting parties, car cruises, and jazz and shimmy dances. Jazz may have been first among the leisure novelties, but it was certainly not alone. In 1924 the critic Gilbert Seldes found jazz to be one of America's seven new "lively arts," expressing "the gaiety and liveliness and rhythmic power in our lives."

Now entertainment was even more of a mass phenomenon, transmitting forms of post-Victorian leisure to thousands and even millions. After 1920 college football stadiums and their crowds exploded in size. Major league baseball recuperated from the 1919 Black Sox scandal thanks to the arrival of dazzling new stars, led by Babe Ruth. Boxing in the 1920s, like baseball, benefited from charismatic champions such as Jack Dempsey, as well as heavy press and movie newsreel publicity. Ruth and Dempsey, incidentally, also popularized the new nightlife by carousing and dancing in New York nightclubs and dance halls. Even their influence paled next to that of Hollywood's more fun-loving motion-picture stars. Movie studios became some of America's most profitable enterprises by perfecting the production of slick, lavish pictures and the marketing of popular performers. Rudolph Valentino, Douglas Fairbanks, Mary Pickford, Clara Bow, Greta Garbo, and others became stars chiefly because they projected enough personal charisma—what the publicists called "It"—to fill the big screen. More often than not, their outsized sexuality, dexterity, social daring, and athleticism were set in cinematic representations of the speakeasy, the cabaret, and the dance hall, and the public came to associate Hollywood's heroes with these "shady" leisure settings.

The emotional and sexual impact of the silver screen tells us that 1920s film—as well as jazz and other popular culture—expressed much more than carefree gaiety. The new mass media explored the fears and temptations about race, sex, and

urban life that audiences confronted in a difficult industrial age. White jazz musicians' memoirs, for example, reveal that the era was filled with uncertainty and tension.

The songwriter Hoagy Carmichael began as a jazz pianist in Bloomington, Indiana, where he worked with Bix Beiderbecke and other members of the Wolverines. According to Carmichael's memoirs, these Midwestern white youths used jazz as a medium for retaining the scale of small-town community living even as the pace and content of that life were being transformed. The symbols of the past—his mother's piano, parlor, and porch—kept "calling out" to his cohorts, but "we were afraid"; veterans of World War I returned as "changed" men, and the boys sensed that the times had changed as well. *Middletown,* the Lynds' study of Muncie, not far from Bloomington, showed small-town Americans bridging the chasm between past and present with difficulty. White residents there both deplored the passing of the old Victorian and rural ways of life and were delighted by the temptations of the silent cinema and the fox-trot. Future jazz stars Jimmy McPartland and Artie Shaw later recalled family crises and difficult socialization in Chicago and Hartford, respectively, and the clarinetist Milton Mesirow was disowned by his respectable Chicago family for pursuing a jazz career. Surrounded by illegal gin, Beiderbecke and many others fell into alcoholism.

What Gertrude Stein called the "Lost Generation" of writers traced this sense of unease and dislocation back to the devastating emotional impact of World War I. In their fiction, Ernest Hemingway and John Dos Passos famously depicted the psychic wounds of veterans returning to the heartland as well as the degradation of idealism and honest communication caused by wartime propaganda and peacetime boosterism. F. Scott Fitzgerald, a soldier who did not go to France, dissected the new leisure activities and wasteful spending of

privileged youth, part of a generation that had returned from the war to find "all Gods dead, all wars fought, all faiths in man shaken." Leisure, like bootleg alcohol and sexual obsession, was an addiction that distracted people from the fundamental dishonesty and aimlessness of the time.

The 1920s witnessed an attempt to look beneath the encrusted veneer of "civilization" to find the basic, infantile human passions and drives that seemingly compelled people to make war and to waste their lives. The psychologist John B. Watson pioneered behaviorism, which sought to prove that an infant's personality could be formed completely by those who determined its early environment. Sigmund Freud, wildly popular in twenties America, had theorized that infantile trauma caused lifelong difficulties. The fascination with primitive emotional drives and infancy found expression in jazz and nightlife. Journalists and jazz promoters emphasized the music's juvenile, even infantile qualities. Broadway slang had already termed club-going women "babies," and soon dancers with bobbed hair and bracelets were known as "jazz babies." Squalling trumpets imitated an infant's cry in many of Ferde Grofé's arrangements for Paul Whiteman, and Whiteman's pianist Zez Confrey as well as "nut" jazz novelty groups specialized in childlike musical nonsense (echoing somewhat the avant-garde "Dada" of European surrealist poets). According to Hoagy Carmichael, young Bix Beiderbecke and their friends enjoyed shouting out nonsense syllables to each other as much as playing jazz.

Raw infancy, Freud argued, was driven by basic sexual drives, and 1920s leisure helped to stoke the public's fascination with the sexual. In twenties books and periodicals a sanitized but still daring public discussion of sexuality, bodily functions, and hostile or "depraved" dreams or wishes took place. Movie "bedroom" melodramas also brought vulgarized psychoanalysis to the masses. The rising divorce rate was

linked with married persons' heightened search for sexual and psychic fulfillment, often amid the new nightlife. Adult fears about growing adolescent sexuality undoubtedly stimulated many of the attacks on jazz. Henry Ford was fairly explicit in his condemnation of the music as "monkey talk, jungle squeals, grunts and squeaks and gasps suggestive of cave love."

Like sexual issues, the greater presence of dark-skinned people in the cities both stimulated and disturbed 1920s white Americans. Popular culture was a notable arena for white racial anxiety. Since the late 1800s promoters of the new public leisure had been obsessed with the racial purity of their audience. Movie theaters, amusement parks, and vaudeville houses almost always excluded or segregated black customers while diverse ethnic groups were homogenized into one "white" audience. By the 1920s, though, dark-skinned musicians and dancers were common on stage and floor shows, and the mingling of fair and dusky merrymakers in "black and tan" speakeasies often prompted condemnation in the press. Such commentary was charged with sexual anxiety and concern about the alleged lack of inhibition on the part of black musicians and the predatory nature of swarthy "tango pirates." The pink-cheeked society girl, yielding to the clutches of the tango pirate, was a common type in popular journalism. In silent film, the bronzed face of Rudolph Valentino in *The Sheik* (1922), pressed close to the kidnaped damsel's fair skin, panicked censors and strangely moved white female viewers. White writers such as Madison Grant and Kenneth Roberts foresaw "the decline of the great race" and pointed as evidence to popular culture and the increased "mongrel" mixing of ethnic groups, socially and sexually, in the new urban nightlife.

— Twenties whites often vehemently denied that African Americans had made any contribution to the creation of jazz. New Orleans "Dixieland" musicians, including Nick LaRocca

and other members of the ODJB, made it a point of honor never to mix with black musicians or acknowledge their talents. Light-skinned Creoles sometimes fooled them, though; Jack Laine hired "niggers" who "played so good we couldn't tell what color they was." *Jazz* (1926), a long study written by the music's "king," Paul Whiteman (and a coauthor), defended the bandleader's well-known belief that jazz was "modern" concert music, but it systematically ignored black Americans. To their credit, the music critics who wrote about jazz openly debated the issue of black involvement. Echoing Dvořák's 1890s praise of spirituals, Henrietta Straus and the composer Henry F. Gilbert perceived black musical genius at the core of ragtime and jazz. But Carl Engel gave the credit to Jewish songwriters, and Sigmund Spaeth argued that it was traditional (white) American individualism that had given birth to jazz. Dr. David Smith acknowledged black involvement but saw this as evidence of jazz's "debased" urban nature. The confusion over jazz's bloodlines would continue until legitimate jazz history first appeared in the 1930s, yet politically charged disagreements on this issue persist to this day.

When black musicians appeared before white customers, they usually did so either in disreputable or in carefully controlled settings. White thrill-seekers in Manhattan who traveled uptown to Harlem could either dare to mingle in the often lurid and unsafe "black-and-tans" or visit elite nightclubs designed especially for them. Connie's Inn was a major black jazz site for white customers only, but its fame was overshadowed by that of the Cotton Club.

The club was located on Lenox Avenue at 142nd Street. Its building had originally been owned by Jack Johnson, the first black heavyweight boxing champion. In 1922 the Irish-American gangster Owney Madden took over the Cotton Club with quiet police approval. For the next thirteen years the club presented black musical shows for "slumming" elites visiting

from around the world. Here jazz was presented in the context of "jungle revues" derived from popular notions of African primitivism. Performers were forbidden to mix with customers, though male patrons were rarely prevented from pursuing dancing girls they fancied. Gangland violence occasionally intruded on the fantasy; Madden himself was murdered, and his rivals often threatened employees, including bandleaders Andy Preer and Edward "Duke" Ellington. The club flourished well into the 1930s. In settings such as the Cotton Club, white Americans used jazz to investigate the darker race that so obsessed them and to experiment with sexuality and fluid social relationships. As Victorian restrictions and institutions weakened, black jazz and neighborhoods attracted white Americans while simultaneously stirring their fears of the unknown, of new and greater social interaction, and of the sensuous allure of jazz and the blues.

Such basic fears also underlay the furious attacks on jazz by other whites. Jazz music in fact became a symbol for all the modern innovations that traditionalists despised—the new leisure, city life, Freud, and other elements of 1920s cultural modernism. Traditionalists yearned for a return to a mythical past, to the dominance in America of Victorian values and persons of Anglo-Saxon stock. They responded to President Warren Harding's homely pleas for "normalcy" and small-town traditions, and fueled political attacks on modern culture. In 1924 Congress restricted immigration from non-Protestant Europe with strict quota ceilings. The Ku Klux Klan gained five million members by opposing cities, immigrants, Catholics, Jews, and liberal Protestants as well as blacks. Fundamentalist Protestant attacks on the teaching of Darwinian evolution not only gained the support of small-town and rural folk who felt increasingly neglected and isolated but of many city dwellers who sought rescue from their dense, impersonal surroundings. Even in sunny and spacious

Los Angeles, thousands flocked to Klan meetings, religious revivals, and "Iowa picnics." The nostalgic Henry Ford encouraged city youth to take up country fiddling and dancing. Prohibition was the traditionalists' greatest triumph. Despite widespread violations in the cities, it considerably reduced the nation's liquor consumption.

Battles between "wet" and "dry," rural and urban, Anglo-Saxon and "ethnic," conservative and radical Americans defined 1920s culture. Jazz was on the front lines of this battle, drawing the furious opposition of antiurban conservatives who knew a bold innovation when they saw one. Jazz music and the behavior it nurtured illustrated both the racial, social, and sexual daring of some white rebels and the greater caution of the larger mass audience, a group enticed by the allure of both nostalgia and novelty.

For 1920s African Americans, jazz was not the Cotton Club or Aeolian Hall. For them jazz thrived in white-owned clubs like Chicago's Lincoln Gardens, where they were relegated to the back seats by the preferred white customers. They also heard jazz in Harlem's Savoy Ballroom, also white-owned and patronized; in 1937 a journalist observed that only one in five dancers there were black. South Chicago's glittering "Stroll," around 35th and State streets, also saw plenty of white customers, but here black residents dominated the sidewalks. Like the side streets of Harlem's Lenox Avenue, Pittsburgh's "Hill," and South Central Avenue in Los Angeles, the Stroll held tiny speakeasies and "chicken shacks" which featured jazz by and for black people. Tourists did not go there. The locals could converse freely, and families and couples found pleasure and laughter in the midst of good food, bad drink, and jazz and the blues. For urban blacks, jazz represented a different reality from the one their white contemporaries experienced.

Black jazz flourished in part because gangsters became un-
likely patrons. Speakeasies, run by liquor-smuggling syndi-
cates, were rarely policed in the swelling black neighborhoods
of Northern cities. Black-and-tans and other establishments
provided various jobs for unskilled migrants, but jazz musi-
cians in particular were hired as inexpensive club entertain-
ment at the exact moment their music needed some form of
patronage. (Scott Joplin, who died in 1917, might have been
saved by such employment.) Vaudeville, carnival, and the re-
maining minstrel circuit promoters also helped, expanding
their touring operations and hiring more players and singers.
The Theater Owners' Booking Agency (TOBA), founded in
1920, provided the first permanent touring circuit across the
South. "Down-home" Southern blues stars such as Ma Rainey
also came north, meeting black bandleaders such as Will
Vodery and Erskine Tate, and pianists also toured extensively.
Such black ensembles as King Oliver's Creole Jazz Band,
McKinney's Cotton Pickers, and Zack Whyte and his Choco-
late Beau Brummels spent years refining their sounds in clubs
and on circuits. Successful black bandleaders enforced group
discipline, drove hard bargains with promoters, and dealt ef-
fectively with the white-dominated musicians' union's regula-
tions. And by 1923 bandleaders had to satisfy the tastes of
increasingly discerning black audiences. The players had to be
accomplished, prove adaptable to the wishes of audiences and
club owners, and usually be able to read music notation. The
era of the jazz professional had arrived.

The record companies that had made the ODJB and Paul
Whiteman famous were late in publicizing black jazz. The
trumpeter Freddy Keppard apparently refused a 1917 record-
ing offer, and while James Europe and Wilbur Sweatman did
record ragtime, no black jazz was "waxed" until 1920. In that
year in New York, Sophie Tucker's illness opened studio time
for Mamie Smith, who made the first blues recording, "Crazy

Blues," accompanied by the trumpeter Johnny Dunn and his Jazz Hounds band. Smith's recording became a best-seller and ignited the "race records" phenomenon of the 1920s. Thousands of recordings made for the African-American market popularized a great many musicians. Colorful cartoon advertisements for OKeh 8000s, Paramount 12000s, Columbia 14000s, and other race record series built up the public images of blues stars by showing them involved in the amorous, dangerous, or humorous predicaments their songs described. The ads appeared in black newspapers such as Robert Abbott's *Chicago Defender,* which appeared in a popular national edition. Blacks nationwide also bought phonographs; by 1930 even about 30 percent of poor sharecroppers' households in the Mississippi Delta owned hand-cranked record players.

Bands recorded hundreds of purely instrumental numbers, and these records are the main documentation we have of 1920s black jazz. A surprisingly large amount of the music sounded like Whiteman's or Lombardo's "symphonic" or "sweet" jazz. Fess Williams, Erskine Tate, Will Vodery, and Charlie Elgar performed polished dance music, often modeled on Tin Pan Alley standards. Certain migrant ensembles, however, particularly those from New Orleans, maintained closer contact with the "dirty" blues that powered the race record craze. New Orleans bands also stressed collective improvisation more than other groups. Their recordings generally showed rapid stylistic development after 1924; tempos sped up, ensemble work became more intricate, and broad slides and "dirty" notes were toned down for a more urbane sound. The tuba, banjo, and cornet quickly gave way to the string bass, guitar, and trumpet—instruments more suitable for acoustic recording horns and large Northern halls. Greater exposure to vaudeville practices increased showmanship values in jazz as bass players added "slaps" and drummers twirled sticks and tapped odd kinds of noisemakers. In 1925

Jelly Roll Morton, based in Harlem, became a bandleader. His diverse background allowed him to compose remarkable arrangements on paper and lead his group, the Red Hot Peppers, in recordings. Morton's classic arrangements, as well as those produced in Chicago by the young pianist Lil Hardin, paved the way for greater sophistication in jazz arranging.

The migrants clearly were influenced by players trained in the North. Private music teachers, as well as music programs at such black colleges as Wilberforce University in Ohio (where McKinney's Cotton Pickers and Lloyd and Cecil Scott's band were formed) and urban conservatories, produced scores of accomplished black players. Northern blacks preferred less "dirty" and more well-schooled musical styles, and their tastes stimulated the rapid "refinement" of 1920s black jazz. While the two finest reed players from New Orleans, clarinetist Jimmie Noone and multi-instrumentalist Sidney Bechet, had already developed profoundly "Creole" sounds they would never lose, they polished their runs and vibrato and sped up their improvisations while in Chicago and New York, respectively, to suit more closely the preferences of their audiences. When the French composer Maurice Ravel applauded Noone in Chicago, and the Swiss conductor Ernest Ansermet wrote approvingly of Bechet during the latter's tour in Europe, it was clear that "down-home" and conservatory styles were finding common ground. Younger players trained for classical careers would turn to jazz when they found the concert stage closed to them. Jazz quickly became blacks' classical music.

It was in the 1920s, moreover, that New York City's brand of ragtime piano, called "stride," was grafted onto the Dixieland jazz styles. African Americans in New York faced stiff housing discrimination, and as a result white Harlem landlords demanded inflated rent from their captive tenants. "Rent parties" became Harlem institutions, where neighbors

paid into a rent fund for admission to a party in the apartment. Keyboard striders entertained on pianos or portable organs, regaling the parties with finger tricks, repartee, and colorful singing. Successful pianists excelled at informal, intimate, and boisterously humorous performing. Piano "professors" such as Eubie Blake, Luckey Roberts, Thomas "Fats" Waller, James P. Johnson, and the war veteran Willie "The Lion" Smith (followed in the 1930s by the phenomenal youngster Art Tatum) thrived in Harlem, finding expansive new venues for their entertaining and intensely creative styles. Blake found an audience on Broadway in 1923, cowriting the hit musical revue *Shuffle Along* with Noble Sissle (a veteran of James Europe's band). Roberts became the favorite of the world's best-known playboy and clubgoer, the Prince of Wales. High society, Broadway, and the unique density of its population made Manhattan the place where jazz styles blended and were publicized most quickly. The lure of fame, glamour, and commercial success drove the most ambitious New York players.

Jelly Roll Morton could have dominated the New York scene, but his disdain for other blacks and his combativeness kept him in limbo in Harlem. By contrast, the twenty-three-year-old second cornet in King Oliver's band, Louis Armstrong, arrived from Chicago in 1924 with a clear goal of success in mind. Armstrong had learned much from Oliver and had overcome his own faulty blowing technique (apparently the product of poor teaching at a New Orleans orphans' home) to produce the biggest and most versatile cornet sound in jazz. Armstrong developed an enormous confidence, an elegant harmonic language, and an unmatched sense of what New Orleanians called "swing." His greatest mature solo, the 1928 recording of "West End Blues" with his Hot Five, showed an awesome command of swinging—in three different tempos in the brief introduction!—and a tremendously

theatrical and emotional sense of communication, especially in the great four-bar-long high B-flat in the final chorus, which proclaimed the pain and beauty of Delta life for all the world.

Paul Whiteman's white fans did not know it, but Armstrong and other blacks were developing the foundation for many of jazz's most important later styles. No element of this foundation was more important than "swing" itself, an elusive practice usually defined as playing before or after "the beat" (the steady rhythm kept by the drums, piano, and bass). The soloist "swung," in other words, by avoiding the rhythm section's cadence, consistently placing notes behind or ahead of the beat in ways that enhanced the music's tension, sensuousness, or propulsiveness. Like minstrelsy and ragtime, swing was a New World echo of African polyrhythms. When 1920s jazz musicians displaced established rhythms by "swinging," they created polyrhythmic patterns—often subtle but sometimes bold and extravagant—which sounded "African" even to untrained listeners. Armstrong, in solos such as 1928's "Muggles," swung irresistibly, his trumpet expressing vivid phrases against the plodding background of his less inspired bandmates. Swinging expressed both the traditions of black rhythm and the heightened keenness of street-smart urban black nightlife.

Armstrong's playing, while bold and often humorous, also eschewed most of the slides and comic effects of "nut" bands, bringing a new dignity and substance to twenties jazz. His aggressive swinging was his personal stamp on jazz, which almost all major figures in the following decade would emulate. He also virtually invented jazz singing. By singing wordless "scat" in the bluesy, improvisational style of his horn playing, Louis liberated the voice from stylistic clichés of the day. More than any other jazz pioneer, Armstrong helped to make improvisation a deeply personal act of musical creation which

drew on vital essences of African and African-American musical traditions.

Armstrong also cultivated both a bohemian personal life and a public performing profile which soon became widely imitated at nightclubs. He enjoyed smoking marijuana; brief jail time in 1929 only encouraged him to use it even more openly. In the 1950s he confessed that anger at racism was the source of his rebellious behavior, but he typically redirected this anger into creativity and a sociable desire to overcome boundaries. Biographer James Lincoln Collier has suggested that Armstrong, lacking a father, always sought love and support, but other scholars have disputed this analysis. In any event, onstage Armstrong promoted the affable, grinning popular persona the public came to love. In the light of his musical genius, the trumpeter's minstrel-like clowning has long puzzled students of his life, but it may well have indicated simply that Armstrong was willing to give audiences what they wanted. His canny hiring in the 1930s of the skilled nightclub promoter Joe Glaser as his manager also speaks to his eagerness to take care of business. Armstrong was a complex man whom we may never fully understand. His voluminous letters and memoir drafts, in which he reflects probingly on fame, music, race, and sex, still await careful investigation. These documents may help us to understand how this poor boy from uptown New Orleans became the founding father of "hot" jazz.

Armstrong's early style epitomized how jazz expressed urban blacks' tremendous spirit of postmigration optimism. The future jazz bassist, Milt Hinton, as a teenager in the 1920s on Chicago's South Side, found himself "playing the violin. And I'm a superstar. I've got nice clothes, you know, everything. I could take a girl to the restaurant. . . ." African-American players, listeners, and dancers thoroughly enjoyed the

thriving leisure institutions open to them. Especially in the dance halls, where physical energies found a profoundly creative outlet, communities' identities were formed and individual lives were bolstered by companionship, public displays of skill, and nurturing social interactions in a wide range of situations. "Jookin,'" the elaborate new dance styles of young 1920s blacks, brought a brilliant athleticism to the old barnyard steps. Tap dancing became an extraordinarily sophisticated art form, as dancers such as the Nicholas Brothers and John "Bubbles" Sublett matched Armstrong's gift for rhythmic flexibility and subtlety. Like jazz, the dance renaissance reflected the explosion of creativity and optimism among black migrants in Northern cities.

Initially not all urban blacks welcomed jazz. The music antagonized black traditionalists in many of the same ways it worried white cultural conservatives. The black church had never approved of the messages or social function of the blues, and condemned its entrenchment in the "godless" longshore bar and sporting crowds of the jook joint. Jazz, based in part on the blues, seemed little better to many ministers. Major black newspapers such as the *New York Age* and the *Chicago Defender* hired music critics (Lucien White and Dave Peyton, respectively) who soberly chastised jazz musicians for promoting "uncivilized" frivolity and cacophony. Echoing white critics, black opponents of jazz condemned the music as a corrupter of youth and morals. Music teachers and chorus leaders demonized jazz and warned young people not to play or enjoy it. Unlike white critics, though, some African Americans were especially concerned about the impact jazz might have on the image of their communities in the white-dominated world. Ministers and others feared the white ridicule and scorn that jazz might bring down upon the entire race.

Other black cultural movements of the 1920s were criticized by cautious elites. Marcus Garvey's mass movement, the

Universal Negro Improvement Association, brought pageantry and a sense of black unity to many communities, but W. E. B. Du Bois and other educated leaders ridiculed Garvey's bombast, business enterprises, dreams of retaking Africa, and even his dark complexion. At the same time African-American writers collectively promoted what their publicist, Professor Alain Locke, called "the New Negro"— the educated, proud Negro, free from Jim Crow, thriving in large Northern urban black communities. Based in Harlem, the painter Aaron Douglas, the novelists Jessie Fauset, Walter White, and Jean Toomer, the folklorist Zora Hurston, and the poets Langston Hughes and Sterling Brown drew on folk culture such as slang, dance, and the blues to give 1920s blacks a sense of who they were and what they might become. These artists were attacked by two kinds of black critics—elite traditionalists who were shocked at their use of blues and other folk culture, and cynics who believed they were selling out to white audiences, patrons, and publishers. Hughes, for example, was simultaneously attacked as the "Poet Low-rate of Harlem" for his blues lyrics and called a "stooge" because he once lived on a stipend from a meddlesome wealthy white patroness.

These divisions among blacks were quickly bridged in the twenties by a growing sense of community. For saint and sinner, dandy and sharecropper, black urbanization brought strength in numbers and important new advantages. Funeral and life insurance plans, banks, fraternal organizations, and churches grew quickly, becoming new financial and social networks for all. By 1925, as Marcus Garvey began to face legal and business troubles, elites acknowledged that they shared the Jamaican's concerns for black unity and economic self-help. Harlem schools and audiences grew to appreciate the creative genius of many Renaissance writers and artists. Drawing on African-American verbal traditions, 1920s street ora-

tors and "scholars" used humor and effusive rhetoric to create politically edged "toasts" (monologues) and "dozens" (stylized insults). Similarly, black vaudeville comedians commented sharply on the woes of city life, creating a pool of knowledge and communities of laughter for their urban audiences.

Jazz also helped bridge the divide between common folk and elites. Musicians accommodated the mixed tastes of their neighbors, blending styles to attract the most varied black audiences. Music teachers and school principals became more tolerant of student jazz performance and instruction, and as the musician Ralph Brown reported, parents' resistance to jazz was worn down by 1930. Articulate, tuxedoed, and college-educated bandleaders such as Fletcher Henderson (B.S. in chemistry and mathematics, Atlanta University) moved in the "best" circles and were perfect examples of what Du Bois had long ago called the "talented Tenth," the elite leaders that Afro-Americans needed. Their carefully tailored performances and polished artistry did much to gain jazz the strong approval of black elites.

As jazz's reputation grew, black communities came to value the music as an expression of their hopes and strength. Swaggering and proud, vaguely African in its swinging rhythms and moaning ecstasy, jazz became a symbol of global and local black unity. Musicians served as mouthpieces for the black public, "preaching" jazz and the blues in ways that expressed collective and individual emotions. In dance halls, nightclubs, and chicken shacks, jazz helped to cement audiences into communities; along with food, liquor, and dance, jazz stimulated the creation of politically active neighborhood groups. Leading jazz bands performed at hundreds of social events, fund-raisers, and other functions sponsored by the NAACP, the Urban League, and the political machines of Raymond Jones in Harlem and William Dawson in Chicago. For a decade and a half, until World War II changed the ghettos

profoundly, jazz would be the main musical expression of protest, an anthem for civil and economic rights.

The optimism and growing sense of community of urban black neighborhoods were nonetheless deeply undermined by a persistent and intensifying Northern racism. Ghettoization was quickly boxing these neighborhoods in. Realtors and banks were systematically segregating blacks residentially in defined city areas. Job discrimination by white employers was rampant in black neighborhoods as well as downtown. All department stores and utility companies in 1920s New York City, for example, refused to employ African Americans. Organized crime, by default, became one of the largest ghetto employers. Young men often could find work only producing and distributing bootleg liquor or "running the numbers" for illegal lottery rackets (control of which had been wrested from black gangsters). As cities and police forces looked the other way, vice took root in black neighborhoods and polluted their work ethic and economic health. The quality of black life in the North steadily deteriorated. In 1930 a study concluded that health care in Harlem was actually inferior to that in the Mississippi Delta, and that infants, the sick, and the elderly were suffering accordingly.

While jazz continued to serve as a powerful expression of black optimism, it too suffered from prejudice and discrimination. Gangsters such as Owney Madden and Al and Ralph Capone offered welcome employment to musicians, but they were also frightening dictators, apt to mistreat employees at the slightest whim. Outbursts of violence in clubs terrified musicians and dancers, who also became pawns in mob turf struggles. For example, a rival of Madden's warned that a Cotton Club musician would be killed if he did not immediately join the band in another nightclub. Jazz musicians escaped the underworld only in 1933, when Prohibition was repealed.

Commercial promoters were scarcely more ethical. Vaudeville agents, circuit producers, and record executives paid unsophisticated black jazz players poorly and would steal from band payrolls. Even the musicians' union was predatory. While players could thank the American Federation of Musicians for generally maintaining high wage rates for the best jobs, it usually reserved these positions for white members and created blacks-only locals to enforce job segregation in urban areas. In addition, each union local had strict employment rules, such as restrictions against work by musicians visiting from other cities, which grated against black jazz musicians' tendency to tour and casually to form "pickup" bands.

Black jazz musicians faced constant discrimination and humiliation. Much of it was due to the common racism of the day, which forced them to ride in the backs of buses, find lodging in black neighborhoods, and enter nightclubs and theaters through back doors or freight elevators. Touring bands, on trains or on buses, suffered insults from whites who sought to put African Americans "in their place." White women taunted players on the bandstands, deliberately tempting them to cross the dangerous sexual color line. Most musicians in Harlem and on Chicago's South Side labored in near-poverty while white bands in downtown Manhattan and Chicago made comfortable livings playing black jazz standards. Composers such as Jelly Roll Morton saw riches depart when they signed away song and arrangement rights to crafty publishers (white and black). In the 1920s, when the black composer Andy Razaf wrote songs such as "(What Did I Do to Be So) Black and Blue?" or "I Gotta Right to Sing the Blues," he captured the dispirited feeling of many black jazz musicians. Only the most gifted and commercially astute black artists, such as Armstrong and Duke Ellington (carefully managed by Glaser and Irving Mills, respectively), could thrive in this hazardous environment.

Twenties racism was a formidable barrier between white and black jazz. Few white listeners or musicians found the "hot" styles of Armstrong or Ellington to their taste. In Chicago such downtown bandsmen as the trombonist Glenn Miller almost never visited the Stroll to acquaint themselves with black music. Other whites, such as the hardworking teen clarinetist Benny Goodman and the "sweet" bandleader Guy Lombardo, made occasional trips to black nightclubs, but they made little important contact with the musicians they found there.

Still, some white improvisers immersed themselves in the blues-drenched "hot" style of Armstrong and Oliver and the sophisticated syncopations of stride pianists. Adolescents such as Bud Freeman in suburban Chicago, Eddie Sauter and Charlie Barnet in New York City, Gil Evans in Stockton, California, and Bill Davison in Defiance, Ohio, rebelled against their parents' warnings and traveled to "darktowns" to hear the bands there. White university students had blazed trails to black nightclub districts for high schoolers, but they had usually taken only a recreational interest in black people and their culture. The younger enthusiasts were more committed. Young Artie Shaw was transfixed by the stride piano he heard in the speakeasies of Harlem and Cleveland, and Max Kaminsky was "converted" by the church choirs in black South Boston. In Austin, Illinois, Bud Freeman, Jimmy McPartland, Dave Tough, and Frank Teschemacher overcame strict ethnic barriers on the West Side and traveled often to visit the Stroll. The guitarist Eddie Condon recalled that for his peer group, the King Oliver band on the South Side "was hypnosis at first hearing.... Freeman and McPartland and I were immobilized." Freeman noted that "I had never really heard any music as creative and exciting as this band played," and his colleague Milton Mesirow ("Mezz Mezzrow") remembered that black music "hit me like the millennium would hit a

philosopher." The "Austin High Gang" went on to develop the most striking white "hot" band style of the decade.

Thus within the small, rebellious cliques of white "hot" musicians, many of the racial barriers that defined the 1920s were breached. The musicians tended to ignore racial norms and anything else that would prevent them from learning at the feet of their black idols. Friendly daily encounters between black and white players took place on street corners, in speakeasies, and on band stages after hours. The bassist George "Pops" Foster, a black New Orleans migrant, recalled that musicians from both races "always" socialized together and even dated the same women. These musicians opened informal channels of instruction in swing, collective improvisation, and the subculture of black jazz. Some whites, like Mezz Mezzrow, went beyond the music and mimicked superficial elements of "hip" black ghetto behavior such as "jive" slang, accents, oversized suits, and marijuana smoking. The whites' absorption in black culture was not a political cause; few white players became civil rights advocates. Still, this odd bunch pioneered the biracial "swing" phenomenon of the 1930s which would enthrall an entire generation of white adolescents.

White "hot" jazz was fundamentally built upon the swinging black New Orleans–Chicago small-band style. "Hot" had become a key expression in the growing jazz argot, a convenient label for the distinctive elements of the hard-driving new sound.* Louis Armstrong's trumpet playing epitomized hot jazz. White performers such as the cornetists Jimmy Mc-Partland, Bill Davison, and Muggsy Spanier, the clarinetist Frank Teschemacher, and the saxophonists Frank Trumbauer and Bud Freeman became able disciples of the Armstrong style. By 1930 Earl Hines's piano playing, with its Louis-like

*The music industry would soon adopt "hot" as a marketing code word for black "jungle" music, in contrast to the "sweet" music of Lombardo and other white bandleaders.

"trumpet" articulation in the right hand, had begun to attract the attention of white keyboardists. New Orleans reed players and drummers such as Jimmie Noone, Johnny Dodds, Baby Dodds, and Zutty Singleton also influenced white students. Northern white groups such as the McKenzie-Condon Chicagoans (featuring many players from the Austin High Gang) played a rugged but highly influential brand of collective improvisation. Southern white musicians weaned on black spirituals and the blues, such as Jack and Norma Teagarden from Vernon, Texas, also flourished in Northern nightclubs.

Well into the 1930s, though, the American public as a whole preferred sweeter and more symphonic jazz to the swinging hot variety. Before the swing craze began in 1935, hot jazz players struggled to make ends meet on touring circuits, recording dates, and radio broadcasts. The pianist and arranger Bill Challis recalled that the dance-hall business actually got worse for hot bands as the twenties progressed, since sweet music dominated the radio waves and set popular tastes. The small labels that recorded hot music either bore the "race record" stigma or produced limited issues that received narrow national distribution. White "hot" musicians, like their black mentors, were often at the mercy of gangland employers and the violence that surrounded them. The drummer Joe Darensbourg almost died after he was beaten by gangsters, and players like Mezz Mezzrow and Paul Mares grew afraid as shootouts and stabbings erupted around them. Whites at least could flee the danger more easily than blacks and find employment in safer venues. Mezzrow, perhaps an extreme example, in 1928 saw the entire nation "awash in blood" and "sickness." He caught a ship to France and spent the next few months in Paris playing in a band.

While their playing and respect for black culture set them apart, the white "hot" musicians otherwise were quite similar

to other 1920s whites. Their curiosity, social daring, and hard and fast living were more pronounced versions of the cultural experimentation that permeated all levels of white society. The radical implications of their embrace of black music and culture in an era of racism and segregation would become apparent only in later years.

During the twenties all types of jazz firmly indicated that a new cultural style had emerged, a style that encouraged urban living and leisure, the casual public interaction of men and women, exploration of the psyche and the libido, speed, moral tolerance, free spending, anxiety, and drinking. This was the emerging jazz subculture—a style that encouraged white interest in "liberating" leisure and sexuality and in the new black ghettos. The meeting of jazz-age leisure advocates and proud and militant black populations in ghetto nightclubs created tension and debate in the 1920s about racial mixing and the value of black culture. But it also stimulated the creation of new white jazz styles and the promise of future racial interaction. By the end of the decade, as the economic prosperity that fueled the new leisure began to evaporate, controversies surrounding jazz and the new secular culture continued. Like the music itself, debates about jazz would thrive during the Great Depression and beyond.

•

3

The Great Depression, the "Common Man," and the Swing Era

IN THE 1920s, as Americans tried to redefine the identity and goals of their culture, jazz played a complex role. Jazz was entertainment, but it also represented rebellious behavior, urban institutions, tolerant morality, avant-garde art, entertainment, and biracial culture. The music became a useful point of reference for both modernists and traditionalists—Americans who approved of the fast new urban life and tolerance, and those who opposed it. Jazz helped crystallize the debate. After 1929, as the nation slid into a prolonged economic depression, Americans' dilemmas changed.

The depression began just when hot jazz was developing extraordinary creative momentum. By 1930 Louis Armstrong's landmark style had become the common dialect for trumpet soloists. In the next few years the tenor saxophonist Coleman Hawkins (the star of Fletcher Henderson's New York band) skillfully adapted the swinging, extroverted Armstrong sound to his reed instrument and bred a generation of imitators. The Harlem bandleader Chick Webb had become the model for many drummers, who heard how in Webb's hands the "traps" or drum set became a force for ensemble leadership and a powerful generator of swing rhythms. Pre-

mier entertainers such as the pianist and organist Thomas "Fats" Waller made swinging jazz humorous and bold, a statement of hedonistic optimism and celebration. Players hungrily absorbed the tricks and signatures of masters of their instruments and competed among themselves. "Cutting contests," held onstage as well as in after-hours roadhouses, in alleys, and elsewhere, created some ill will and competitive ugliness among young players, but they also became effective training camps for novices and standard formulators for all instrumentalists.

Still largely divided by race and according to "hot" and "sweet" styles, musicians nevertheless often crossed paths and created an informal and durable professional solidarity. Somewhat like the printers, shoemakers, and other skilled craft workers of preindustrial America, jazz musicians created modes of instruction, apprenticeship, and quality control that advanced the music. This jazz "guild" could not have existed without such venues as speakeasies, ballrooms, rent parties, and the musicians' union's rehearsal halls, but it was the musicians who made these locations incubators of an experimental art form. Thirties bands served as training workshops, talent agencies, and arranging clinics as well as small businesses, and they helped to make jazz a mature and complex American music.

In unassuming locales across America, musicians dramatically accelerated innovation in jazz ensemble playing. The instrumentation, arrangement, and harmonic complexity of bands, big and small, changed decisively. Building on the achievements of Frankie Trumbauer and the arrangers in Paul Whiteman's band, B-flat saxophonists made their instrument the melodic foundation of jazz groups, and the four sax models—soprano, alto, tenor, and baritone—were quickly blended in rich combinations. Tuba, banjo, and the acoustic guitar were dispensed with, and trombones and elaborate

drum sets (benefiting from manufacturers' innovations) became mainstays of the bass and rhythm sections, respectively.

Duke Ellington proved the most brilliant blender of band members' personalities and of their distinctive timbres. "Rough" players were matched with urbane, educated musicians to achieve his band's unique sound. Ellington had learned enough during his brief formal tutelage under the bandleader Will Vodery to experiment audaciously with conventional harmonies. Ellington's Cotton Club Orchestra, with its chordal ninths and thirteenths, muted ensembles, complex tempo changes, whole-tone passages, and flirtations with bitonality, enriched the twenties palette immeasurably and transformed jazz. By 1932 Ellington had produced miracles of impressionistic tone color such as the trumpet-alto sax-clarinet unison in "Mood Indigo," the exquisite wordless vocal of "Creole Love Call," and the locomotive cacophony of "Daybreak Express."

Ellington preferred to create his arrangements through discussion with band members during long rehearsals. But the written jazz arrangement was also coming of age. In Harlem, while the pioneer Jelly Roll Morton was now a marginal figure, Fletcher Henderson and Don Redman (who had aided Henderson as well as Jean Goldkette's white band) refined the big-band style they had created in the mid-1920s. Younger arrangers such as Sy Oliver and Benny Carter followed Henderson's lead, attending composition classes when possible, studying arrangement manuals for sweet bands, and adapting these materials to hot jazz tastes. The golden age of the African-American swing bands had already begun, as Henderson, Chick Webb, Jimmie Lunceford, and Luis Russell blended "hot" swinging with urbane sweet timbres to produce exciting blends of power and sophistication.

Jazz was on the move geographically as well. Southern black and white musicians continued to stream north in

search of work, and the thirties also witnessed a maze of other migrational patterns. Band personnel turnover was usually heavy as leaders replaced undisciplined or stylistically inflexible musicians. Players joined and left bands while touring across the country, increasing their time on the road (often to the detriment of their marriages and other relationships). Regional centers such as Chicago, Los Angeles, Boston, and Kansas City became foci for rural and small-city players, who in turn became fodder for cutting contests and the myriad of part-time "gigs" (engagements) available night and day. Established players also circulated more as jazz's national network of performing opportunities expanded. As in other show businesses, jazz bands most often used the summer months to travel and spread their fame.

For these efforts bands needed effective promotion. In many cases the touring circuit managers who had given many players their first work in vaudeville and other touring bands now booked jazz groups into various ballrooms and hotels. For many early bands, however, their hometown managers would develop an itinerary and oversee the tours, receiving shares—often excessive shares—of the profits. By the early 1930s it had become more common for booking agencies to form their own bands, nurturing "sidemen" and then making them leaders of new groups. This was a tactic perfected by the Music Corporation of America, based in Chicago, which became the dominant manager of dance bands, and by the Schribman brothers of Boston, who helped fledgling groups led by Glenn Miller, Artie Shaw, and Tommy Dorsey. When they could effectively market these bands across regions or the country, MCA, the Schribmans, and other promoters made small fortunes.

New electronic mass media had reached their maturity, and promoters eagerly devised ways to spread new jazz sounds to almost every American home. Record sales in 1929 were dou-

ble their 1919 levels, and electrical recording technology was reproducing music more realistically for a global audience. Sound film, while it put "live" theater orchestras out of work, broadcast the latest musical styles more efficiently. Most important, the radio waves had been commandeered by commercial advertisers and the Radio Corporation of America (RCA), which created NBC and network broadcasting in 1927. NBC and its competitor, CBS, ran wire hookups to ballrooms to broadcast bands for hour-long segments. All varieties of dance music were featured, and although sweet music dominated, some of the hotter blues and swing-oriented groups appeared as well. By 1930 Harlem's darlings of the Manhattan smart set, Duke Ellington's Cotton Club Orchestra, appeared occasionally on network affiliate stations, as did Fletcher Henderson's equally popular band at the Roseland Ballroom. Local stations, particularly in New York, brought considerable regional exposure to hot bands. While almost all stations were white-owned, some forms of black music were immediately accepted by the managers and audiences. White "hot" players, sounding "black" over the radio, also gained exposure, and on a few occasions interracial pickup groups played in studio broadcasts.

With hillbilly or country music, jazz virtually matured from infancy on the electronic media, before a worldwide mass audience. The phonograph instructed young instrumentalists in jazz improvisation. In the 1920s Chicago's Austin High Gang had gained their initial jazz lessons from New Orleans Rhythm Kings recordings, and in the 1930s players of all races and backgrounds listened to records repeatedly, wearing down the grooves to capture the nuances of favorite solos and ensemble arrangements. Records were no substitute for personal instruction and real jobs, but they offered plenty of initial inspiration to young instrumentalists in high school bands. The exciting timbre and rhythm of an Armstrong or

an Ellington, based on centuries of rural and African cultural practices alien to young whites, liberated the musical creativity of Gil Evans in California, George Shearing in England, Mildred Bailey in Washington state, and many others. Established jazz players also carefully studied their rivals' recordings. In 1930, when Paul Whiteman and his orchestra appeared in his Hollywood film biography, *The King of Jazz,* the music began a long and close relationship with talking pictures, the world's most influential entertainment medium. Many other jazz musicians soon worked on-camera and performed on soundtracks as well.

An even greater jazz age seemed to be dawning as the 1930s began, but the economic affluence that had supported and popularized the music was vanishing in the Great Depression. By 1931 production of leisure products had virtually stopped. A year later came the nearly complete shutdown of automobile and machine factories, shipyards, and other key manufacturing sites. Banks then foreclosed on farms and called in home mortgages, hitting the employed middle class as well as the poor. By 1932 a quarter of the workforce—fifteen million Americans—were out of work or underemployed, and their families poorly housed and fed. A million citizens traveled roads and rails in search of work; evicted families moved in with relatives, and some were found living in caves or under bridges; and despite President Hoover's denials, thousands of starvation cases were reported. Labor tensions worsened as coal and textile-mill workers struck and confronted company violence. In the Midwest, farmers threatened banks, and in Washington, D.C., the army dispersed World War I veterans demanding a pension bonus from Congress.

For African Americans everywhere, bad economic situations grew worse. In the South, blacks found their jobs targeted by unemployed whites; one Atlanta group frankly demanded "No Jobs for Niggers Until Every White Man Has

a Job." Sharecroppers made unprecedented efforts to organize into a militant union, but suppression by local law enforcement defeated their cause. This tension fed racist hostility and led in part to the infamous 1932 rape trial of nine innocent young black men in Scottsboro, Alabama. Even after Franklin Roosevelt replaced Hoover in the White House, civil rights and antilynching legislation languished in Congress. In the cities veteran black activists despaired; W. E. B. Du Bois resigned from the NAACP's board and drifted toward the Communist party, as did Richard Wright, Langston Hughes, and Paul Robeson. In March 1935 Harlem erupted in its first major race riot. The police had arrested a black Puerto Rican youth suspected of robbing a store. Crowds attacked the officers and their reinforcements and then looted and burned white-owned stores in the neighborhood. It was the first antipolice, antiproperty riot by an exclusively black community, setting the model for later ghetto uprisings. In the following years economic, law enforcement, and civil rights grievances only grew in this overcrowded, rapidly decaying community. The writer Richard Wright perceived that "Negro life was a sprawling land of unconscious suffering" in the ghetto, and portrayed it in his landmark 1940 novel of young black alienation, *Native Son.*

The depression devastated the fragile market for jazz music. By 1932 demand for records had almost vanished, and production of disks fell 96 percent from 1928 levels. Small record companies, radio stations, band managers, and music publishers failed, and even such large entertainment firms as RCA-Victor and Warner Brothers edged close to bankruptcy. More expensive restaurants, nightclubs, and dance halls suffered. People did not lose their desire for entertainment, though, and they continued to seek inexpensive escapism. Ten-cent movie matinees soared in popularity in 1933, saving the film industry; beaches and parks remained crowded; and

saloons (following the repeal of Prohibition) regained some of their earlier popularity. Although female taxi dancers (paid by young men for each dance) became depression casualties, cheap dance halls remained popular. 1930s dance marathons, which often lasted for days, were bizarre symbols of the American public's determination to survive. At home, network radio and board games such as Monopoly became inexpensive and popular pastimes.

Grueling tours by jazz bands and other groups kept live popular music before the public. Black audiences eagerly welcomed visits by well-dressed and high-spirited African-American bands. In beleaguered segregated communities, well-known leaders such as Cab Calloway or Fats Waller arrived as heroes, as proof that life outside Jim Crow could lead to success. In the thirties young Mississippians such as McKinley Morganfield (later the blues singer Muddy Waters) were inspired by visiting jazz bands to head north. Banned from most Southern hotels and forced to stay in black families' homes, the groups' contacts with Southern residents boosted their morale. The arrival of Earl "Fatha" Hines's band once drew hundreds to a bus station because rumors had circulated that "Father Hines" was a famous preacher. Some touring bands expanded their popularity by doubling as semiprofessional baseball or softball teams and challenging local black clubs. Bands did draw attack from some local ministers and other traditionalists (as well as jealous husbands) who branded Northern musicians amoral outsiders, but generally black Southerners embraced jazz as an embodiment of progress.

White Southerners also heard black bands at segregated dances. Calloway's band, for example, performed at the racetrack in Florida before fifteen thousand white customers (and a few blacks who had sneaked in). In many towns whites and blacks attended together but were separated by police and at least one rope running down the middle of the dance hall.

Throughout the decade, in all regions of the nation, small towns were visited by white and black bands playing in every style. The white "Cornbelt" veteran and polka bandleader Lawrence Welk gained a huge base of fans in the Plains states, which served as his springboard to national fame. Black jazz bands appeared everywhere as well, in such unlikely places as Rocky Mountain mining towns and Great Plains farm communities. The saxophonist Eddie Barefield's experiences with the Joy Generators of Des Moines, Iowa, touring a circuit of scattered black townships in Iowa, Kansas, and the Dakotas, were typically stimulating. Evangelists of jazz, these bands transmitted city music and culture to America's increasingly neglected rural areas.

While touring swelled the fame of thirties bands, the biggest profits in jazz flowed almost exclusively from the biggest cities: New York, Chicago, and Los Angeles. The repeal of Prohibition in 1933 caused active musical sites such as Cincinnati's riverfront and San Francisco's Barbary Coast to fall silent. Many bands and performers relied on growing entertainment syndicates, such as MCA. In New York and Chicago, speakeasy and mob-owned nightclub managers gradually adjusted to legitimate managerial careers. Joe Glaser, who formerly oversaw Al Capone's Lincoln Gardens club in Chicago, became Louis Armstrong's manager in 1935. Glaser and other skilled managers devised strategies that enabled some of the best bands to survive and even thrive during the depression. Duke Ellington relied on the song publisher Irving Mills to map a careful strategy for making the Cotton Club Orchestra an international success. In exchange for his talents, Mills claimed about half the band's profits and cowriting credits on many of Ellington's compositions. The band's lavish tours in well-appointed Pullman cars were easily the most lucrative travel itineraries of all black jazz bands. Earl Hines's talented band also did well, but manager Ed Fox em-

bezzled thousands of dollars from the band payroll, forcing Hines to wage a long and costly (but ultimately successful) legal battle. John H. Hammond, Jr., of New York was a much different kind of impresario, a Vanderbilt heir with no real job whose private passion was to promote jazz musicians and racial equality. Hammond heard the unique virtues of Count Basie's orchestra, Billie Holiday, and Benny Goodman, and helped to tailor their sounds for success in the perilous 1930s economy.

New managers and the diminished market forced out those musicians who were less talented, disciplined, and well-connected, and intensified the central role of the most accomplished and versatile players. The jazz guild was becoming increasingly exclusive, tight, and self-consciously protective of its interests. Female instrumentalists, always at a hiring disadvantage, were virtually blacklisted from permanent employment during the depression. "All-girl" bands such as Phil Spitalny's and the International Sweethearts of Rhythms were promoted as novelty acts. Talented players, male or female, took any work they could find. A few found work abroad: the saxophonist and arranger Benny Carter headed to Paris, Teddy Weatherford led bands to China and India, and the trumpeter Valaida Snow played throughout Asia and in the Soviet Union. But overseas jobs were also scarcer than they had been in the 1920s, when Sam Wooding's large orchestra toured in Europe for two years and the British government did not ban American bands (as they did in 1935 to protect domestic employment). At home in the cities, rent parties remained common and employed pianists irregularly. Most often musicians were forced to take nonjazz assignments, such as recording Muzak (the new "canned music" for department stores) and playing in sweet bands. Others left music altogether. In Harlem, Sidney Bechet and the trumpeter Tommy Ladnier opened a laundry shop.

Thus jazz too was a victim of the depression. Its story was a small part of a general crisis of spirit and enterprise at every level of American society. What was to be done about this economic catastrophe? Throughout the early thirties, debates about jobs, wealth, and reform and threats of revolution shook America. The moralistic 1920s debate between modernists and traditionalists evolved into a more materialistic discussion about the distribution of power and wealth. Entangled in these strands were despairing laments for American democracy and government. Citizens writing to Presidents Hoover and Roosevelt indicted them for the failure of the American dream—"what a lie, what a godamned lie," one man wrote—or begged for dictatorial action to resolve the crisis. Conservatives lamented the increase of government jobs programs and "the dole," foreseeing the end of rugged individualism. The intense new debates popularized radical political alternatives, caused a revolution in government action—and, not incidentally, bred a cultural climate that helped to make hot jazz, or swing, the most popular music in the nation and the world.

In the first half of the thirties some political movements proclaimed American capitalism a failure and demanded radical change. Right-wing populists responded to the demagoguery of Senator Huey Long, Father Charles Coughlin, and Gerald L. K. Smith and their calls for equal distribution of wealth by a quasi-dictatorial government. On the political left, what the historian Warren Susman called the thirties' "culture of commitment" was especially pronounced. Previously apolitical Lost Generation writers now studied and endorsed the radical aims of communism. The American Communist party worked to organize unskilled workers and sharecroppers, defended the Scottsboro Nine, and gained support among African Americans. The party reached the peak of its popularity in 1932 when its national ticket (including a black candi-

date for vice-president) polled more than 120,000 votes. Intense Communist organizing in Harlem, parades, and the well-publicized courting of intellectuals helped to radicalize African-American protest.

Black jazz musicians were not untouched by the radical ghetto politics of the era. In 1932 the Communist party's International Labor Defense and jazz promoter John Hammond (not a Communist but an NAACP member) recruited the Duke Ellington and Benny Carter bands for a fund-raising event for the Scottsboro defendants; smaller groups and pianists were playing at lesser party functions in Harlem. The Socialist party's Manhattan radio station, WEVD (named for party founder Eugene V. Debs), gave such players as Benny Goodman early regular work. Later in the decade the Communist newspaper *Daily Worker*, the Young Communist League (especially citywide in New York), and scattered activists (such as those organizing meatpackers' strikes in Oklahoma City) hired jazz bands to liven up their gatherings. Noting jazz's working-class roots, Communists tried to recruit the music for the cause. A writer in the *Daily Worker* claimed that "jazz is the music of the American proletariat. If Negroes have been more prominent in its development, it is because more Negroes are proletarians." At Camp Unity, the Young Communists' summer retreat in upstate New York, mostly white jazz players provided the entertainment for dances. Black players were also involved; the Harlem party office opened a biracial "swing club," and the trumpeter Dizzy Gillespie and others played at Camp Unity. Some of the first major swing-band concerts of the late thirties, featuring black and white musicians and groups, were promoted by the left-wing journal the *New Masses*.

Besides communism, many other angry political movements caught the attention of urban blacks. Hard times brought the emergence of permanent grass-roots black politi-

cal activism. "Don't Buy Where You Can't Work" boycotts were effective in Harlem. Angry crowds formed around street-corner orators and supported poor tenants who had been evicted from their apartments. The black nationalism pioneered by Marcus Garvey was now championed by a diverse group of activists. The Rastafarian cult arose at the pivotal time when its deity, Emperor Haile Selassie, gained fame protesting Ethiopia's invasion by fascist Italy. The Harlem street activist Sufi Abdul Hamid gained prominence as a promoter of Islam as the faith of salvation, and in Detroit and Chicago, Wallace Fard and Elijah Muhammad launched the highly nationalistic Nation of Islam. Christian leaders such as Harlem's Father Divine and Adam Clayton Powell, Jr., also mobilized citizens politically and economically. The Scottsboro Nine were the beneficiaries of numerous fund-raisers. The Harlem riot of 1935 was both a culmination of the intense new mobilization and a portent of future grass-roots anger and activism, a spirit that would be increasingly central to black jazz.

Radical politics, however, did not prevail in the ghetto or in the nation as a whole. Most blacks were loyal Republicans or, increasingly, Democrats. The demagogue Huey Long was assassinated in 1935, and calls for dictatorship faded. American support for communism was never large, and feuds between Stalinists and Trotskyites weakened the party. Above all, the New Deal policies of Franklin Roosevelt and congressional Democrats dominated public life. While conservatives voiced alarm, federal relief programs—public works jobs, farm credits, cash payments, and housing—reassured the middle class and helped keep many of the poor from starvation. Bank accounts were insured, young men were hired to build dams and bridges, Dust Bowl migrants gained food and shelter, and rural areas were electrified to support future economic expansion.

Roosevelt and New Deal supporters also gradually developed a moderate version of the radicals' populist propaganda, a message of praise for and confidence in "the common man." Americans now generally mistrusted business tycoons, intellectuals, and the leisure class they had celebrated in the twenties. In thirties political oratory and popular culture, Americans proclaimed the virtues of farmers and workers, their folkways, and their perseverance. Hollywood films such as Frank Capra's *Mr. Deeds Goes to Town* and *You Can't Take It with You* preached this common-man message, and such novels as John Steinbeck's *The Grapes of Wrath* also championed the merits of the poor in their struggle for dignity and security.

Roosevelt and the New Deal actively promoted the common-man ideology. FDR scolded elites ("I welcome their hatred") and fashioned a Democratic coalition of labor, Southerners, and urban African Americans. Despite Roosevelt's caution on civil rights, most blacks enthusiastically endorsed his message and the New Deal. The president's "Negro cabinet" of advisers and First Lady Eleanor Roosevelt's endorsements of equal rights were welcomed by the black press. Secretary of Agriculture Henry Wallace proclaimed "the century of the common man," and New Deal programs actively promoted this vision. Roy Stryker, head of the Farm Security Administration's famous photographic project, claimed that the faces in the pictures told him "that the American people have the ability to endure . . . a determination that not even the Depression could kill." The WPA Murals Project encouraged artists to reject modern art styles in favor of folkish primitivism and homespun themes; authors in the WPA Writers Project also sought out quaint Americana for inclusion in state guidebooks. The WPA Theater Project romanticized the "comradely ideal" of men and women in "pioneer democracy" and produced plays such as

Triple-A Plowed Under, The Adding Machine, and *Injunction Granted,* which took the side of oppressed workers and farmers. The common-man ideology, in short, blended modern industrialism and nostalgia into a new populism, supporting government in the service of human welfare.

Like theater and film, music was recruited as an expression of the common-man ideology. Composers Aaron Copland and Virgil Thomson (veterans of the Paris scene and avant-garde modernism), with Roy Harris, wrote concert works in polished folk-song styles and on homespun American themes. While jazz remained the ultimate urban popular music, it too was swept up in this new populism. A populist "swing ideology" (as the historian David W. Stowe has called it) emerged after 1935 when the sudden mass popularity of "hot" big-band music brought the music unprecedented attention.

In retrospect it seems understandable why 1935 saw a major change in popular tastes. By then Americans, especially those in the middle class, sensed that the worst of the depression had passed. Threatening calls for radical change had been dampened by New Deal reforms and Huey Long's assassination. With fears of war still minimal, Americans were in the mood for something resembling the lighthearted leisure of the twenties. Popular culture already showed this trend; love songs "crooned" by Bing Crosby (a former Paul Whiteman singer) conquered the airwaves, and films about gangsters and hoboes were giving way to the gentle "screwball" comedies of Frank Capra and Preston Sturges. This optimism was perhaps naive, but it generated an important renaissance in thirties popular music and leisure.

Swing's sudden ascent began with the emergence of Benny Goodman's band. John Hammond had hired Fletcher Henderson, now struggling as a bandleader, to revise his swing-band "book" for the Goodman group. Goodman's demanding leadership had created a disciplined band, but the success for

which Hammond had groomed them proved elusive. Late Saturdays at 1 a.m. the band broadcast from New York on the NBC radio program "Let's Dance" and acquired a large following on the West Coast, which heard the live performances at a more accessible 10 p.m. Californians thus became cultural pioneers again, as they had been in the early 1910s when they accepted New Orleans jazz (and as they would be in many other ways in coming decades). Goodman's national tour that summer inspired little notice until it reached Los Angeles, where his stand at the Palomar Ballroom drew thousands of enthusiastic fans. The return tour to the East spread the excitement nationally. Suddenly masses of white youth had adopted big-band jazz as the core of their adolescent subculture, in the same way that scattered groups had embraced "hot" playing the decade before. The popularity in September 1935 of a novelty song, "The Music Goes 'Round and Around," also showed the sudden appeal of a massed big-band sound. It is hard to hear any real "swing" in this recording by the Riley-Farley Band, but its sale of 100,000 copies for the enterprising new Decca label revived dance-band disks, which sold in the millions for the next six years. (Decca founder Jack Kapp's strategy of hiring low-paid bands and issuing budget-priced records laid the groundwork for much of swing's success.)

Swing's appeal was wide. Sweet groups such as the Guy Lombardo Royal Canadians adopted some diluted swing numbers, and even Lawrence Welk's polka-based band added swing arrangements as a novelty. Most notably, swing led to the first important blending of jazz with country or "hillbilly" music. Like African-American blues, this descendant of English and Scots-Irish folk song had become a nationally popular music in the 1920s through recordings and the migration of Southern fans. In those years country music's conservative, white rural values and religiosity had made it a symbol of tra-

ditionalism—just as jazz had represented modernism—but in the 1930s country (and the politicized "folk-singing" of Woody Guthrie and the labor movement) became part of America's more cosmopolitan celebration of the "common man." Contrary to the view of its more reactionary fans, "country and western" music had never been purely Anglo-Saxon. Jimmie Rodgers, its first major recording star, had been deeply influenced by the Delta blues he grew up with in Mississippi. In the mid-thirties Texas bandleaders such as Milton Brown and Bob Wills deliberately incorporated swing rhythms into faster numbers, and Wills's Texas Playboys swept to popularity from New Orleans to Los Angeles—especially in the cities, where rural whites had flocked for work. Brown's and Wills's "country swing" sound (soon emulated by Roy Acuff in Nashville and a plethora of "singing cowboys" on stages and film) helped to solidify the blending of urban and rural identities, black and white traditions, and homespun and commercial elements that would characterize American cultural populism and country music for the next few decades.

In the late thirties, though, observers most often associated swing with purely urban populations and behavior. After the initial excitement over Benny Goodman, many listeners mislabeled the diluted sounds of sweet bands as "swing," but radio stations (and their new market-conscious playmasters, the disk jockeys) now canvassed city dance halls to learn what youth were really listening to. Radio brought the more propulsive, brassy, and full-throated sounds of "hot" veterans to the fore by 1937. By 1938 swing was a topic of national fascination. *Life* magazine printed two photo essays on jazz, featuring detailed and approving texts; Hugues Panassié's book *Le Jazz Hot* was translated into English; Goodman (not yet thirty years old) wrote his autobiography; and journals of all varieties contained extensive debate about the merits of the

"new" sensation. Essayists for leading journals of opinion, especially Otis Ferguson of the *New Republic,* repeatedly invoked jazz as an expression of the urban common man. Left-wing journals enhanced their discussion of swing as the music of the proletariat.

By the late thirties white swing players had clearly become symbolic common men, little fellows with "hip" knowledge and a commanding creative gift. Jazz had brought black slang into white circles; during Prohibition a "hipster" was anyone who carried his own liquor flask and was "hip" to the presence of police. Swing fans, the "jitterbugs" who swarmed to dances, caught the public's fancy in the same way. Diminutive nicknames such as Shorty and Buddy; the baggy-suit fashion of the Manhattan scene, which made men look like youngsters in grown-ups' clothing; and the clean-cut, slick-hair fashion of the day made swing seem like a joyous romp by wisecracking but decent kids. Sympathetic juvenile delinquents became popular cultural figures, displaying a spirit of youthful toughness Americans valued in their depression struggles. Like the alley youth in Sidney Kingsley's popular Broadway play and film *Dead End,* swing musicians and fans elicited America's new sympathy for urban problems and its victims, its faith in the goodness of city youth, and a playful interest in their eccentric styles of dress and speech. Even such publications as the *Saturday Evening Post,* which in the twenties had expressed traditionalists' fears of new dances and popular music, displayed little anxiety about swing and its young fans.

Enthusiastic commentators drove home the importance of swing, both as music and as cultural phenomenon. Before his premature death in 1937, George Gershwin had become an outspoken advocate of jazz as the fundamental inspiration for "the composer in the machine age," arguing that it was as capable as impressionism and the atonal Second Vienna School of revolutionizing concert music. Robert D. Darrell, a young

critic, had written probing jazz criticism since the 1920s, but it was largely left to scholarly Frenchmen, Belgians, and Britons to write the first detailed appreciative critiques of *Le jazz hot*. Hugues Panassié's 1934 book of that title excessively praised white groups such as the Austin High Gang, but with the journalism of Spike Hughes and books by Charles Delauney, Edmond Goffin, and Constant Lambert, it signaled the spawning of "formal" jazz criticism out of the classical tradition.

Europeans turned to jazz, in fact, as music and culture became pawns in the increasingly lethal struggle between democracy and totalitarianism. In Germany Hitler's regime condemned jazz as "degenerate" Jewish and Negro music. A German swing underground of young fans emerged. Musicians who fled Germany as political refugees, such as Kurt Weill, Ernst Krenek, and Paul Hindemith, incorporated jazz elements into their works as symbols of their resistance to fascism. Another foreigner had already helped bring jazz into American academe for the first time: in 1932 the Australian composer and pianist Percy Grainger, teaching at New York University, invited Duke Ellington to give a series of classroom demonstrations.

Jazz increasingly gained the respect of music critics and the cultural elite. Somewhat awkwardly, jazz was brought into the lecture and concert halls. Sociologists call this a process of formalization, by which established elites recognize an art form as "important" and place it on various pedestals. Swing arranging was discussed in university lectures; psychologists explored the emotions stimulated by swing; and critics defined the "standards of the art." This increasing formalization, of course, bound the music more closely to white elite values.

Scholarly fans devoted intensive research to the historical origins of jazz. A group of young, affluent, white Ivy League

graduates helped to form the United Hot Clubs of America, which reissued old recordings and initiated fervent discographical research (still a staple of jazz fans' scholarship). Neglected New Orleans pioneers were rediscovered. Local enthusiasts, led by the composer and writer William Russell, obtained new recording dates for aging "musicianers" such as Sidney Bechet, Bunk Johnson, and Kid Ory. Alan Lomax, a leading folklorist, secured WPA funding from the Library of Congress and recorded Jelly Roll Morton's detailed oral history (the first in jazz) in 1938. As in the 1920s, the new prestige of jazz invited humorous comparisons with elite music and culture. "Swinging the classics" once again became popular; a promoter hired Louis Armstrong to contribute to revamping a Shakespeare play into a Broadway revue, *Swingin' the Dream;* and Benny Goodman collaborated with the composer Belá Bartok and appeared in Carnegie Hall.

Swing's pretensions soon became a cliché. The showman-bandleader Kay Kyser promoted his Kollege of Musical Knowledge, and the 1942 Hollywood film *Ball of Fire* featured befuddled "square" linguists who were enticed by a slang-talking female big-band singer. "Jive," widely proclaimed to be the secret language of swing "cats" and hipsters, received its own mock-academic treatment in such publications as Cab Calloway's *Hepster's Dictionary.* These superficial products, as well as the more sober interactions between jazz, scholars, and the classics, indicated rapidly evolving American attitudes toward art. Above all, jazz was used to help overthrow barriers between "high" and "low" culture that seemed stodgy in the age of the common man. In this age it was the classicists and the scholars who had to catch up and to pay respects. The 1934 film revue *Murder at the Vanities* shows the Duke Ellington Orchestra in eighteenth-century dress and powdered wigs; when the band is mowed down by a machine-

gun-wielding, jazz-hating symphony conductor, it is "long-haired" high culture that is made to look ludicrous.

African Americans saw special importance in the growing prestige of jazz. Black journalists of the thirties wrote extensively about swing. The editor and poet Frank Marshall Davis examined the music in the *Atlanta Daily World* and other black newspapers, and the trumpeter Rex Stewart also contributed thoughtful essays. Duke Ellington wrote a piece for *Down Beat* on racial politics in jazz and gave many published interviews. In general, black writers pushed for greater opportunities for musicians and increased appreciation for their cultural achievements. Ellington, for example, thought George Gershwin's *Porgy and Bess* was "old hat" and condemned its reception as a work of "Negro music." Like the educator Mary McLeod Bethune and the athletes Jesse Owens and Joe Louis, Ellington was a "race hero" who found ghettoization and Jim Crow more and more intolerable. The liberal idealism of the thirties helped to clarify jazz's use as an element in the black critique of American injustice.

Jazz's social liberalism was represented most dramatically in the racial integration of some major swing bands. African Americans took considerable pride in the hiring of Teddy Wilson and Lionel Hampton into the band and quartet of the "King of Swing," Benny Goodman. With equal publicity, black musicians were hired by successful bandleaders such as Artie Shaw, Charlie Barnet, and Woody Herman. Among white critics, a cautiously liberal sentiment toward race predominated. *Down Beat,* the dominant jazz journal, published the views of its Ivy League–educated critics Marshall Stearns and George Hoefer, who favored a color-blind approach to jazz and opportunities for all talented musicians. John Hammond, a more independent polemicist, advanced this opinion even more forcefully in various writings while playing down

the political egalitarianism (mistaken by some to be communism) he had advocated in the early thirties. Aside from Hammond, though, many writers of these liberal manifestos were tentative and continued to emphasize racial differences. *Down Beat* articles such as "Can a Negro [Teddy Wilson] Play His Best in a White Band? ... Is Idea Good?" were typical of the era. The frequency with which Hammond was accused of reverse racism against white musicians also showed how swing was generating new tensions. For all their attention to and appreciation of black jazz bands and concerts, the critics (Hammond excepted) clearly felt more comfortable in a white jazz milieu, and their readers repeatedly named white bands and soloists as their favorites in annual polls. Given the Roosevelt administration's caution on civil rights—and the unyielding intransigence of the white South—white jazz fans' wavering color-blindness clearly reflected the cautious liberalism of the times.

Despite the dynamic optimism of the New Deal and its supporters, the realities of daily life for many Americans in the thirties remained grim. In 1937 a recession wiped out much of the new industrial employment created in the preceding five years. The suffering of Dust Bowl migrants further illustrated the basic failure of the New Deal to end the depression. Continued slow consumer demand kept industrial production low. Conservatives gradually regained political strength and began to cut New Deal spending. Most Americans remained cautious and pessimistic in their behavior; immigration and emigration rates were at historic lows. Americans delayed marriages, childbirth, and divorces as well, and in general they were doing less and pondering their predicaments more. News of impending war in Europe and Asia, while a call to vigilance for many, did nothing to relieve them of their gloom. In 1939 the New York World's Fair presented a vision of a gleaming, automated urban future for ten

million visitors. It was a potent vision, acknowledging the fundamental strength of America's resources and technology, but for most patrons of the fair it probably still seemed a distant fantasy.

Jazz in 1939, like the World's Fair, was also beginning to welcome multitudes of tourists. Greenwich Village clubowners self-consciously cultivated a bohemian, leftist jazz community. Harlem spots and dance halls continued to serve black residents and scattered white enthusiasts, but they would no longer be prosperous tourist sites. After the 1935 Harlem riot the Cotton Club lost its white clientele at Lenox Avenue and 142nd Street, and it soon closed. The club reopened in a midtown location, near the theater district and high-priced restaurants. This area, the fifties blocks west of Broadway, became the locus of the new jazz center in town, convenient to white Manhattanites, businesspeople, coventioneers, and sightseers. Fifty-second Street—"Swing Street"—and its imitators marketed jazz for tourists and big-band fans. Jimmy Ryan's, the Famous Door, the Flamingo Club, the misnamed Harlem Uproar House, and other places became attractions for the casual sightseer. The top big bands also played such major midtown hotels as the Waldorf and the Biltmore. Similar evolutions occurred in other cities, such as Los Angeles, where swing lured many whites away from the Club Alabam and other South Central sites toward Hollywood and the Wilshire strip, to Billy Berg's and the Cocoanut Grove ballroom. Swing was being "mainstreamed" into the neighborhoods and leisure institutions of a middle class partially renewed by the optimism of the New Deal. The streamlined, gleaming Art Deco style of the new clubs asserted Americans' revived fascination with wealth and technology. African Americans occupied an uncertain position in this future-minded new swing environment. Black musicians and customers were not usually made to feel welcome in the club audiences of these new districts,

and integrated groups such as Benny Goodman's faced numerous difficulties on the road.

In short, late thirties swing displayed American tastes and attitudes shifting from cultural populism toward a new era of slick, urbane commercialism, reminiscent in some ways of the modernistic mid-1920s. But popular moods and tastes were highly volatile in these years. The swing craze hit its peak in the year 1938, the last year of the decade to experience any form of peace. After war broke out in Europe in 1939, the United States would avoid fighting for more than two years, but even before Pearl Harbor the conflict would drastically reorient the activities of government, industry, and concerned citizens. Jazz, already a symbol of urban American energy, optimism, and resilience during the depression, would also be profoundly reoriented during the war years.

4

Jazz Goes to War

IN THE LATE 1930s, as war clouds gathered, jazz reached the pinnacle of its popularity. Musicians' skills and promoters' efforts had made possible the success of "swing," but the political and social climate had also been favorable. In the midst of the depression, America had rediscovered a measure of energy and optimism which found a perfect expression in the informal, urban setting of the swing dance hall. There "jitterbugging" youth created a vivid new subculture of dance, dress, language, and urban leisure values, a blend of African-American and white adolescence that became even more pervasive than the twenties jazz rebellion. At the same time the swing era revolutionized the popular music business. Major bandleaders such as Artie Shaw or Glenn Miller earned as much as $20,000 a week—more than any film star—and managers such as MCA made annual profits in the millions. Common-man populism may have reigned, but this gold mine of mass musical tastes would increasingly become the province of large entertainment corporations.

Jazz had survived the depression, but it was now being transformed by disparate and dramatic social forces. The 1939 World's Fair, Nazi aggression, and the growing bureaucracy in Washington suggested to Americans in different ways that the future would be highly unpredictable. More dramatically

than during World War I, adults and youth during the new global conflict found their neighborhoods, cities, and economic lives transformed and their emotions shaken by violence and uncertainty. Similarly jazz—as a music, business, and subculture—was profoundly altered in this mix of unprecedented destruction and prosperity. The swing era vanished, and startling new music and behavior emerged.

In the two years after the war began in September 1939, government spending for war production and defense reinvigorated the American economy and ended the Great Depression. In 1940 a peacetime draft was begun. Economic mobilization for war meant retraining, high wages, and widely available jobs for the first time in a dozen years. Practical issues of economics and self-preservation—not the dreams of glory and adventure that inspired enlistees in 1917—motivated men and women during this war. American soldiers rarely sought glory. They fought simply to put a quick end to Axis militarism and to return to a more prosperous civilian life.

The U.S. mobilization for war above all stimulated enormous human movement. As millions of men and women went off to basic training and to installations around the world, another three million Midwesterners and Southerners flocked to West Coast war plants, two million others relocated to work in the Great Lakes region, and the South gained another million residents around its new military bases and factories. Appalachian hill folk poured into Detroit, Akron, and Chicago, black sharecroppers into Detroit and Gary, Indiana, Texans and Oklahomans into Los Angeles. Apartment shortages, overcrowded schools, and overburdened grocery stores and police departments were familiar fixtures of the wartime boom towns. Six million women were employed at war work, one million of them in factories. Mothers with absent hus-

bands, in the face of shortages and rationing, struggled to find day care for their children. Children endured emotional and psychological difficulties caused by their strange new surroundings, family upheavals, and frightening war news. A turbulent new era of American family life was beginning. Many returning veterans, transformed personally by the war, parted ways with their families, and the divorce rate doubled during the course of the war.

Popular music was not immune to the unsettling economics of mobilization. Just as industry came under increasingly centralized control, the music business was becoming concentrated in large corporations in New York and Los Angeles. In the war industries, contracts and private bank loans flowed to the biggest producers; in music, financial resources also became monopolized by the largest businesses. To consolidate their positions, the major promoters of popular music struggled to gain greater shares of the market. Talent agencies such as William Morris and MCA were well positioned to maintain high earnings, but radio and recording companies were dissatisfied with their share. In radio the battle had begun in the mid-thirties when the American Society of Composers, Authors, and Publishers (ASCAP) demanded higher royalties for the on-air performance of ASCAP-licensed songs. The angry networks responded by founding Broadcast Music Incorporated, or BMI, in 1939, to control the royalties of all subsequent music written for the airwaves, largely for the networks' benefit. The two organizations then disputed the ownership of various new hit tunes and engaged in a struggle for control which lasted for decades. BMI kept hundreds of popular favorites from the airwaves throughout the war. Recording was curtailed because of government rationing of vinyl and shellac, and in 1942 a decades-old feud between the American Federation of Musicians and record companies reached its climax. The AFM's fiery president, James C.

Petrillo, had argued that record companies should share their profits so that the union could support musicians who were deprived of "live" work (in theaters, for example) by "canned" or recorded music. Now the AFM began a ban on recording by its members which lasted for eighteen months.

These business battles had odd effects on wartime jazz. The radio ban against ASCAP kept from the airwaves most of the hits that had made the Goodman, Miller, Shaw, and Tommy Dorsey bands famous, and forced broadcasting swing bands to improvise on folk songs and classics in the public domain. The AFM recording ban similarly led to the dominance of unaccompanied singing on new swing disks (since vocalists were not AFM members) and a two-year gap in jazz-band recording. Before the ban took effect, worried companies had stockpiled studio material, and the public did not particularly notice a gap. Jazz musicians, however, had to wait for years for innovative new recordings that important players would have made from 1942 to 1944. V-disks, produced by the War Department and featuring service bands, were an inadequate substitute, since printings were small. The radio and recording gridlocks intensified the importance of the live performance scene in New York City, where civilian musicians congregated and refined their styles with a new intensity, largely out of the nation's earshot.

Jazz was affected by changing intellectual currents as well. Just as money and populations shifted dramatically with the war, so did Americans' ideas about their nation's role in the world and the nature of their society. Isolationism, rooted in the same traditionalism that had bred Prohibition, had dominated twenties and thirties American foreign policy. As war fears grew, opposition to U.S. involvement had been strong on college campuses (which were also hotbeds of swing). In 1940 the fall of France and the battle of Britain intensified isolationists' calls for a "Fortress America" policy. While the

Japanese sneak attack on Pearl Harbor in December 1941 silenced them, their mistrust of foreigners, radicals, and New Dealers lingered on. Roosevelt's unequivocal internationalism (supported by many Republicans) made the war a major turning point for the nation, politically and culturally. The presence of millions of soldiers in Europe, Africa, and Asia ushered in a long postwar overseas dominance of American capital, military strength, and popular culture. Internationalism, like the New Deal before it, also helped to isolate and weaken left-wing radicalism. Communist party squabbles in the thirties, as the historian Richard Pells notes, had caused "political and psychic wounds" which "virtually paralyzed an entire generation of intellectuals." Stalin's nonaggression pact with Hitler in 1939 led to massive and permanent defections from the American Communist party; the 1941 German invasion of the USSR (which led the United States to aid the Soviets) did little to revive the group. It took twenty years for American radicalism to recover.

Most African Americans had not been isolationist or radical, but they became the most militant ethnic group because of the war. In the thirties ghetto residents had boycotted and rioted for economic and social justice, and blacks had become a major component of Roosevelt's Democratic majority. NAACP lawyers had launched a series of lawsuits against public universities to secure equal facilities. (They were not yet ready to challenge directly the separate-but-equal doctrine of *Plessy v. Ferguson*.) In 1941 white and black Quakers in Chicago formed the Congress on Racial Equality and pioneered nonviolent resistance to segregation. Also that year the labor leader A. Philip Randolph threatened a March on Washington and compelled Roosevelt to ban discrimination in war industry hiring. Older blacks, bitter with memories of the last world war, were profoundly skeptical about the merits of service in World War II. One editor declared that "our war is

not with Hitler but with the Hitlers at home." Black newspapers condemned the army's internment of Japanese Americans as "Jap Crow." Armed with the president's assurances, most African Americans grudgingly worked and fought for their country but vowed to demand rights and opportunities in return for their service. The *Pittsburgh Courier* launched a "Double V" campaign, pushing for victory against fascism abroad and racism at home.

All Americans were subjected to waves of wartime propaganda, which reduced the nation's complex war goals and the nature of the enemy to simplistic slogans and images. Large corporations wrapped themselves in the mantle of patriotism. Radio blended its existing role as a mouthpiece for advertising agencies and program sponsors with a new patriotic message. The movie industry made dozens of training films and theatrical releases which glorified our Allies, promoted hatred of the Axis, and paid tribute to war workers on the home front (especially the film industry's own celebrity volunteers, who very publicly entertained troops at the Hollywood Canteen).

In all these media, swing bands were enlisted to help convey the general patriotic message. In the process, swing's meaning for Americans—established during the New Deal—was considerably revised. During the war swing music told the world that while Americans were just as wisecracking, irreverent, and egalitarian as they had been in the thirties, they were now jitterbugging their way toward a confrontation with jackbooted nemeses. While female instrumentalists continued to be neglected, "girl" singers, a popular ornament of big bands in the late thirties, now became symbols of the wholesome American womanhood for which GIs fought to return home. The AFM recording ban put former band vocalists such as the Andrews Sisters in even brighter spotlights.

In a variation on the "common man" theme, magazines and newsreels praised the blending of Irish, Jewish, Italian, and

WASP boys in jazz bands; like multi-ethnic GI platoons, they were symbols of American tolerance. In films such as *You'll Find Out* and *Orchestra Wives,* all-white bands such as Kay Kyser's and Glenn Miller's functioned both as well-oiled professional units and as groups of "average guys"—an echo of the popular portrayal of U.S. fighting groups. African-American and mixed bands were more problematic for the studios, appearing more often in "race"-themed material destined for black theaters (such as *Cabin in the Sky* and *Jammin' the Blues*) or in "soundie" shorts (on reels which could easily be excluded from matinees in the South).

Propaganda was unremittingly harsh in its portrayals of the enemy. The depiction in films, radio, posters, and popular song of violent and fanatical Nazis seemed justified, but the entire Japanese people were described in vicious and time-worn racial terms. This pervasive denigration encouraged the relocation of 120,000 Japanese Americans from the West Coast to the interior. In a larger sense, though, such propaganda only reflected and reinforced the general spirit of hatred and aggression stimulated by the war. Long months overseas made GIs restless and vengeful; soldier riots, plundering, and rapes marred American campaigns in Italy, Germany, and the Pacific. At home, urban migrations and crowded conditions stimulated a series of wartime riots, in 1943 by black veterans in Harlem, and in 1942 and 1943 by whites and blacks in integrated public housing in Detroit. One million African Americans in uniform, while distinguished in the line of duty, suffered from continuing segregation. Black canteens, barracks, and even blood supplies were separate, and as an ultimate insult, the services gave privileges to German prisoners of war within the United States which African-American troops did not have.

Hundreds of the leading jazz musicians experienced the tensions and violence of wartime service life. Players who had

been deeply influenced by a biracial professional subculture were brought into contact with servicemen who did not share their sensitivities and attitudes. The stress and hostility of wartime worsened tensions in the segregated armed services, where anti-Semitism and other prejudices also flared. Swing dances on bases, at home and abroad, were marred by frequent fights growing out of ethnic and racial liaisons. Perhaps the most famous fracas occurred in 1943 in nightclubs on the East Side of Los Angeles, between young white, Mexican, and black "zoot suiters" (a costume favored by male African-American swing dancers) and white soldiers and sailors. Stimulated by rumors of racial mixing and a recent murder implicating Mexican Americans, the troops prowled the clubs and beat up teenagers during a week of drunken vengeance.

Swing musicians faced various difficulties abroad. Max Kaminsky recalled that Artie Shaw's navy band was regularly harassed by sailors at a base in Sydney, Australia. "We were in the Navy as regular sailors, and not in Special Services, but we hadn't even gone through boot training, and in the eyes of the regular servicemen we weren't one of them, which was true." Advocates of black jazz were vulnerable. Gil Evans brought V-disks of his favorite players, especially Louis Armstrong, with him in Europe, and white GIs almost assaulted him for carrying "colored music." John Hammond, serving stateside in the army's Information and Education section, tried in vain to improve conditions at substandard black army camps. His second campaign, to give black entertainers employment at segregated functions, was more successful. Integrating some athletic and swing events at Louisiana bases, Hammond later felt he could claim that "segregation was demolished by sports and music."

Jazz bands, like other businesses, lost many talented employees to the draft and enlistment. Before the war Benny Goodman's band had been deserted by soloists who went off

to lead their own groups, but by 1942 far more had been lost to the draft, including Mel Powell and Cutty Cutshall; the next year the government's "work or fight" edict forced saxophonists Vido Musso and Zoot Sims to leave. Many other well-known young swing musicians also entered the service. Jimmy Dorsey's pianist Joe Bushkin, Tommy Dorsey's arranger Sy Oliver, drummers Buddy Rich and Kenny Clarke, the Duke's bandleader son Mercer Ellington, bassists Arnold Fishkin and Arvell Shaw, balladeer Johnny Hartman, and pianist Billy Butterfield were taken away from their careers. Others, notably John Coltrane, Al Haig, Dave Brubeck, Paul Desmond, Jimmy Giuffre, and Paul Gonsalves, gained some of their first significant playing experiences while in uniform.

Many established musicians were recruited for military swing band service. Bob Crosby led the most popular Marine band in the Pacific, while Artie Shaw performed the same service in the navy. Bob Scobey and Sam Donahue also led popular groups. Glenn Miller's highly publicized Army Air Force unit epitomized the glamour associated with service swing bands. As Miller's mysterious death aboard a transport plane in 1944 also indicated, danger on the front lines was a part of the touring bands' experience. (But bootleg liquor in the 1920s had cost far more American jazz musicians their lives than the greatest war in history.)

On balance, military service did little for jazz, only serving to emphasize how harshly the music's biracial, intellectually open, and fundamentally creative spirit was treated in wartime. The ordeal of the great tenor saxophonist Lester Young clearly illustrated this. A New Orleans native, "Prez" Young had risen to prominence as the leading soloist in Count Basie's band, which John Hammond had promoted as the leading exponent of the Kansas City or "boogie-woogie" swing style. The light "eight-to-a-bar" rhythm stimulated and complemented Young's supple and imaginative solos. Young

brought a Delta native's blues feeling to boogie-woogie, especially in ballads, as well as a fleet and subtle dexterity to up-tempo numbers which contrasted with Coleman Hawkins's popular booming style. Shy and introverted, given to speaking in a convoluted private slang, Young had used heroin before the war as a means of escape from professional pressures.

Somehow he passed muster with his draft board in 1944 and entered the army, but he was not assigned to a band. (Few black service bands were funded.) Cut off from his playing, he was unable to cope with military discipline or the physical demands of training, and the routine racism of white soldiers encouraged him to be "insubordinate." Young's habit of speaking in nonsense phrases, while famed in jazz circles, enraged his officers. Caught in the act of shooting heroin, Young was court-martialed, sentenced to several months' detention (but given no treatment for his addiction), and given a dishonorable discharge. After the war his improvisational skills steadily declined, and he relied more and more on stock formulas. His alcoholism worsened too, leading to health problems and to his death in 1959 at the age of fifty. Young was a notable victim of accelerating social change and violence during the war, and his suffering was a moving testament to the passing of an era in which urban guilds and communities and steady employment nurtured fragile jazz musicians. For Young and many other musicians, the war and postwar eras would be (as sociologists termed it) "ages of discontinuity."

More than 400,000 Americans gave their lives in the war, and many more were injured. While North America was spared attack, the home front learned of aerial bombings that devastated Japanese and European cities and killed thousands of civilians. In August 1945 America's great secret weapons, two atomic bombs, instantly killed 150,000 people in Hiroshima and Nagasaki. The bombs hastened the Japanese surrender, which brought joy to the American people, but they

vividly illustrated the new levels of technological change and
violence in the modern world. Victory was welcome, but
many Americans worried about the future of mankind in the
event of another war. The public's mixed elation and anxiety
in 1945 would be reflected in its curious postwar tastes in
music and leisure. The tension between nostalgia and innova-
tion would intensify and lead to the creation of complex new
styles of popular music.

Even before the war ended, popular music evolved rapidly,
acquiring the attributes of speed and technological polish that
characterized the massive American war effort. No genre ex-
panded more dramatically than "country and western" music.
During the war Nashville and Memphis received migration
from the farmlands, and radio stations and small recording
studios were awash in new blues and hillbilly talent.
Nashville's Ryman Auditorium (home of the Grand Ole
Opry), radio stations, and music publishers underwrote a
campaign to make the city the capital of country music, court-
ing the major record companies and Southerners now living
across America. Opry singer Roy Acuff became as well
known globally as Glenn Miller. Memphis developed on a
smaller scale and featured more black blues performers arriv-
ing from the nearby Delta. In Nashville the young mandolin-
ist and bandleader Bill Monroe perfected an intricate and
hard-driving new kind of string-band music, driven by banjo
picking, which featured complex ensemble improvisation and
rhythmic virtuosity. Monroe's group and other new "blue-
grass" bands brought Appalachian music into the atomic age,
with syncopations and breakneck tempos that left the pace of
ragtime and swing far behind. Bluegrass was music that sym-
bolized the 1940s New South, a region transformed by money,
machinery, migration, and urbanization.

During the war undiluted big-band swing maintained its
greatest popularity in African-American communities. En-

gagements by the Hines, Lunceford, Basie, and Ellington bands in major dance halls such as the Savoy in New York and Chicago continued to attract young black crowds. "Jookin'" still attracted young men and women who exhibited their "breakaways," somersaults, and other maneuvers on the dance floor.

Even here, though, swing showed signs of change during the war. By 1941 Duke Ellington, now assisted by Billy Strayhorn, had virtually exhausted the varieties of the three-minute arrangement in a series of extraordinary recordings.* During the war Ellington, stymied by travel restrictions and the military's refusal to sponsor black bands, composed longer works for the concert hall which expressed some of the new black militancy. *A New World A-Comin'* was based on Roi Ottley's optimistic book about black prospects after the war, and *Black, Brown, and Beige,* premiering in Carnegie Hall in 1943, was Ellington's hour-long musical history of the Negro. One white critic lamented Duke's "political ingenuousness," and John Hammond argued that he was "rob[bing] jazz of most of its basic virtues and los[ing] contact with his audience."

Ellington's new work did distance him from the dance-hall crowds, but urban black audiences were generally cooling to big-band jazz. Other leaders such as Jimmie Lunceford found it difficult to keep up with rising band expenses and folded their groups after the war. The Chick Webb Orchestra, run at the New York Savoy by Ella Fitzgerald after Webb's death in 1939, disbanded in 1942. The untimely deaths during the war of Fats Waller and the brilliant young guitarist Charlie Christian and bassist Jimmy Blanton also diminished black jazz.

The turmoil of the home front helped to change American musical tastes significantly. Somewhat inexplicably to swing

*Any short list of them would include "Ko-Ko," "Cottontail," "Jack the Bear," "Warm Valley," "Dusk," "Harlem Air Shaft," and new versions of "In a Mellotone," "Take the A-Train," and "Concerto for Cootie."

fans, the popular hard-swinging big-band music of the late thirties lost favor during the fast-moving war years. Perhaps (as politics and culture after the war would suggest) the white majority once again craved dreamy, nostalgic evocations of an allegedly safer and simpler time, and saw music and dance no longer as an expression of urban culture but as a vehicle for escapism. In 1939, as war drew near, the growing popularity of arranged folk songs such as "Loch Lomond," such naive imports as "Bei Mir Bist Du Schoen," and the classics were early signs of such nostalgia. During the war pro-British ballads in the folk-song mode (such as "The White Cliffs of Dover") and the emphasis on vocalists during the AFM ban also made popular music smoother and more sentimental. Glenn Miller cannily recruited weeping string sections for many of his Army Air Force Band V-disk recordings, and the Tommy Dorsey band's former singer, Frank Sinatra, brought *bel canto* operatic technique to ballads and became America's great new singing idol. Paradoxically, then, jazz—to many a dynamic symbol of modernization—lost its public prominence just as modern industrial forces were decisively transforming American society.

Among jazz musicians, nostalgia also exerted a strong pull. As early as 1938 middle-aged veterans of the roaring twenties had begun a movement to revive the atmosphere and ensemble playing of their youth. White "hot" jazz enthusiasts in New York, reacting against the mass marketing of the big-band industry, sponsored jam sessions as a more "authentic" alternative. Café Society (founded by the shoe merchant and socialist Barney Josephson) and Jimmy Ryan's played host to white and black jazz pioneers in deliberately modest, even antiquated settings. By 1940 the clubowners and many musicians (especially Art Hodes, Mezz Mezzrow, Eddie Condon, and Sidney Bechet) explicitly promoted the jam session as a refuge from big-band hysteria, and "Dixieland" was soon marketed

as the pure, uncorrupted old New Orleans *cum* Chicago style. Musicians who had stayed in New Orleans after 1920 had been neglected, but in the forties revivalists brought such old-time pioneers as the trumpeter Bunk Johnson to New York clubs and recording studios. Dixieland became a profitable new tourist attraction in Manhattan, New Orleans, and San Francisco.

For the first time in jazz, a group of major performers was rejecting innovation in favor of conservatism and preservationism. The revival inspired a fierce debate between advocates of Dixieland and swing. Well-educated revivalists such as Rudi Blesh, Ernest Borneman, and Ralph Gleason claimed that Dixieland was the "true" sound of black folk music, unsullied by commercialism or mass marketing. New Orleanian collective improvisation, to them, represented democracy as well as teamwork—two staples of the American war effort. *Metronome* editor Barry Ulanov, in response, termed the revivalists "moldy figs" who resisted the innovations of swing in favor of a backward vision of music and culture. Swing, he insisted, represented the true triumph of teamwork and expression.

Wartime modernists in the swing camp promoted a handful of groups that looked not backward but toward the future for inspiration. They championed wartime bandleaders who used challenging and complex new musical approaches derived from classical music's modernist avant-garde. Believing that the quickly evolving home-front society was eager for new sounds, young white bandleaders such as Boyd Raeburn and Stan Kenton introduced more dissonance, atonality, and serial music techniques into their arrangements. Woody Herman, a veteran leader and a "progressive" pioneer, even commissioned a work from Igor Stravinsky (the *Ebony Concerto*) to solidify his credentials as an innovator. These experiments showed the increasing sophistication of jazz arrangers. Many

of them now had received instruction at leading conservatories and mined textbooks on modern arranging for new ideas. Arrangers such as Eddie Sauter, Pete Rugolo, Buster Harding, and Mary Lou Williams sought commercial success, but they also wanted to refine jazz into a complex, expressive art form at the "cutting edge" of all musical composition.

This progressive tendency in jazz dated back to Paul Whiteman's 1924 "experiment in modern music," but after World War II it also reflected America's self-consciousness as a newly crowned world power. The United States was now the richest nation on earth, successor to the British Empire as the leader of the "civilized world," and the only atomic power, and many journalists and arts figures claimed that it must now also be the world's cultural leader. Critic-intellectuals (many of them reformed thirties radicals) especially argued that the United States could now produce the boldest new architecture, painting, classical music, literature, and cinema, thanks to refugee European masters (such as Stravinsky, Thomas Mann, Mies van der Rohe, and Fritz Lang) and to young native talents (such as Jackson Pollock, Leonard Bernstein, Norman Mailer, and Tennessee Williams). While "New York stole the idea of modern art" from Europe, as Serge Gilbault has memorably put it, jazz was undoubtedly American, and thus it became a prime focus for thoughtful inquiries into the nature of "American culture" at a time when the nation's expanding media and academy were proclaiming the primacy of this culture to the world.

Few of these advocates of modernism bothered to educate themselves about jazz or to seek out its most daring innovators. The most explosive and influential innovation in 1940s jazz began in humble surroundings in the African-American ghetto, among a handful of black soloists born in the late 1910s and early 1920s. Recordings before 1942 show that the trumpeter John "Dizzy" Gillespie, alto saxophonist Charlie Parker,

and drummer Kenny Clarke began as traditional swing musicians. Many fine players of this generation, such as the trumpeter Roy Eldridge and the saxophonist Illinois Jacquet, remained swing players during and after the war, but Gillespie, Parker, and Clarke revised the swing style and dramatically altered the jazz subculture.

Black ghettos had not seen many of the large bandleader salaries, recording and radio riches, and lucrative touring contracts of the swing boom, but small ghetto outfits such as Chicago's Club DeLisa and Los Angeles's Club Alabam continued to be the leading sites for cutting contests and jam sessions. Minton's Playhouse opened in Harlem in 1938 and was soon operated by the former bandleader Teddy Hill. Dedicated to preserving the jam session for serious improvisers, Minton's quickly nurtured ambitious young musicians. Kenny Clarke and the quiet pianist Thelonious Monk became mainstays of the house band, and Gillespie frequently visited. Intense cutting contests, the scarcity of good band jobs during the war, and the new complexity of swing harmony raised the standard for acceptable improvising at Minton's. Quick-thinking soloists, as well as the raw excitement of fast tempos, accelerated cutting contests to a frenetic pace. Through imitation and repeated recordings, popular chord progressions such as the one derived from Gershwin's "I Got Rhythm," drumming staples like the ride-cymbal beat, and such tunes as "Honeysuckle Rose" and "Body and Soul" had become clichés; young musicians were eager to find any way to push beyond them. New tunes featured more complex harmonic progressions, including chords with altered degrees, ambiguous sixth and ninth chords, dissonances such as the tritone, and unusual chord sequences such as VI-V. The resulting new style was complex and to many sounded harsh.

The Minton's players found early inspiration in Lester Young's light, fleet saxophone improvisations and Charlie

Christian's similarly rapid scalar guitar runs. Not coinciden-
tally, both Young and Christian had apprenticed in Kansas
City, a well-known center for brutal cutting contests. The
city's corrupt political machine had allowed a large and open
vice district to flourish downtown, conveniently near a rail-
road station through which most cross-country travelers
passed. Frequent visitors included "barrelhouse" pianists and
bands from Oklahoma and Texas, who blended blues and
gospel harmonies with a subtle and fleet "boogie-woogie"
dance beat. Some skilled black musicians spent long periods in
Kansas City, including New Jersey's Bill Basie and Minneapo-
lis's Lester Young, and became masters of the local style.

Charlie Parker, born in the city in 1920, was a working mu-
sician from the age of fifteen, but his first trip to New York in
1940 had been a failure. During the war he developed a
unique improvisational style, featuring a small, carefully fo
cused tone (almost devoid of vibrato), masterful use of blues
harmonies, and the ability to play long eighth-note passages at
breakneck tempos. Above all, Parker perfected the practice of
composing new melodies out of the chordal structures of fa-
miliar swing tunes.

Gillespie and his fellow "woodshedders" at Minton's had
also experimented with this practice. In 1944 both "Dizzy"
and "Yardbird" Parker played in the big band fronted by the
popular vocalist Billy Eckstine. Miles Davis, the trumpet-
playing son of a well-to-do East St. Louis dentist, and Dexter
Gordon, a tenor sax man from Los Angeles, also played in the
band and helped each other to create a new improvising style.
Parker's "recompositions" of "Cherokee" into "Koko" and
"Honeysuckle Rose" into "Scrapple from the Apple" were
showcases for his running, rapid solo style. While Parker and
Gillespie were also masters of slow ballad improvisation, their
signature innovation was to make many improvisations more
intricately swinging, tighter, faster, and more intense. The

drummer Art Blakey was also in the Eckstine band, and along with Minton's stalwarts Clarke and Max Roach he revolutionized jazz drumming. Speed was the essence of the new drumming as well. Instead of tapping out a quarter-note beat and embellishing it with the snare and cymbals, the young drummers usually played eighth notes, altering the beat carefully to match fluctuations in the group's or soloist's tempo. Colorful brushing (especially on the cymbal) and other techniques made the drums more of a melodic instrument while they continued to be the rhythmic foundation of the group. Pianists such as Monk developed "comping," the skill of accompanying soloists with well-chosen and atmospheric chords and energetic rhythm. Along with the bass and drums, the piano became the anchor of a more subtle and flexible rhythm section.

The term *bebop* soon became associated with the new style, much to the regret of Miles Davis and others who disliked labels. There was no mistaking that bebop was a dramatic and self-conscious revision of swing. The ghetto origins of bebop were obvious: Minton's and Monroe's in Harlem were the incubators, as were Billy Berg's and the Club Finale in South Central Los Angeles. Because of radio's disinterest and the AFM recording ban, bebop grew only through face-to-face encounters and exchanges of ideas in clubs, back rooms, street corners, and apartments. In addition, before 1945 the core bebop innovators were all African-American. These young players rejected the awkward integration and discriminatory pay scales of big-band swing. Bebop's fiery spirit reflected the new black militancy. A few major pioneers, including Gillespie, Gordon, and Charles Mingus, had explosive tempers, a rage which they later acknowledged grew out of the pressures of racism. After the war, colonial independence movements in Africa inspired Gillespie to tell a white audience, "We're going to take over the world. So you'd better get used to it.

You people had better just lie down and die. You've lost Asia and Africa, and now we're cutting out from white power everywhere. You'd better give up or begin to learn how it feels being a minority."

The bebop pioneers were intensely serious. They explicitly rejected the smiling, joking, audience-pleasing stage manner of Louis Armstrong and the minstrel stereotype it echoed. Parker's indulgences and addictions were legendary, but he was usually fastidious and focused onstage; Davis's habit of ignoring audiences quickly gained notice and imitation; and Gillespie's brand of clowning had an acerbic, signifying edge to it which led few to mistake him as an Armstrong imitator. After 1945 talented young white musicians such as Stan Getz, Gerry Mulligan, Lennie Tristano, and Lee Konitz became leading bebop players, but it is clear that bebop grew out of particular African-American political and cultural developments and institutions, and that in some ways it would always be a "secret" ghetto art form. Bebop represented a new black militancy in America which would continue to grow over the next two decades.

While the national press tended to focus on the eccentric clothing and facial hair of Gillespie and other bebop pioneers, jazz critics quarreled vigorously about the merits of the music. Bebop was rooted in the tunes, harmonies, and instrumental techniques of late-thirties swing, and such veterans as Duke Ellington, Mary Lou Williams, Coleman Hawkins, Benny Carter, and Woody Herman had little difficulty incorporating the style into their music. Other older musicians were extraordinarily hostile. Mezz Mezzrow called it "frantic, savage, frenzied, berserk"; Cab Calloway thought it was "Chinese music"; Benny Goodman said bebop players were merely "faking it"; and to Louis Armstrong it was "crazy, mixed-up chords that don't mean nothing at all." Leonard Feather, a composer, producer, and critic for *Down Beat,* gained many

enemies among older New York musicians for his outspoken advocacy of bebop; fistfights, social snubs, and printed disputes swirled around Feather and his ally, the English professor and *Metronome* editor Barry Ulanov. In a typical condemnation, Feather wrote in 1945 that "just as the fascists tend to divide group against group and distinguish between Negroes, Jews, Italians, and 'real Americans,' so do the moldy figs try to categorize New Orleans, Chicago, swing music, and the 'real jazz.'" Opponents wrote mocking parodies and bogus "defenses" of the music in exaggerated bop slang. Schisms between promoters, clubowners, and record companies worsened the tension in the jazz world.

Charlie Parker, the greatest bebop soloist, saw his heroin addiction become a key component of the subculture forming around the music. Like Gillespie's militancy, Parker's drug use reflected bebop's roots in the pain and increasing despair of ghetto blacks. While World War I, Prohibition, and the first flush of the adolescent subculture had prompted alcoholism among some early white jazz musicians, a deeper disappointment fueled the bebop turn to drugs. By the late thirties, as Harlemites Richard Wright and Mezz Mezzrow reported, marijuana had become the drug of choice for edgy, underemployed black men, in part due to a large supply from the growing local Hispanic population (and from musician Mezzrow, also a leading Harlem "tea" dealer). Within a few years, though, this mild hallucinogen was supplemented by heroin, a highly addictive opiate which soon attracted many insecure and struggling individuals. The great and disturbed swing singer Billie Holiday became an addict, as did the young, experimental, and highly insecure Charlie Parker.

Since the late nineteenth century, devotees of urban leisure had embraced alcohol and to a lesser extent drugs, as a component of the bolder, faster new style of life. Sociability and daring were subcultural values held in far higher esteem than

health and bodily purity—one of the Victorian ideals against which the new leisure rebelled. Nightlife denizens therefore did not fully appreciate addictions or act effectively to break them. Even worse, when substance abuse became closely associated with an impressive bohemian rebellion, it gained prestige. Parker's 1946 arrest in Los Angeles for drug possession and his incarceration in the medical penitentiary in isolated Camarillo only added to his legend; upon his release he created a new bebop standard, "Relaxin' at Camarillo." Within the next year dozens of regular Parker followers, including Dexter Gordon and the white trumpeter Red Rodney, were hooked on "horse."

Heroin depressed the nervous system and created an illusion of fearlessness and confidence, making players believe they could accomplish daring runs with carefree abandon. Some listeners thought the drug also enhanced the spirituality of the nightclub experience. But the drug's powerful addictiveness and erosion of the addict's health over long periods of use, coupled with the bebop community's total lack of interest in intervention and the treatment of addicts, probably destroyed more artistry than it stimulated in the forties and beyond.

The issue of drugs in jazz largely surfaced after the 1940s, when urban drug use became widespread and a larger national debate about delinquency grew. In the late war years and just after, drugs were not yet a notorious topic. Of more immediate concern to musicians and critics was the steeply declining mass popularity of jazz. After 1945, while intellectuals and critics embraced bebop, Dixieland, and progressive jazz, these forms did not resuscitate big bands or swing. The bands themselves were partly to blame, since many of them were inferior imitations of the Shaw, Dorsey, or Miller groups and alienated many dancers and critics from swing. Arrangers diluted bands' swing sounds with sweet, country, and Cuban in-

fluences to profit from the vogue of these styles, but audiences were not fooled, and they turned to authentic samba, bluegrass, and sweet bands instead. Vocalists such as Frank Sinatra captured the public's imagination during the AFM recording ban, and publicists could market singers more effectively than bandleaders in records, radio, and films. Handsome and beautiful singing idols helped to announce Americans' growing postwar endorsement of affluent, confident individualism, while big bands now seemed comparatively nondescript and cumbersome, a relic of the team spirit of the New Deal and World War II eras. Postwar inflation made big-band touring as risky and unprofitable as it had been in the early thirties, in the depths of the depression.

Perhaps most important, the big bands declined because millions of white veterans and their families took advantage of the government's GI Bill benefits. Gaining scholarships and home loans, they flocked to college dormitories and newly built suburban tract housing. Their ties to urban leisure sites such as nightclubs and dance halls quickly weakened. Television, family activities, and household puttering seriously reduced the popularity of urban nightlife and heralded the return of after-work leisure to the home. In short, dynamic social forces such as broadcast media, consumerism, the changing job market, and residential relocation that earlier had made swing "king" now helped bring it down. Even African Americans, who were generally barred from the suburbs by discrimination, lost interest in the big bands they had loyally supported for decades. Count Basie's group, reliably employed for years at the New York Savoy ballroom, in 1950 was forced to dissolve. Chicago's Savoy, the largest dance hall in the world when it opened in 1927 and the pride of the South Side, in 1948 closed its doors. Charlie Barnet's dynamic mixed-race band, which often played in black theaters, broke up the same year. Almost alone Duke Ellington maintained and even en-

larged his band, but he faced many financial difficulties and turnovers in personnel.

As support from the mass audience declined, white jazz critics and journalists somewhat desperately tried to take stock of the music. Through numerous books and articles, a small group of New Yorkers proclaimed the virtues of old and new jazz styles with greater intensity. Leonard Feather, Barry Ulanov, Stanley Dance, and such new writers as Nat Hentoff, Martin Williams, and André Hodeir performed the valuable service of keeping jazz in the American consciousness.

Tellingly, these critics also became the self-appointed protectors and arbiters of jazz, and formulated the prevailing and "proper" opinions about jazz and its artistic standards. Much like the New York art scene's critical elite at that time, these writers decided what belonged in the jazz tradition and what was excluded: Paul Whiteman, Guy Lombardo, and Frank Sinatra were cast out while the hot, swing, and bebop conquerors of Manhattan's Swing Street were retained. The jazz critic Stanley Dance coined the term "mainstream," which became the somewhat misleading label for this newly defined tradition. Mainstream jazz, according to the critics, was not the middle-of-the-road popular music the term suggests, but rather the jazz they valued the most. Incorporating some of bebop's seriousness, *Down Beat, Esquire,* and other magazines became less interested in commercial success and more focused on publicizing the serious and arcane cutting edge—the mainstream—of the jazz subculture.

By 1948 bebop reigned as the most esteemed jazz "artistry," and its black master practitioners were granted perhaps the warmest reception white critics had ever given to African-American musicians. In the tradition of Duke Ellington's series of ambitious Carnegie Hall concerts, Parker, Gillespie (for a time a big bandleader), and other bebop leaders also received major concert-hall bookings. By 1949 the New York main-

stream bebop cult had succeeded temporarily in creating a viable jazz enterprise. That year a Broadway club site around the corner from Swing Street was renamed Birdland in honor of Parker. The pianist George Shearing soon wrote the congratulatory "Lullaby of Birdland," which quickly became a jazz standard and added to the self-conscious mythmaking of the New York scene.

In the years after the war, as critics defined the mainstream of jazz and excluded the musicians they deemed unworthy, Americans in general strove to define the nation's social and political mainstream. Alleged Communists and "subversives" who seemed to pose a threat to the nation's internal and external security were excluded from "the vital center" of American life. Global tensions, like those within the jazz guild, compelled Americans to seek simple explanations and to create dichotomies of good and evil behavior and identity that would help them make sense of a changing world.

American culture, however, had never featured a monolithic mainstream. Citizens had always been highly diverse, and after 1945 they diversified even more. The war economy, the postwar expansion, the migration of millions, technological innovations, and the shadow of the atomic bomb made the choices and the tastes of the swing era seem quaint and distant. Jazz musicians would have to fight—and adapt—to ensure that their art would remain important to listeners. The 1950s, often incorrectly considered a bland and static historical interlude, would give them many opportunities to do this.

5

Cool Jazz, Hard Bop, Affluence, and Anxiety

IN TWENTY short years, how far from the jazz age America had come. By 1950 millions of Americans lived in new surroundings, and families earned an average of 60 percent more than they had before the war. Old cities such as Detroit, and new centers such as San Diego, swelled with hundreds of thousands of newcomers. During the war, liquor flowed and strangers mingled at a rate that astounded those who remembered the twenties. New music—bluegrass, bebop, and the samba—captivated the public. The U.S. government spent billions of dollars for tuition and home loans for veterans and sent billions more to Western Europe and Japan to aid their postwar recoveries.

In the decade and a half between the end of World War II and 1960, jazz developed new styles that expressed both the affluent optimism and the pointed anxiety of postwar America. Musicians and critics struggled with the diminishing popularity of "mainstream" bebop. New music partly derived from jazz, such as rock and roll, stole jazz's mantle as the voice of the huge youth audience. Jazz was becoming a "niche" music, but it also was gaining new energy through its intimate ties with the greatest social movement of the era—

the black struggle to gain equal rights and justice in America. By the end of the fifties, jazz and American culture would both be poised to explore daring new courses of action with new energy.

As swing faded, the advocates of two new styles—progressive jazz and bebop—pursued musical experimentation instead of mass commercial success. Crowd-pleasing was not the main goal of Charlie Parker or Lennie Tristano or even Stan Kenton, the leading progressive bandleader. Their music was complex, often dissonant, and it spoke not to the general public but to educated cliques of fellow practitioners and critics. Public interest in jazz was nonetheless high enough that Parker, Kenton, and others gained considerable attention. This jazz avant-garde was zealously publicized and debated by critics. As the recording industry recovered after the war, jazz innovations were followed by a growing listening audience of college students, graduates, and affluent suburbanites—a fraction of the late-thirties swing audience but still numbering in the millions. This influential, educated audience was entertained by jazz but also found it an expression of Americans' real and substantial worries about the future.

As the poet W. H. Auden noted, the psychological term "anxiety"—denoting a fear that one does not know how to resolve—perfectly defined the spirit of the time. Despite the Allies' great victory, world events suggested to Americans a state of permanent crisis. Hitler's Final Solution raised the specter of mass annihilation, and Hiroshima and Nagasaki showed that the United States held similar power in its hands. The cold war led Americans to focus their fears on communism and their former ally, the Soviet Union. Revelations of atomic spies, the Soviet A-bomb (a reality in 1949), and the "super" hydrogen bomb (ready by 1953) swelled the public's persistent,

vague fear of World War III. Waves of sightings of unidentified flying objects (UFOs), 1950s science-fiction films about atomic mutations, interplanetary wars, and brainwashed zombies, and even popular songs like "The Atomic Boogie" and "Thirteen Women" reflected Americans' worries about impending attack. The Berlin airlift and the Korean War seemed like real-life harbingers of the nightmare to come.

In the face of these frightening prospects, some intellectuals disavowed existing political movements and fell into extreme pessimism. French existentialists argued that every individual was now isolated in the midst of a culture of "nothingness," and Marxist philosophers (many now in the United States) argued that only the total "negation" of a dehumanizing mass culture could save civilization. One of these thinkers, Theodor Adorno, commented that "to write poetry after Auschwitz is barbaric." These intellectuals had a direct impact on academic and critical thinking in cold war America. Their prevailing pessimism encouraged the rise of an "official" hard-edged modernist style. In university music departments, for example, it became popular to argue that music was primarily a science and not an art, and composers advocated the use of severe composition systems such as the refugee Arnold Schoenberg's serial or tone-row method. Veterans attending universities on the GI Bill imbibed varieties of this steely modernism in several academic disciplines. The new European style was publicized in magazines such as Henry Luce's *Life* and *Time*, and everywhere the avant-garde influenced new architecture, design, and painting. The "International Style" in building design brought severe functionality and "glass boxes"—such as the United Nations headquarters in New York—to American skylines. The abstract "drip" paintings of the gifted and mentally troubled Jackson Pollock were hailed by critics as symbolic of the current pessimistic spirit. Everywhere in American culture, from product design to motion pictures,

the comfortably ornate, organic, and softer styles of the past were replaced with the severe functionalism of an atomic age.

Some older jazz musicians thought bebop expressed the new postwar despair as well. Mezz Mezzrow called it "rip-bop," "the agony of the split, hacked-up personality." In jazz, however, pessimistic European-style modernism was best represented in the much discussed "progressive" jazz movement. Stan Kenton, a tall, strong-willed pianist from Los Angeles, most forcefully advocated the idea that big-band swing was avant-garde classical music. Despite his lack of formal training and showman's instinct, Kenton thought about music in the scientific terms favored by academic composers. The dry and abstract names of his bands—the Artistry in Rhythm Orchestra, the Innovations in Modern Music Orchestra—and his arrangers' titles (such as "Conflict in Three Sharps," "Artistry in Bolero," and "Opus in Abstract") clumsily echoed avant-garde modernism. So too did Kenton's announcement in 1949 that he was quitting music to become a psychiatrist (a project he did not pursue). Massive blocs of brass, dissonance, serial techniques, and other vaguely avant-garde features became part of the Kenton sound. *City of Glass* (1948), a long work composed by a serious young man named Bob Graettinger, conveyed this forbidding new spirit, with unrelieved dissonances and chilly blasts of brass and percussion. Progressive jazz differed vastly from swing music; at the typical Kenton performance, the comedian Mort Sahl joked, "a waiter drops a tray and three couples get up to dance." Kenton had many critics, and his reputation and popularity have declined since the fifties, but his training of major jazz soloists, his hundreds of albums, and his long involvement in university jazz education made him an influential musical figure.

Kenton's highly trained arrangers and his band's scholarly pretenses reflected the postwar expansion of higher education as well as the increasing dominance of technical complexity

and academic training and elitism in jazz. Some ambitious young musicians had sought out major classical composers for private instruction. The war veteran Dave Brubeck had lessons from Arnold Schoenberg and Darius Milhaud, while Johnny Carisi worked with Stefan Wolpe. White critics in the late 1940s, while divided about Kenton, were captivated by the music and teaching method of an intense blind pianist from Chicago, Lennie Tristano. Tristano trained one of Kenton's leading arrangers, Bill Russo, and in New York he gained an extremely dedicated group of students. Recordings of Tristano's 1949 sextet, featuring the tenor saxophonist Lee Konitz, presented improvisations with no established chord changes and little sense of swing—only the gradual, fuguelike introduction of voices in a dispassionate and dissonant kind of polyphony. Tristano's austere, academic-sounding work tantalized many critics and encouraged them to define the "mainstream" as a site for avant-garde experimentation. In 1951 Tristano founded the first jazz conservatory, a one-man effort which lasted five years.

While white jazz performers and critics dominated this European-style avant-garde, African Americans with formal training also helped make jazz an academic, modernistic endeavor. George Russell began as an arranger for Dizzy Gillespie and other bandleaders, but his study with Stefan Wolpe also led him to explore the harmonic foundations of jazz. After researching medieval and ancient music, Russell wrote the first major work of jazz theory, *The Lydian Chromatic Concept of Tonal Organization,* published in 1953. Russell argued that the ancient Lydian mode (which he traced back to Africa) was the best scale for jazz melodies and improvisation, and he supplied charts showing the pitches most helpful to improvisers within particular keys. Using the Lydian Concept, Russell wrote for symphonic as well as jazz groups. Some white jazz musicians had emulated the dissonant classi-

cism of Igor Stravinsky—Boyd Raeburn had written a work called "Boyd Meets Stravinsky," and Woody Herman even commissioned the master's *Ebony Concerto*—and Russell, sharing that admiration, in 1949 composed "A Bird in Igor's Yard."

The "Bird" of the title, Charlie Parker, shared Russell's interest in the classical avant-garde. In 1954, just before his death, he hoped to begin study with the composer Edgard Varése. John Lewis, another African-American former bandmate of Dizzy Gillespie's, supplemented his bebop piano education with studies at the Manhattan School of Music. Lewis developed a command of classical counterpoint unmatched in jazz; no one else could so skillfully compose fugues based on blues melodies. In the fifties Lewis cofounded the Modern Jazz Quartet, which presented an African-American vision of jazz as elite concert music. Playing in clubs, Lewis would demand that cash registers be silenced during the group's performances. The MJQ soon was booked mostly in concert halls, where they appeared wearing tuxedos. Lewis's joyous involvement in bebop and the blues, though, distinguished him from the sober Kenton and Tristano avant-gardists and connected him more closely with James Europe, Duke Ellington, and other black jazz concert pioneers.

As jazz became avant-garde during these anxious years, it also was recruited to help fight the cold war. The U.S. Information Agency stocked embassy libraries with jazz records, and Radio Free Europe, guided by a jazz-loving manager named Willis Conover, broadcast swing records behind the Iron Curtain (inspiring a future generation of jazz players there). In 1953 the Eisenhower administration began to use cultural diplomacy as a tool for propaganda and goodwill. A production of Gershwin's *Porgy and Bess* visited the USSR, a White House aide wrote, to "belie the commie racial-discrim-

ination line" used in Soviet propaganda. Jazz also became a cultural ambassador. The impetus, surprisingly, came from the Harlem activist, cold war critic, and former husband of the jazz pianist Hazel Scott, U.S. Representative Adam Clayton Powell, Jr. In 1955 Powell persuaded the State Department to sponsor the Dizzy Gillespie band's tours of the Middle East and South America. Gillespie proved an unorthodox cold warrior: he ignored statements prepared for him by the government and told Greeks, Turks, Pakistanis, and Brazilians "the truth" about American race relations. Soon more traditional jazz figures, such as Louis Armstrong, Wilbur De Paris, and Benny Goodman, toured Africa and the Soviet Union under State Department auspices.

These tours came during a relative lull in the cold war. Earlier, in the decade before 1955, jazz figures such as Gillespie and the harmonica virtuoso Larry Adler had been targeted in the great government hunt for Communists and other disloyal Americans. Gillespie and Adler were among the millions of Americans tracked by the FBI, other government agencies, labor unions, and local and private groups. The cold war had triggered this anti-Communist crusade, but it originated in the lingering traditionalism and isolationism of Anglo-Saxon America. Postwar chaos had revived old fears about the presence of "aliens," "subversives," accomplices, and political radicals in the United States. Senator Joseph McCarthy and other conservatives charged some New Deal Democrats with being "reds" or "fellow travelers." Unlike the movie industry, jazz was not subjected to public hearings or industry blacklists. The FBI, though, had imposed the so-called "cabaret card" on New York City in 1940, when the waiters' union was suspected of Communist ties. Anyone with a police record was denied a card by the police department and could not work in clubs or restaurants. In this indirect way the anti-Communist

crusade forced dozens of major jazz figures out of work for
extended periods in the 1940s and 1950s.

At the same time jazz was affected by the cold war's spirit
of *machismo*. During and after World War II, many American
men felt under assault as women worked in factories, ob-
tained more divorces, entered universities, and pursued ca-
reers. Female sexuality was likened to atomic power as a
threat to security and order; official government pamphlets
depicted radiation rays as beautiful "bombshell" women, and
a revealing new bathing suit was named after the Bikini island
testing site. Senator Joe McCarthy exhibited a brusquely mas-
culine style and gained support in the heartland by attacking
more refined Ivy League diplomats as "State Department per-
verts." In the 1950s *Playboy* magazine and film star Marilyn
Monroe promoted the "sex kitten," a new female image dis-
playing a dim intellect and exaggerated body curves, while
"pulp" fiction by Mickey Spillane and others glamorized male
control and brutality. In the bebop subculture, the sexual
prowess of Charlie Parker and other stars quickly became
mythology, and psychologists noted the aggressively phallic
symbolism of musicians' intense, self-involved improvisation.
The leading jazz critics were all male, and female jazz per-
formers such as the trombonist Melba Liston, the composer
Mary Lou Williams, and the pianist Marian McPartland had
trouble finding jobs.

McCarthyism targeted outsiders, Americans who did not
seem to belong. While jazz musicians were not often charac-
terized as subversive or disloyal, they were stereotyped in this
anxious age as deviants. As American veterans and their fami-
lies settled into new jobs, schools, and communities among
strangers, they sought reassurance about the safety and "nor-
mality" of their surroundings. Sociologists studied both their
fears and the objects of those fears: ethnic minorities, crimi-
nals, juvenile delinquents, and drug addicts. The phenome-

non of deviance, it was found, involved both the majority's stigmatizing of certain groups and those groups' acceptance of outsider status. Jazz had symbolized cultural rebellion since the 1920s, and its subculture became a popular topic of study. The sociologist and jazz band musician Howard Becker examined deviance among other white players in the 1950s. He found that they proudly expressed their scorn for "squares" and accepted with bitter pride the public's perception of them as deviant "dope fiends."

To an alarming extent, drugs did help nightclub musicians to define themselves as an exclusive, deviant group of artists. Charlie Parker's talent was so revered by young players that they also emulated his abuse of heroin—and of alcohol, food, and women. New York's size and coldness, police intimidation through the cabaret card, and intense competition for jobs strengthened newcomers' needs for a defined bebop subculture. Young musicians were so eager to do anything to belong to the nightclub scene, and heroin was so addictive, that many became enslaved to the drug almost unknowingly. Miles Davis, John Coltrane, and Wardell Gray each lost about two prime years of their careers in the 1950s because of heroin. Arrests and prison time took a considerable toll on musicians. Billie Holiday, Gerry Mulligan, Hampton Hawes, Art Pepper, Dexter Gordon, and Chet Baker all served lengthy prison sentences for drug convictions, as did many other lesser players. Dupree Bolton, a promising trumpeter, eventually spent twenty years of his life behind bars, mostly on drug convictions.

Deviance became a subtle selling point for jazz. While they did not celebrate drug use and other vices, mainstream jazz writers and journals, as well as such important record labels as Blue Note, promoted an image of jazz as the music of anxious, even tormented, young men. Blue Note's album cover photos of its artists, sweating and struggling with their instruments

inside shadowy, smoky nightclubs, conveyed this image perfectly. The 1950s was an era when "method" acting and Italian realism revolutionized theater and the cinema, and in the United States the expression of inarticulate male yearnings—in the mumbling and violence of Marlon Brando's performances, for example—became popular. Psychological layers were revealed that seemed to explain, and even justify, deviance and anxiety. The mighty struggles of the jazz soloist, living in a notoriously deviant subculture, fit this model perfectly. Fittingly, the 1951 film of Tennessee Williams's *A Streetcar Named Desire*, with Brando in his first great role, also featured the first major bebop soundtrack score (composed by Alex North). Hollywood also produced movies of varying quality about troubled white jazzmen, including *Young Man with a Horn, Pete Kelly's Blues, All the Fine Young Cannibals,* and *The Rat Race.*

Drug addiction and the other sufferings in jazz had their roots in the unique and worsening anxiety of urban blacks. While the war had brought jobs, training, and military honors to blacks, and had given an impetus to civil rights reform, discrimination continued and some conditions worsened. Southern whites mobilized against integration; the Ku Klux Klan was revived in Georgia in 1946; and racial violence in the rural South increased. Across the nation, job and housing discrimination had a devastating effect in this era of new suburbs and industry. When factories departed for the suburbs and the Sunbelt, black ghetto residents could not find work. Many unemployed men deserted their families, creating domestic crises. Public housing, slum clearance for freeways, and increased policing made the ghetto even more of a prison. Glendale, California, imposed night curfews for blacks, and Miami Beach required passes for entry at night. At times black males' spirit turned predatory, despairing, and self-destructive. Street gangs and heroin epidemics—what Claude Brown called "the

shit plague"—flourished. Realtors and banks legally steered black customers away from lily-white suburbs. Black families fleeing the ghetto faced white homeowners who resisted integration; black families in Chicago were bombed and burned out of their homes in mostly white areas.

A former jazz musician and child of the boogie-woogie joints of Oklahoma City, Ralph Ellison, wrote the great mythic portrait of postwar African-American suffering. His novel *Invisible Man* (1955) is the memoir of a nameless man who migrates from South to North, through emblematic settings for black labor, education, and political action in this century, attempting to become a "leader of his people" in various hopeless guises—as an educator, laborer, Communist, street speaker, and fomenter of riots. Jazzlike in its improvisation on basic themes, encyclopedic in its use of current literary techniques, Ellison's work not only expressed the general sense of existential anxiety felt by all groups in the atomic age but also the special despair (and grim humor) of postwar blacks.

But with postwar anxiety came unprecedented affluence for Americans. Even many blacks experienced a higher standard of living in the fifties. Despite discrimination, the GI Bill, job training, and larger and better-organized urban communities and national networks produced advantages for a growing number of blacks. Not without admiration, the sociologists Horace Cayton and St. Clair Drake wrote in 1960 of Chicago's "gilded ghetto"—a ghetto, to be sure, but with new reservoirs of comfort and wealth.

Above all, the white middle-class majority reaped enormous benefits from American affluence. By 1947 corporations were successfully mass producing for the civilian market for the first time in twenty years, inflation had stabilized, and hiring for factory and office jobs had swelled. A severe housing

shortage was being eased by the efforts of suburban develop-
ers such as William Levitt, who brushed off a current fear by
saying, "No one who owns his own house and lot can be a
Communist. He has too much to do." Furniture, appliances,
and automobiles sold well, and the first credit cards were in-
troduced in 1950. The marriage rate escalated, and soon
young wives were having babies at record rates. The baby
boom, as well as the ample attention and nurture paid to the
new arrivals, produced a powerful spirit of optimism that
counteracted many Americans' fears of communism, atomic
bombs, and deviance.

While the "mainstream" jazz critics spoke for and to a
modest following, some musicians sought the mass audience
and its ample new spending power. Louis Armstrong took ad-
vantage of a wave of 1920s nostalgia after the war and toured
with a small combo called the All-Stars (an apt name, since it
featured Earl Hines, Jack Teagarden, and Barney Bigard).
Even more riches awaited him in the 1950s as Joe Glaser led
Armstrong away from jazz and into film and touring engage-
ments that spotlighted him as a unique and legendary ballad
singer. The bandleader Billy Eckstine switched to popular
ballads in the late forties and made history as the first black
idol of adolescent white fans; the fine young swing pianist Nat
"King" Cole made a similar career change. Duke Ellington,
by contrast, stayed in jazz, and his band languished for years
until its "comeback" performance at the 1956 Newport Jazz
Festival. Benny Goodman and Count Basie had to disband,
and among younger players, Dizzy Gillespie, Tadd Dameron,
Gerald Wilson, and Roy Porter all failed to keep their big
groups together.

Promoters for the most popular fifties jazz performer tar-
geted his music at the booming suburbs and university cam-
puses. Dave Brubeck became a success only after a long period
of struggle and experimentation. His difficulties included a

near-fatal diving accident in 1951 which forced him to change his piano technique, but Brubeck's growing popularity came mostly because he gradually simplified his group's sound. Beginning as an atonal modernist, he honed his sense of audience tastes during hundreds of campus concerts. The Brubeck sound eventually rested on simple rhythms and memorable tunes, which helped to make novice listeners comfortable with excursions into dissonance and odd accenting. For the first time in popular music, actual avant-garde techniques and dissonances were accepted by a mass public, revealing its willingness to be prodded by the new—as long as it was packaged in convenient and emotionally familiar formats. Brubeck's conquest of the campuses made him famous. His quartet (featuring his superlatively polite altoist, Paul Desmond) played to huge, clean-cut, almost entirely white crowds. The decorum, tidiness, and homogeneity of the crowd belied the importance of the spectacle: jazz was being defined for the great new middle class on its own terms. It was significant that Brubeck was the first jazz musician to be featured on the cover of *Time* magazine, in the 1950s a key indicator of middle-class tastes.*

Brubeck's success was part of a large shift in American attitudes, stimulated by affluence and changes in mass culture. Subdued emotion and quiet intellectual control, neither nostalgic nor modernistic, came to be valued in jazz and in American society. In a word, American culture became "cool." As an expression for emotional self-control in times of crisis, "keeping cool" had appeared in Harlem "jive" and then in the Army Air Corps. After the war, test pilots epitomized cool. In 1947, after a wave of labor strikes, Congress passed the Taft-Hartley Act, which mandated a "cooling-off period" in such disputes. The American policy of containment, the diplomat

*Brubeck appeared in 1954. Duke Ellington was on a *Time* cover in 1956, and no jazz musician appeared again until Thelonious Monk in 1964.

George Kennan wrote, involved "firm and patient" measures against the Soviet Union. Cool, in short, was required at this crucial point in history. Fictional heroes such as Mike Hammer and James Bond, as well as film stars such as Robert Mitchum, taught Americans how to remain impassive while the world exploded around them.

Jazz became a central component of the culture of cool. Well before Brubeck, the foundation had been laid by the young Miles Davis. Briefly a student at New York's Juilliard School of Music, Davis had quickly left it for the Harlem bebop scene, where Dizzy Gillespie was both his mentor and rival. After the war Gillespie pioneered the incorporation of Afro-Cuban music into bebop. The drummers Chano Pozo and Chiquitico practiced the West African–derived *lucumí* spirit religion and brought ancient folk roots into jazz, creating what some called "Cubop." Davis, by contrast, built ties to formally trained arrangers in the late forties; his experiments proved even more popular. The 1949 Davis nonet project, the *The Birth of the Cool* recordings, featured arrangements by John Lewis, Johnny Carisi, Gil Evans, and a nonet member, the saxophonist Gerry Mulligan. Tristano's student Lee Konitz and a classical French horn prodigy, Gunther Schuller, also took part. The understated sound of this unusually large combo was highly influential.

Miles Davis came to symbolize "cool" in jazz because of his alleged neglect of audiences, refusal to stay onstage for others' solos, disdain for other jazz innovators, understated European clothing, and especially his closeted and introspective solo style (often featuring the stemless Harmon mute). Davis's guarded demeanor masked tremendous volatility, creativeness, and hatred of racism, and for some time it reflected his heroin addiction. Cool in jazz cannot be divorced from the numbing effects of ghetto despair and heroin. In any case, the

restrained and opaque musical style pioneered by Davis became an important new facet of jazz and its image.

For many readers, the "cool" nature of jazz was defined by Jack Kerouac in his novel *On the Road* (1955), or in similar work by other "Beat" writers such as John Clellon Holmes and Kenneth Rexroth. In those works jazz is a vital component of a culture of rootlessness which the Beats associated with black ghettos, poverty, sex, and purposeless travel. Kerouac had frequented Minton's Playhouse in the early forties while he was a student at Columbia, and even lent his name to a Dizzy Gillespie arrangement. (Another white Minton's regular, the heroin addict Herbert Huncke, introduced bebop to another Beat pioneer, the poet Allen Ginsberg.) Kerouac's understanding of jazz, though, was minimal; for example, in *On the Road* he made the derivative British pianist George Shearing into a bebop demigod. Kerouac was attracted to jazz because of its apparent similarity to the automatic writing style he hoped to master, a style he labeled "spontaneous bop prosody." "Cool" for the Beats embodied their attempt to comprehend and master sexual anxiety, racial and class fragmentation, and social alienation. In the fifties, while Ginsberg grew more involved in the music of Thelonious Monk, Kerouac drifted westward. He depicted the exhausting bebop life and travel of *On the Road* less frequently and turned to stories about protagonists' search for peace through Zen Buddhism and life in the California wilderness.

Kerouac's mythological treatment of California reflected a major 1950s cultural trend. While the Beats' notion of "cool," linking the West Coast to Zen and nature, gained considerable notoriety, most white Americans associated "California cool" with the allure of the seemingly easygoing middle-class affluence of the Golden State's suburbs. The state's population grew by seven million during the 1950s, nearly doubling, as

migrants were drawn by California's temperate climate, defense industries, and massive suburban development. Hollywood and local promoters encouraged people to abandon their cares and indulge their fantasies in California. Walt Disney's new vision of the amusement park illustrated this. By 1955 Disney had transformed an Anaheim orange grove into Disneyland, an immaculate array of fantastic realms and ingenious carnival rides (joined to a vast parking lot for suburban cars).

The popularity of California helped to create a sensation in the 1950s for what came to be called "West Coast jazz." This variety of jazz and its "cool" reputation illustrated the growing importance of California to American society and culture. Although the Eastern jazz press enjoyed belittling the West Coast scene, it did weaken New York's monopoly on innovation and talent. Native Californians such as Dexter Gordon and Charles Mingus still had to go to New York to prove themselves, but Easterners such as Charlie Parker also traveled west to secure gigs and support. Increasingly, Westerners kept their career operations at home. South Central Los Angeles had been a bebop center since wartime, and local firebrands like Gordon, Hampton Hawes, Teddy Edwards, and Art and Addison Farmer (as well as Parker and other visitors) maintained its prominence.

The dominant California image, though, was white and suburban, and it shaped public perceptions of West Coast jazz. Record labels such as Contemporary, Pacific Jazz, Fantasy, and Capitol portrayed West Coast jazz as a fantasyland: jacket-cover photos showed musicians in casual clothes, frolicking on the beach, enjoying the sunshine, and ogling young women in parks. Unlike Eastern labels such as Blue Note, these companies rarely depicted musicians in nightclubs, sweating, concentrating on their music, or even playing at all.

A film studio briefly groomed the handsome trumpeter Chet Baker for an acting career.

As the jazz historian Ted Gioia has shown, West Coast jazz grew out of more diverse roots than its image suggested. Many of the leading white players had served under Stan Kenton's demanding leadership, including the saxophonists Art Pepper, Bud Shank, Lennie Niehaus, and Bill Perkins, trumpeters Shorty Rogers and Maynard Ferguson, drummer Shelly Manne, and guitarist Laurindo Almeida. Reed player Jimmy Giuffre, the most innovative West Coast composer, had worked in Boyd Raeburn's band. Chet Baker had arrived from Oklahoma as a child during the Dust Bowl migration. The Cuban-vibes specialist Cal Tjader was a San Francisco native, as were Dave Brubeck and Paul Desmond. Clubs such as the Lighthouse in Hermosa Beach and San Francisco's Black Hawk provided groups with stable gigs.

West Coast jazz often explored new avenues of jazz expression. Complex composing strategies, scoring for such unusual instruments as the cello and oboe, ensembles such as the Mulligan-Baker "pianoless quartet" of 1953, use of odd meters, and relaxed rhythms were hallmarks of the style. While East Coast drummers preferred powerful and complex timekeeping, Westerners Shelly Manne and Chico Hamilton created a far less frenetic beat and stimulated more melodic improvisation.

In many ways, of course, California and East Coast jazz were quite similar, giving the lie to the West Coast mystique. The cool jazz pioneers Miles Davis, Gerry Mulligan, and Stan Getz lived in New York, and many California players (such as Teddy Edwards and Hampton Hawes) were as hard-driving as East Coast bebop stars. West Coast players were not immune to professional pressures and heroin addiction, and Los Angeles race relations were probably worse than New York's. The police department's systematic harassment of black musi-

cians and South Central clubs surpassed injustices in Manhattan. In general, California was a mixed blessing for African Americans. Of almost half a million new houses sold in booming northern California from 1945 to 1965, less than a thousand went to black purchasers, and as late as 1964 white voters in the state soundly rejected a fair-housing ballot proposition.

The "cooling" of jazz was part of a general 1950s tendency in the arts. Television became the new dominant mass medium. The movie studios, already hurt by a 1949 court decision that stripped them of their theater chains, saw weekly attendance decline rapidly as television ascended. Television production largely shifted from New York to southern California and took over many faltering film studios. The West Coast mystique shaped the tone and content of network television, as situation comedies such as *The Donna Reed Show* glamorized suburban family life in southern California. Even more fundamentally, as the communications scholar Marshall MacLuhan noted, television was the perfect "cool medium." Restrained acting and broadcasting styles worked best on the small screen. Politicians such as Richard Nixon and film actors such as Ronald Reagan (both Californians) exploited the medium. Jazz played a minor role in this new video style. In 1958 Henry Mancini's music for the detective series *Peter Gunn* led to the use of cool jazz in many network dramas.

Nationwide, the growing habit of television reflected new trends in leisure that further undermined the popularity of live jazz. More than any other medium, television was pulling leisure out of the realm of public space. In the same way that the baby boom and the suburbs encouraged families to focus inward on their home life, television lured them away from evening entertainment on the town. Many new suburbs had no nightclubs or dance halls. Team bowling, hobby clubs, PTA meetings, and Little League were suburban staples, but they were far less central to family life than amusement parks,

movie theaters, professional sports, and vaudeville had been to urbanites a generation earlier.

At the same time private leisure was pulling Americans away from live jazz, new musical styles were claiming the allegiance of adolescents—black and white, in cities and suburbs—in search of tastes and pastimes that helped define their own new subcultures. Among urban blacks the combined effects of ghettoization and scattered economic progress within their communities turned them toward a more simplified, pulsating, electronically amplified variety of the blues. In the 1940s "rhythm and blues" had been the major labels' latest euphemism for "race records," but blacks now claimed it as the name for this new style.

Some "R and B" pioneers came from jazz, such as the California bandleader Johnny Otis (a white man genuinely integrated into black Los Angeles) and Louis Jordan, who adapted the big-band "Texas tenor" saxophone sound into the popular "honking" style. As the historian Nelson George has noted, small local labels and radio disk jockeys promoted R and B, as well as valuable hope, optimism, and economic enterprise, in Chicago, Watts, Detroit, Harlem, and Memphis. While many guitarists and blues "shouters" were overtly emotional, other R and B artists favored subtler steady rhythms and "cooler" expression. Small male vocal groups, heirs to the Mills Brothers and the Inkspots, blended sophisticated bebop harmonies into popular songs. In the late fifties an autoworker-turned-producer named Berry Gordy worked R and B elements into straightforward "pop" vocal formats, creating the Motown Record sound that later conquered the national market.

Most dramatically, in Memphis clubs and studios, white singers blended their basic country and western style with R and B sounds, creating music and stage personas that combined explosive adolescent emotions with cool control. Like

the advent of jazz from 1917 to 1925, the genesis of "rocka-
billy" signaled the growth of optimism and prosperity among
a group of migrants—in this case, rural whites in the postwar
boom city of Memphis. One of them, Elvis Presley, brilliantly
blended black blues and gospel with the white actor James
Dean's movie persona. Sneering, shouting joyously, and seem-
ingly possessed by Pentecostal fervor and black "snake hips"
dancing, Presley became a national star in 1956. A Northern
disk jockey labeled the music *rock and roll*. Suburban white
youth and even some optimistic blacks embraced the exhila-
rating spirit of good times, fast driving, and youthful indepen-
dence that the music conveyed. While cities and urban leisure
were in decline, rock and roll's rise showed that adolescents
still maintained and valued a separate subculture.

Like *jazz,* the term *rock and roll* originated in black slang
for sexual intercourse. Presley and other early rockers con-
veyed above all a male sexual aggressiveness, a quality they al-
ternately released and restrained in public performance (to the
delight of young female listeners). Thus, while rock and roll
was emotionally "hot," like the volatile screen presence of
Brando or Dean, it also celebrated a "cool" male skill and con-
fidence derived from popular images of test pilots, hard-
boiled detectives, and such pop singers as Dean Martin
(another Presley idol). Also imbedded in that image was the
cool black urban hustler, brought to life in rock and roll by
Chuck Berry, Bo Diddley, and other African-American stars.
These enormously popular new musical idols completely
eclipsed the brooding bebop players and modest West Coast
jazz musicians of the fifties.

The struggle in popular culture to become "cool" reflected
Americans' basic optimism and material satisfaction but also
their real sense of uncertainty. To many, the world and the na-
tion seemed precariously perched between peace and war, sat-
isfaction and rebellion, order and chaos. President Dwight

Eisenhower pursued order and predictability: he stymied Joseph McCarthy, gained a truce in Korea, and tried to minimize open tensions with the post-Stalin Soviet Union. A moderate bipartisan "consensus" ruled domestic affairs, and the economist John Kenneth Galbraith wrote confidently of "the affluent society," faced with the pleasant task of deciding how to allocate its unprecedented riches.

Such complacency was short-lived. In 1956 the Soviets crushed revolt in Hungary, and the next year they launched the first man-made satellite into orbit and frightened America into breakneck science education and missile development. That same year a violent confrontation over civil rights broke out in Little Rock, Arkansas, as Central High School admitted its first black students. The NAACP had succeeded at last in overturning *Plessy v. Ferguson* in 1954, when the Supreme Court agreed in *Brown v. Topeka Board of Education* that segregated public schools were inherently unequal. The boycott of segregated public buses by black residents of Montgomery, Alabama, in 1955 launched the nonviolent grass-roots attack on Jim Crow, led by the Reverend Martin Luther King, Jr., and organizers from CORE. The nuclear arms race stimulated a "ban the bomb" movement. Blacklisted folksingers from New York's bohemian circuit emerged to advocate civil rights and to attack the bomb, and when a Cuban peasant revolution succeeded in 1959, they praised it as well.

This cultural tension helped to inject new excitement into the New York jazz "mainstream." Despite their lack of mass popularity, problems with addiction and the cabaret card, and the challenge from the West Coast, New York's musicians remained extraordinarily productive. Although Charlie Parker died in 1955 and other talents faded, fresh new masters kept appearing. Miles Davis became the only young black jazz musician to rival Dave Brubeck's popularity. Both gained lucrative Columbia recording contracts. Davis, working with the

arranger Gil Evans, was among the first in jazz to exploit the long-playing record format. Specialized new labels, however—Blue Note, Savoy, Prestige, Atlantic, Riverside, and Impulse—were the backbone of jazz recording. While most nightclubs and dance halls shut down forever, LP records brought the latest jazz (as well as reissued older recordings) into millions of living rooms. The "hi-fi" phonograph made jazz a private pastime in the same way that television brought vaudeville and the movies to viewers at home.

Jazz music remained dynamic. While Parker's style still inspired reed and brass players, pianists were now the foundation of mainstream combo playing. Bud Powell's Parker-like speed and rich harmonic "comping" were often emulated, while the sparer, harmonically eccentric playing of Thelonious Monk inspired iconoclasts. The modest Monk's use of silence, remote chord degrees (especially the ninth) in the bass, and gift for composing original tunes made him the most provocative and endearing figure in the mainstream. Every major mainstream player, almost by definition, played with Parker, Powell, or Monk at some point. Besides Miles Davis, new masters included the tenor saxophonists Sonny Rollins and Cannonball Adderley and the trumpeter Clifford Brown. Davis recorded with Monk in 1953 and then formed his own quintet, which featured the rising altoist John Coltrane. The recordings of this group, along with various important small combos led by Monk, Rollins, Powell, Gillespie, and Charles Mingus, brought bebop to new levels of complexity.

Sharing in the cultural ferment of the late 1950s, New York jazz began to evolve away from the Parker tradition. Certain players, almost all of them African American, began to develop a playing style that mainstream critics soon christened "hard bop." The increasingly pyrotechnic drumming of Art Blakey, Philly Jo Jones (of Davis's quartet), Elvin Jones, and

Louis Hayes, and the pounding pianism of Horace Silver, gave hard bop a powerful drive. Maintaining breakneck speeds, tenor saxophonists like Buddy Tate adopted the R and B "honking" style and trumpeters such as Lee Morgan and Freddie Hubbard played the throaty trumpet sounds of the young Louis Armstrong. Perhaps most important, while the chord changes remained as complex as ever, new tunes reflected the raw vocal excitement of both R and B and the urban church. These institutions—sacred and secular—voiced the pain, despair, and anger of ghetto residents in the 1950s, in the age of the "shit plague" and slum clearance. The growling, shouting, wailing, and relentless rhythmic drive of hard bop made it the most explosive music mainstream critics and fans could imagine.

The key feature of hard bop was its militantly African-American identity. While a few white participants, such as the trombonist Jimmy Knepper, took part, hard bop was presented to the public as an expression of angry black men. In this era of civil rights activism, a few black musicians were bringing protest to the ranks of jazz. Charles Mingus's activities best exemplified this, from his founding of Debut Records and the Jazz Composers' Workshop in 1953 to his staging of a hard-bop event outside the 1960 Newport Jazz Festival to protest its nostalgic and white-dominated tastes. Mingus wrote works that attacked segregation ("Fables of Faubus") and lamented the fate of Lester Young ("Goodbye Porkpie Hat"). Similarly Max Roach recorded *Deeds Not Words* in 1958 and, with his wife, the vocalist Abby Lincoln, *We Insist! The Freedom Now Suite* in 1960. Even non-hard-bop artists, most notably John Lewis and George Russell, admired the earthy new sounds and encouraged their development. Lewis helped to found the summer Jazz College in Lenox, Massachusetts, in 1958, which assisted hard-bop players. Even white critics could appreciate and support hard bop; while it was complex,

it clearly stayed within bebop's harmonic and rhythmic traditions.

But more controversial innovations were also emerging. In 1958 Miles Davis made a sudden retreat from the mainstream. Declaring that bebop had become too complex, he moved into George Russell's theoretical territory and began to explore modal improvisation. Chord changes would be replaced by solos in a single mode or key, enriched by overlaid chord degrees but far less complex than standard hard-bop melodies. The 1959 sextet album *Kind of Blue,* improvised on scales and simple tunes Davis had given his sidemen only hours before the session, ushered in modal jazz. Emotionally static and "cool," *Kind of Blue* nevertheless also reflected the hard edge and haunted black timbres of bebop. As Russell had predicted, modes were both a rejection of the European chord progressions that had dominated jazz and the path toward a more Afrocentric American music.

Davis did not become a purely modal player; he veered into explorations of the blues and Spanish music with Gil Evans. But many bop players switched to modes and began to revolutionize the mainstream sound. In 1958 John Coltrane, who had hit the bottom of his drug addiction, experienced a spiritual rebirth. Afterward he became a leading modal improviser, blending naive-sounding harmonic stasis with increasingly agitated rhythms and distorted timbres.

The most dramatic late-fifties development was the arrival of a slight, disheveled black saxophonist from Los Angeles at New York's Five Spot club. Ornette Coleman had grown up in Fort Worth, Texas, and toured with minstrel and country-western bands; frail and independent, he had brought his rich musical background to California clubs, where he faced almost universal rejection. Growing long hair and a beard, Coleman played in a style even rougher than hard-bop honking and ignored standard chord changes. His ensembles, in-

cluding the trumpeter Don Cherry, improvised together in different keys but mysteriously maintained cohesion through their shared affinity for the music and Southwestern styles. Charlie Haden, a Missouri bassist with roots in country music, often joined Coleman and Cherry. New York had heard nothing quite like Coleman; Martin Williams approved, while Miles Davis and the critic George Hoefer dismissed him as a mad failure. Journalists ridiculed his "new thing" or "*cosa nova.*" At the Five Spot for six months, Coleman put post-bebop, quasi-atonal music into the mainstream consciousness and thus stimulated interest in experimentalists such as Cecil Taylor, Sun Ra, and Bill Dixon, who had previously been shunned. Coming at a time of brewing ghetto anger and a civil rights revolution—not to mention a nation thawing from its cold war mentality—these musical developments promised to be explosive.

By 1960 the travails of the generation that had fought World War II had run their course. The postwar years had bred affluence and a spirit of daring experimentation, in foreign policy and weapons research as well as in progressive jazz and bebop. These frontiers, however, had also created tremendous anxiety in an uncertain public, leading to hunts for "disloyal" Americans, a yearning for safety in the suburb and the nuclear family, and such private and "cool" forms of leisure as television and West Coast jazz. Now the energies of young new artists—in cinema, rock and roll, and rhythm and blues—fit the mood of Americans seeking to grow beyond affluence and anxiety. Most important, hard bop and modal jazz were among the many cultural indicators of the impact of the black revolution for civil rights. Older Americans in 1960 may have sensed a coming decade of enormous change, but no one in jazz knew what role this rich but increasingly marginalized musical avant-garde would play.

6

"We Insist": Jazz Inside and Outside the 1960s

THE STORY OF JAZZ in the 1960s illustrates that the decade defies simple description. Despite its struggles in the fifties, jazz continued to be a popular and profitable music. It remained highly experimental and perhaps entered its most daring creative phase. Jazz musicians remained at the forefront of the international artistic avant-garde, and many were hard-working advocates for civil rights and racial justice. Nationwide the 1960s witnessed the peaking of many of the cultural trends that had shaped jazz since the twenties—urban political protest, African-American pride, the growth of indigenous American art forms, sexual license, and affluent leisure. Writers were attracted to jazz metaphors. Norman Mailer wrote about "a second American life" dawning in the Kennedy years, "the long electric night with the fires of neon leading down the highway to the murmur of jazz." *Newsweek* in 1965 found "the whole world . . . jetting and jazzing its way somewhere or other." The veteran critic Dwight Macdonald attacked "the jazzed-up style" of Tom Wolfe's "new journalism," which many others considered a major sixties innovation.

But jazz's continued growth and vitality in the sixties was

overshadowed by much larger and more startling cultural developments. The trends that had weakened the centrality of jazz to American life beginning in the 1940s also intensified. U.S. efforts to contain communism, its technological advancement, corporate and suburban expansion, and the relocation of mass leisure into private homes (mainly due to television) dwarfed and often demolished the urban nightclub scene. (Fifty-second Street clubs in Manhattan were torn down to make way for gleaming midtown skyscrapers.) The pace of change in the sixties was phenomenal, a topic of concern in itself. Americans confronted a flood of new experiences—on superhighways, in outer space, in the jungles of Vietnam, and in personal relationships—which had no real precedents in the jazz and swing ages. Adolescent "baby boomers" did build a powerful subculture around music, but that music was not jazz. Swing's popularity had waned before most of them had been born. As Albert Goldman wrote in 1968, "The youth of the swing era thought they knew who they were; today's youth has no such illusion. But lacking any clear-cut sense of identity has only made them more keenly aware of everyone else's." The new music, youth culture, and debates about America's future grew out of conditions that emerged long after swing had declined. By 1970 Americans wondered if jazz had any relevance to the new cultural scene.

Jazz *was* relevant, but it often exerted a highly indirect influence. As the sixties opened, jazz was clearly and passionately a part of the first and greatest social movement of the decade—the struggle for racial justice and for African-American rights. Black musicians, with sympathetic white colleagues, prefigured the cultural rise of Black Power that would soon transform the inner cities. They maintained memory of the race pride of Noble Sissle and Eubie Blake in the 1920s and the polished public activism of Duke Ellington in the thirties, and bebop and hard-bop players still perpetu-

ated an explicit subculture of artistic and personal protest. By the late 1950s protest themes in jazz were common. Charles Mingus's "Fables of Faubus" and other works introduced jazz political parody, which would flourish in the sixties. Sonny Rollins's cover portrait for the album *Way Out West* (1957) startled white observers with its then-incongruous image of a black gunslinger posing in the desert. Mingus's and Max Roach's protest counterfestival at Newport in 1960 was the major signal of black musicians' discontent with mainstream complacency. The 1961 festival was canceled (it would be discontinued permanently after a 1971 riot). The stylized anger of hard bop became explicitly political with early 1960s albums such as Roach's *We Insist! The Freedom Now Suite.* One movement of this work featured unaccompanied screams of pain from the singer Abby Lincoln, Roach's wife, who released a series of militant-themed recordings in the sixties. By 1963 the saxophonist Jackie McLean's album *Let Freedom Ring,* as well as scattered numbers celebrating Marcus Garvey and the Muslim leader Malcolm X, also appeared.

The music of protest drew from the new culture of the ghetto. After 1957 hard bop had simplified chord changes and rhythms and borrowed from popular urban styles. Urban blues brought "shouting" and spare electric guitar licks into prominence, while rhythm and blues groups popularized more upbeat and joyous vocalizing (as well as a more integrated "studio sound" in the instrumental accompaniment). Notably, African-American gospel music was now a major enterprise, both in the large Baptist and A.M.E. congregations and in the smaller storefront Sanctified churches. Long-play records made stars of the singer Mahalia Jackson, and even the preaching of C. L. Franklin and other ministers sold well on LPs. By the mid-1950s, as many ghettos suffered from joblessness and addictions, the term *soul* appeared with frequency, defining both a musical style and the special cultural

strengths of blacks. Ray Charles, a young jazz pianist, brought the shouting Sanctified style to his secular singing and song-writing, and brought national fame to soul music.

In jazz this sort of fervent style had first been promoted by true eccentrics, who later felt at home in the sixties. In the mid-fifties the Chicago bandleader and Fletcher Henderson protégé Lester Blount transformed himself into Sun Ra, the visionary folk "Arkestra" leader whose Afrocentric tendencies were represented in the album *Nubians of Plutonia* (1959), re-leased by his own Saturn Records. By 1959 established figures were also tapping into the Sanctified spirit. Such recorded performances as Ornette Coleman's "Ramblin'" and Charles Mingus's "Better Git in Your Soul" displayed the "funky" tim-bres of down-home vocals and gutbucket playing with blues harmonies. In their use of soul, hard bop and Coleman's "new thing" turned away from the complex, internationalist avant-garde qualities of Dizzy Gillespie's and Miles Davis's bebop styles. A new emphasis on communal feeling and folk perfor-mance—of tapping into "soul"—enabled Coleman's quartet to dispense with chord changes and to remain artistically uni-fied in dissonantly expressive new ways. Coleman resuscitated the rural "honk" of the 1940s Texas tenor style while John Coltrane pioneered the sounding of two notes on the sax—a "dirty" effect also reminiscent of the old tent shows and carni-vals. Mingus, for his part, stopped writing his arrangements and began shouting out melodies to his sidemen, often es-chewing chord changes entirely.

Hard-bop innovations sometimes were widely popular; Horace Silver's "The Preacher" sold 100,000 records. But some jazz musicians refused to abandon the more complex and avant-garde tools of their trade, and as a result their fol-lowing was limited. While a conservatory student, the pianist Cecil Taylor formulated his "energy" piano style, an onrush of improvisation without fixed harmony or rhythm. Later, in

Harlem, he associated this style with the soul energy of the African-American tradition rather than the European avant-garde, nurturing a concept that some in the sixties would call "black classical music." But Taylor's overwhelmingly complex improvisations gained little following among the black masses or the New York jazz clique, and he languished for years in odd jobs. Much more successful was the tenor saxophonist John Coltrane. Coltrane usually retained modal and other harmonies but also pushed chord changes and note runs to extreme speeds, producing volcanic solos that echoed the styles of Taylor and Coleman. (The rising Los Angeles multi-instrumentalist Eric Dolphy improvised in a similar manner.) Coltrane's rapidly developing spiritual interests, like Sun Ra's, also reflected a growing movement in the ghettos away from drugs and toward Afrocentric forms of spirituality. While the innovations of Coleman and Coltrane stimulated raging debates in the mainstream camp in 1960 and 1961, their work also sought to build bridges between this camp and the increasingly militant black masses.

In the early 1960s jazz musicians could sense a certain militancy in their own ranks. The major musicians' union locals were gradually integrating. In New York City the police department's discriminatory and harmful cabaret card system was overturned through the effort of the entertainment lawyer Maxwell Cohen. For the most part, though, militancy in jazz was inspired by the great "second Reconstruction" of the South—the nonviolent African-American movement against segregation and injustice. As the Reverend Martin Luther King, Jr., had hoped, the tenacity and suffering of humble black boycotters, picketers, and arrestees moved the nation's conscience when reported by the mass media. Civil rights acts were again passed, the Justice Department enforced court orders and protected activists, and supporters nationwide gave money and time to the cause. The cool medium of

television was filled with "hot" images of beatings, fire-hosings, police dogs, Klan mobilization, and mob intimidation. This image of ordinary citizens boldly making a difference was the engine that drove the revolutionary spirit of the 1960s. Opponents of nuclear weapons, the Vietnam War, and industrial pollution, as well as advocates of progress for women, Hispanics, and Native Americans, would follow in the Southern black movement's footsteps.

Hope and militancy also bred anger and impatience, especially in urban black communities. Despite the civil rights revolution, the inner cities remained de facto ghettos. While Presidents Kennedy and Johnson initiated affirmative action and the "War on Poverty," it was clear that many white taxpayers considered the programs "giveaways" to undeserving blacks. In the inner cities, anger and militancy increased. Nationalist and liberationist movements were inspired by the recent independence of black African nations and became a focus of rage among young urban residents. Raised to find narcotics common, organized crime prevalent, and the ghetto an encased slum, people of Claude Brown's and Malcolm X's generation—particularly young men—brought a new urgency to urban black protest. Malcolm X warned listeners of the brittle anger of the ghetto, and the Nation of Islam sought to convert young black men and instill pure behavior. The Nation itself, though, was riven by violent divisions that culminated in the 1965 assassination of Malcolm X in Harlem.

Harlem had already rioted the year before, in protest against a police arrest, and participants had attacked the police and white-owned businesses and apartment houses. Sociologists would call this a symbolic cleansing of the community; suburbanites saw it as frightening confirmation of their worst racial fears. In 1965 Watts burned for a week after a similar arrest situation on the hottest day of the year; perhaps one in five residents took part in the street action and looting, and

the National Guard killed thirty suspected participants. For the next two summers dozens of ghettos were shaken by such uprisings and suppression.

The prose of James Baldwin, the oratory of Malcolm X, and the poetry of Leroi Jones articulated the anger of the ghetto, but they could not equal the visceral force of avant-garde black jazz. Ornette Coleman's 1960 recorded experiment *Free Jazz*, in which two quartets improvised without prearranged chords or scales, initiated the sixties' "outside" jazz movement. It was dominated by the wails, grunts, and dissonant pleading runs of major saxophonists such as Coltrane, Jackie McLean, Pharoah Sanders, Archie Shepp, and Albert Ayler. Any pretense toward "cool," whether stimulated by heroin, West Coast living, or material comfort, was buried by their fury.

While Coltrane retained modal structures as late as his landmark big-group session *Ascension* (1965), it was the unrelenting speed and striving, dissonance within and between solos, and twisted and torn timbres that captivated listeners. Ayler took the free method to its extreme, distorting every note of his playing with forced breathing and the overtaxing of his instrument. Trumpet and trombone could not bend as flexibly as saxophones, but Don Cherry, Freddie Hubbard, Donald Ayler, Dewey Johnson, and Bobby Bradford worked to convey similar senses of desperate energy. (Miles Davis, while scornful of free jazz, also experimented with choked timbres, pungent dissonances, and controlled chaos within modal structures.) Pianists such as Cecil Taylor and McCoy Tyner altered timbre with an array of touches, including hammering the keyboards with fists and forearms, and Taylor's group improvised explosively over spans lasting as long as ninety minutes.

"Outside" or "energy" jazz, while expressing anger, also gave voice to power. Anxious whites perceived the Black

Power movement of the late sixties as a violent and divisive force. The mass media derided a Newark gathering's demand for $500 million and territory for a separate black state, the Black Panther party's declaration of war on city police, and Olympic athletes who showed open disdain for the American flag. Black Power, though—as even Martin Luther King, a critic, perceived—was creative as well as destructive. The movement cleansed communities of some rage, brought a sense of political involvement to the poorest ghetto resident, revived past self-help and nationalistic programs, and dramatically increased black people's pride in their heritage and self-worth. In short, Black Power created a context in which dispossessed urbanites could feel "powerful," politically and culturally. Activists organized political groups, community services, banks, locally owned cosmetics and other businesses, Afrocentric schools, and self-defense squads.

Black Power also inspired Black Arts—prose, poetry, theater, art, dance, and music that expressed African-American difference in an era of mass-market homogenization and conformity. The jazz avant-garde flourished within the Black Arts context. In New York a network of coffeehouses sponsored militant black poetry and jazz long before the emergence of Black Power in 1966. Leroi Jones (later Amiri Baraka), a poet and musician and the first regular black columnist for *Down Beat,* had been shaped both by the civil rights movement at Howard University and avant-garde seminars at North Carolina's Black Mountain College. Jones's seminal 1963 study of the jazz tradition, *Blues People,* reasserted the African and rural blues roots of that tradition and shattered the veneer of urbane liberalism that had typified white writers' jazz histories. Jones's kinetic poetry often accompanied the playing of the New York Art Quartet in the coffeehouses, redefining the white-oriented jazz-poetry fusion of the Beat writers, and his advocacy stimulated a stable of

musicians (especially the saxophonist Marion Brown) and writers to develop this basic aesthetic.

More than Coltrane or Coleman, Jones used jazz to indict and to incite. Among musicians, the saxophonist Archie Shepp shared Jones's militancy. Composer of such numbers as "Malcolm, Malcolm, Semper Malcolm" and the play *Junebug Graduates Tonight,* Shepp gained national attention for his Black Power declarations. Reflecting Jones's perspective, Shepp announced that "This is where the avant garde begins. *It is not a movement, but a state of mind.* It is a thorough denial of technical precision and a reaffirmation of *das Volk.*"

Many black militants, from Jones to the Black Panthers, adopted a Marxian materialism, but others emphasized spirituality as a cultural force. The "soul" concept had been given new momentum by the role of music among civil rights workers in the South. "Freedom songs" and spirituals helped to give them strength through tense nights of Klan and police intimidation and days and weeks of protests, sit-ins, arrests, and jailings. In jazz, John Coltrane most prominently emphasized the spiritual foundation of his tortured explorations, in such albums as *Om* and *A Love Supreme* (which sold 200,000 copies). Other major "outside" musicians found a spiritual calling. Sun Ra and Albert Ayler fashioned their own faiths out of various pantheistic concepts. All of them blended excruciatingly dissonant voyages with simple, extremely naive-sounding chantlike tunes. (Ben Sidran has called Coltrane's style "a vortex of screams and simple songs.") This dichotomy showed that Black Arts also attempted to recover the lost innocence of African-American childhood and tradition. Avant-garde jazz expressed a vulnerability and fragility that political militants could not express. Similarly the African-American musicians who turned to Islam to purify themselves—Art Blakey, Yusef Lateef, Rashied Ali, and Muhal Richard Abrams—emulated the quiet asceticism of Elijah

and Wallace Muhammad rather than the militancy of another
Muslim leader, Louis X (Farrakhan).

Jazz, like Islam and Black Power, seemed like a way to heal
communities and put young people on the right life path. For
the first time jazz innovators involved themselves heavily in
educational and community institutions in the ghettos. In
Harlem, Jackie McLean became involved in HARYOU-ACT,
an effort to involve children in the arts. Leroi Jones soon relo-
cated his poetry, theater, music, and publishing efforts (includ-
ing his magazine *The Cricket*) to Newark. In Chicago, pianist
Muhal Richard Abrams created his avant-garde Experimental
Band in 1961, and four years later helped to form the Associa-
tion for the Advancement of Creative Musicians (AACM),
probably the most influential jazz musicians' collective. The
AACM established its own school in Chicago and performed
workshops in public classrooms.

Roscoe Mitchell's group, and later the Art Ensemble of
Chicago, worked slapstick political skits and colorful cos-
tumes into their performances. Mitchell's album *Sound* (1966)
might have been the most avant-garde jazz effort to that time,
obliterating almost all musical conventions and depicting the
contrast of primitive sound with silence. Anthony Braxton,
stimulated in part by technology and science fiction, produced
a stunning array of highly original solo saxophone albums,
combo sets, and complex multi-orchestral works. Braxton
epitomized the cosmopolitan nature of "black classical music."
Swing, bebop, and the blues were only starting points for jour-
neys through many musical landscapes. Works by such
AACM members as Henry Threadgill, Von Freeman, and
George Lewis reinforced Chicago's reputation as the most vi-
brant center for avant-garde black music.

In St. Louis—a city devastated by white flight, reckless
slum clearance, and shoddy public housing—the Black
Artists Group was formed in 1968 by avant-garde musicians

Oliver Lake, Julius Hemphill, Phil Wilson, Charles Bobo Shaw, and Bakaida Carroll. Difficult local conditions forced the BAG to disband in 1972, and many of its members moved to New York. In South Central Los Angeles the pianist Horace Tapscott had formed his Pan Afrikan Peoples Arkestra in 1961, and after the 1965 riot he launched the Nimbus record label and the Union of God's Musicians and Artists Ascension. The UGMAA worked with gospel groups and writers' projects to direct Watts's anger into healing creativity. Important musicians such as Bobby Bradford, John Carter, Arthur Blythe, Lester Robinson, Walter Lowe, Raymond King, Linda Hill, and Stanley Crouch took part. Oakland, New Orleans, Minneapolis, and Philadelphia also saw organized "black music" renaissances which were intimately related to the spiritual and political strivings of angrier, more Afrocentric populations.

Despite this valuable activity, jazz failed to regain the central cultural role it had once held in urban black communities. It remained a somewhat difficult avant-garde music, and it was still highly multiracial. Ornette Coleman preferred white string bass players because he felt they were better trained on the instrument. Since the late fifties John Lewis and Gunther Schuller had promoted a musical "third stream," blending jazz and classical practices, and many black (and white) innovators remained preoccupied with this goal. Cecil Taylor counted Bartók and Stravinsky as decisive influences, and Anthony Braxton was initially inspired by Arnold Schoenberg's tone-row system. (White composers such as Lalo Schifrin, Bill Evans, and Leonard Feather, however, wrote the major jazz works in Schoenberg's serial style.) Taylor performed in large-scale concert works by Mike Mantler, and Coleman and Braxton were drawn to composing for string quartet and symphony orchestra. Even Duke Ellington's later works (es-

pecially the three *Sacred Concerts*) fit the ambitious, complex, and dissonant trend of this time.

In New York the major avant-garde organization, the Jazz Composers Guild (founded in 1965 by the black trumpeter Bill Dixon), was racially mixed. Pianists Paul and Carla Bley and Mike Mantler, saxophonist Steve Lacy, and bassist Buell Neidlinger were important white participants. In contrast with such Afrocentric ensembles as the New York Art Quartet and the Albert Ayler group, the Guild maintained a cosmopolitan profile. Its members interacted with such European innovators as Albert Mangelsdorff (perhaps the world's most innovative jazz trombonist), Frederick Rzewski, Alex Schlippenbach, and Vinko Globokar. In 1972 Ornette Coleman and the West German vibraphonist Karl Berger cofounded the Creative Music Studio in Woodstock, New York, a key center for avant-garde jazz. For the first time too, black African jazz musicians migrated to the United States, especially refugees from South African apartheid such as the pianist Dollar Brand (Abdullah Ibrahim), the trumpeter Hugh Masekela, and the singer Miriam Makeba—the originators of "township bop."

Unfortunately many African Americans were more interested in other new music. While jazz vividly expressed black pride and anger, it did not entertain the masses or always reflect their group identity or leisure tastes. Attempts by Charles Mingus, Max Roach, Milford Graves, and Don Pullen to run musician-owned jazz record labels failed. Meanwhile white-owned rhythm and blues labels such as Chicago's Chess and Memphis's Stax had blazed paths to success for such fifties stars as Ray Charles and Dinah Washington, and Berry Gordy's Motown Records and Kenny Gamble's Philadelphia International Records gained large shares of the national market.

Rhythm and blues and soul music—separated by an increasingly vague boundary—commanded the allegiance of the mass black audience. Radio disk jockeys effectively gauged the popularity of songs and disseminated hits. Stars such as Sam Cooke, the Supremes, Otis Redding, James Brown, and Aretha Franklin (the daughter of the Baptist minister C. L. Franklin) crystallized the sound of soul for black and white audiences alike. While Motown successfully catered to a biracial audience, the African-American vernacular of songs featuring Marvin Gaye, Smokey Robinson, the Temptations, and later the Jackson Five also made them ghetto anthems—celebrations of energy and soul in the midst of heat, hatred, and poverty. The harmonies, dissonances, and complex rhythms that typified avant-garde jazz could not compete commercially with the alluring glitter and the emotional immediacy of R and B and soul.

In the 1960s jazz enjoyed its greatest following among the aging former adolescents of the twenties, thirties, and forties. The nostalgia of affluent senior citizens was beginning to dominate the jazz business. Louis Armstrong's career was as vital as ever, and the Count Basie Orchestra (revivified by new arrangements by Neal Hefti and Quincy Jones) reached the peak of its popularity. Basie's collaboration with Frank Sinatra in 1963 produced one of the decade's best-selling albums. Benny Goodman, Woody Herman, and other swing leaders hired new players and found steady work before legions of longtime fans. Dave Brubeck's popularity remained high. Almost alone, Duke Ellington defied the trend toward swing-era nostalgia, enriching his idiosyncratic composing style and consistently challenging his band and his listeners. A controversy erupted in 1966 when the Pulitzer Prize music committee (dominated by white academic composers) overruled the general board's decision to award Ellington a special music prize; the considerable public indignation that resulted

showed how vital (and controversial) the great composer remained.

For most Americans, jazz was almost totally eclipsed in the sixties by social traumas and musical tumult. The black revolution was the vanguard of protest and cultural struggle that shook all but the most isolated American communities. President Kennedy's murder in November 1963 shocked the nation out of its sense of security and complacency. Lyndon Johnson's enactment of civil rights, the War on Poverty, and Great Society legislation only contributed to the widespread sense of accelerated change. In 1964 Congress almost absentmindedly committed the United States to an escalation of military aid for a collapsing South Vietnam. The next year President Johnson began bombing North Vietnam to force it to negotiate while divisions of American infantry troops arrived to protect the South. Students, already rallying for civil rights, created a mass antiwar movement while their working-class contemporaries bitterly answered draft calls. Politicians soon split over the war, and opponents began to question America's cold war containment policies. Conservative criticism, though, led Johnson to employ still more force in Vietnam and to neglect the War on Poverty.

New cultural forces also contributed to the larger sense of upheaval. In 1961 the birth-control pill was placed on the market, contributing to an explosion in casual and serial sexual activity, especially among youth. Drugs such as LSD and marijuana stimulated renegade "drug cultures" which praised chemically induced escapes from reality. The journalist Betty Friedan, writing in *The Feminine Mystique* in 1963, attacked housewives' imprisonment in suburban homes; she prescribed careers for wives and mothers and launched a new feminist campaign. While nostalgia attracted many Americans in the sixties, daring cultural innovation appealed to others. Following the Beat writers' pioneering efforts, "hippies" and others

used drugs, Eastern religion, and rural, transient, and communal living to "drop out" of society. Subcultures grew up around gurus, motorcycle gangs, surfers, and other deviant social types. Blending with antiwar protest, the new behavior created an apparent "counterculture" for millions of youths and adults. As "the movement" gained the world's attention, helping to pressure Johnson to drop out of the 1968 presidential race, the possibilities of the counterculture seemed extraordinary.

The main expression of this radical movement was popular music. Beginning in the late fifties, a revitalized folk-song movement provided the greatest expression of protest. Recovering from blacklisting, left-wing singers kept old labor and protest songs alive and gained a surprising new popularity. The same city coffeehouses that had nurtured Jack Kerouac and Leroi Jones now promoted Woody Guthrie, Pete Seeger, and other troubadour-critics. The popular success in 1959 of the clean-cut Kingston Trio had signaled a stirring in the mass audience. A young Guthrie disciple, Bob Dylan, adapted folk song for the sixties, attacking racism and insensitive elders. Discovered by none other than John Hammond, Columbia's veteran jazz scout, Dylan's abrasive songs became an odd popular sensation.

Rock and roll, meanwhile, was being rescued from sanitizing by the music industry. While Elvis Presley and others had switched to innocuous "pop" material, Brian Wilson's Beach Boys and the New York producer Phil Spector enriched rock and roll's harmonic palette and used studio mixing to create liberating and complex musical tapestries. Also, British bands were rediscovering the painful urgency of African-American blues. In 1964 Cream and the Rolling Stones burst on the music scene, amplifying the taunting sexuality of the early Presley. Another English group cannily disguised their blues sound in the current puppy-love song formats; the Beatles'

eclectic style and melodic genius quickly made them the biggest-selling recorded act in history. In 1965 Bob Dylan shocked the Newport Folk Festival—as much an "establishment" event as Newport's jazz gathering—by playing the electric guitar. Dylan had merged left-wing folk protest with rock and roll. With the Beatles, Dylan brought "rock" (as it came to be known) back to its socially subversive roots. San Francisco's hippies then made rock the counterculture's anthem.

The cultural upheavals of the late 1960s presented Americans with something resembling an anthology of the preceding fifty years. As in the twenties, sexual daring and adolescent subcultures flourished; thirties-style left-wing radicalism, populism, and audience hysteria (for rock instead of swing) thrived; military and home-front violence reminiscent of World War II erupted; and yet the general affluence and material abundance of the fifties persisted and even increased. Rock music reflected this phenomenon. Albert Goldman noted in 1968 that rock showed young people hungering "for the essence of every people or period that displays a striking or exotic style ... the whole of American music ... the sounds and rhythms of Africa, the Middle East, and India ... back in time for the baroque trumpet, the madrigal, and the Gregorian chant ... and forward into the future for electronic music...." The Beatles, Rolling Stones, and Led Zeppelin led the way to "art rock" and "heavy metal," musical fantasies partly inspired by drugs, while Dylan and The Band breathed critical intelligence into country and western models. The counterculture rejected existentialism and severe modernist styles even while it shared their resistance to nostalgic conservatism. Like the antiwar movement, rock was both aggressively forward-looking and rooted in an ancient sense of ritual and community.

The counterculture of the late sixties was a fragile search

for political and behavioral authenticity. Jazz played a minor role in this musical and cultural quest. To 1960s youth, older stars such as Louis Armstrong seemed like inauthentic crowd pleasers, while bebop's "cool" was too withdrawn and isolating. Nevertheless the passion of militant avant-garde jazz made it welcome nourishment for omnivorous rock fans. Hugh Masekela was enthusiastically received at the 1967 Monterey Pop Festival. The Band, the Doors, and the Allman Brothers Band (based in New York, California, and Georgia, respectively) all studied jazz practice and performed extended group improvisations on blues themes. Guitarists' modal improvisations—later the basis for 1970s "heavy metal" styles—resembled the approaches of Coltrane and Miles Davis. Soon some jazz musicians switched to rock: Blood, Sweat, and Tears; Chicago; Dreams; and the aptly named Fourth Way attempted to bring their jazz training to the lucrative rock audience. The fortunes of these bands were mixed, and they failed to establish a major hybrid style. Perhaps jazz's greatest influence was indirect. The iconic image of the male rock guitar virtuoso—Jimi Hendrix, or Led Zeppelin's Jimmy Page—it seems clear today, was a deliriously adolescent updating of the tortured, rapturous jazz soloist in the person of John Coltrane or Albert Ayler.

It was depressingly symbolic for jazz that Coltrane and Ayler died in the years that bracketed the height of the counterculture, 1967 and 1970. Rock bands, led by the Beatles, pushed annual record sales to $1 billion and the industry toward greater mass marketing than ever. Every other style, including jazz, became marginal. Among the worst hit was the complex avant-garde jazz emerging from the ghettos. Columbia's John Hammond, on the lookout for talent, "was less than happy with the directions jazz was taking. . . . The new-found intellectual complexity of jazz was having a strange effect on

young jazz musicians. . . . Jazz was defined, composed, stud-
ied, and dissected, not *played*." A steady stream of opinion
pieces appeared in music journals asking variants of the ques-
tion, "Is jazz dead?" In an era that celebrated youth and inno-
vation, established jazz styles seemed middle aged and
nostalgic. Purists were horrified as Rashaan Roland Kirk,
Eddie Harris, and David Newman improvised on Beatles
tunes; even Duke Ellington kept current by performing "I
Wanna Hold Your Hand." Dexter Gordon, Kenny Clarke,
and the soprano saxophonist Steve Lacy decided to live in
Paris during the mid-sixties, preferring to keep a distance
from the commercial and countercultural frenzy in the States;
Anthony Braxton and the Art Ensemble of Chicago soon fol-
lowed.

American music as a whole seemed to be hurtling into an
uncertain future. In classical music the composer and conduc-
tor Leonard Bernstein made headlines in 1970 by claiming
that the American symphony orchestra had become a "mu-
seum" filled with old, dead music, which had to be completely
overhauled to attract the all-important youth audience. In the
spirit of Ellington's sacred concerts, Bernstein's *Mass* (1971),
performed at the opening of the John F. Kennedy Center for
the Performing Arts in Washington, departed radically from
the traditional liturgy. Bernstein incorporated theatrical "hap-
penings" and electrified rock bands into his Mass setting.
Pierre Boulez, the avant-garde composer, was hired to succeed
Bernstein as music director of the New York Philharmonic to
lure young listeners. Boulez initiated matinee "Rug Concerts"
which allowed patrons to lounge on pillows on the concert-
hall floor (from which the seats had been removed), in the
manner of an informal living room listening session.

The perceived crises in jazz and classical music mainly re-
flected Americans' general uncertainty and sense of crisis.

From a high point of confidence at the start of the decade, violence and political controversy had eroded America's cities, social relations, sense of community, and faith in the future. While jazz critics pondered the possible death of jazz, *Time* magazine's cover in 1966 asked, "Is God Dead?" In 1969, referring to young "Jesus Freaks," the cover asked, "Is God Coming Back to Life?" The Apollo moon missions, one of history's great achievements, provoked cynical reactions from those who complained about their cost and ties to the defense industry. The year 1968 eroded faith in the government and in the Vietnam War. The Tet Offensive, the murders of Martin Luther King and Robert Kennedy, and clashes between police and protesters at the Democratic convention in Chicago made the war look pointless, politics impotent, and the streets dangerous. In 1968 the Kerner Commission on Civil Disorders condemned the United States as a potential South Africa, "moving toward two societies, one black, one white—separate and unequal." Environmentalists worried that air and water pollution were threatening Americans' daily existence, and inflation and unemployment were beginning to eat away at the economy.

In 1969 Richard Nixon, a "law and order" president elected by worried whites, was inaugurated. A clever politician, Nixon often sounded alternately liberal and conservative, but he exploited most whites' confusion and dismay and promoted an angry new conservatism. He continued the war in Vietnam, targeted antiwar groups, and opposed affirmative action, busing as a tool for school integration, and many social programs. Bitter white industrial workers and Southerners, disenchanted with liberalism and racial change, were drawn to Nixon. The president also used popular music to do symbolic battle with the left-wing counterculture. He invited Elvis Presley to the White House to publicize the fight against narcotics (though Presley was privately a heavy drug user),

and Duke Ellington, the sage of jazz, received an extraordinary seventieth-birthday party.* More pointedly, Nixon and Vice-President Spiro Agnew (a ruthless critic of the counterculture) embraced the country singer Merle Haggard and his anti-sixties anthem "Okie from Muskogee." In Muskogee, "A place where even squares can have a ball," Haggard sang, "We don't let our hair grow long and shaggy/ Like the hippies out in San Francisco do." While James Brown, Lionel Hampton, and Sammy Davis, Jr., provided Nixon with prominent black support, the white-dominated country and western scene fit his campaign for conservative white votes most comfortably.

The death of Martin Luther King underlined the painful deflation of the black revolution in the late sixties. In 1966 King had broken with other civil rights leaders to oppose the Vietnam War, citing its inordinate impact on black draftees, and he moved to Chicago to begin what he called his Poor People's Campaign. Like Black Power advocates, King in his last years attacked the poverty and powerlessness that civil rights could not remedy. The FBI had treated King like a suspected Communist; after his death it made the Black Panthers its leading target. Violent suppression of the Panthers (misleadingly thought to be readying an invasion of the suburbs) left two dozen dead and headquarters in many black neighborhoods in ruins. Pulsating soul music and bold Black Power declarations now sounded hollow; as the 1970s began, a familiar exhaustion and pessimism returned. Government aid did help many African Americans gain college educations and secure firmly middle-class careers (especially as administrators of local social programs), but the ghetto would remain, a product of lingering poverty and discrimination.

*To be fair, Nixon was a longtime fan of Ellington's and played the piano himself.

As the sixties ended, jazz's situation seemed critical. The accolades for such veterans as Ellington did not expand the small public following for jazz styles. The efforts of sixties black musicians to contribute to an urban renaissance had largely been thwarted by ghetto disillusion and decline. The dazzling musical advances made by experimental black artists were mostly embraced by the international avant-garde, an arcane network on which jazz had come to rely. But even as conservatism, in the form of country-western and increasingly formulaic "pop rock," reconquered music, jazz sounds were borrowed by rock, soul, and even country musicians with accelerating regularity. Drum, trumpet, and sax "licks" turned up in television commercials, film scores, and tracks in heavily mixed pop instrumentals. American culture, in the wake of Vietnam and domestic disarray, was furiously recycling its resources in a search for meaning. As the seventies dawned, jazz became a thread in the diffuse fabric of music and leisure in which a confused nation sought comfortably to clothe itself.

7

Fusion and Fragmentation: Jazz at the End of the American Century

IN 1968, amid some of the most confusing and pessimistic times for jazz music and American society as a whole, Miles Davis decided on a momentous change in his ensemble's style. The shadowy "Prince of Darkness" who kept his ideas and feelings largely to himself (as he would even in his 1989 autobiography), Davis must have been deeply affected by the increasing irrelevance of avant-garde jazz in a rock-dominated music scene. Preparing for new recording sessions at Columbia, Davis brought in two Fender-Rhodes electronic keyboardists who played in the popular rock and R and B styles. Above all they maintained a constant bass beat that featured simple, catchy syncopations—the seductive hallmark of rock rhythm. Davis's group adjusted its improvisations to the steady beat, drawing jazz close to the repetitive, hallucinatory variation style of rock guitar heroes such as Jimi Hendrix.

The first Davis album of 1969, *In a Silent Way*, startled many listeners and became probably the most controversial jazz record of the decade. His second release, *Bitches Brew*, enlarged the electrified contingent and embraced the "soul" style

still more fully. Whether or not this approach was forced on Davis by Columbia Records (as the story goes, executives demanded that he produce a hit), it became his standard style for the next five years. *Bitches Brew* became the biggest-selling jazz album of all time, competing with rock record sales. Davis had succeeded where nascent jazz-rock bands had struggled; he had "fused" established jazz tradition with the dominant new trend. Davis's collaborators in these years branched out to form the most influential *fusion* bands of the 1970s: pianists Herbie Hancock's sextet, Chick Corea's Return to Forever, Joe Zawinul's Weather Report, drummer Tony Williams's Lifetime, and guitarist John McLaughlin's Mahavishnu Orchestra (which in turn begat the violinist Jean-Luc Ponty's popular groups).

This surprising turn of events set the stage for the creation of new cultural roles for jazz. These roles materialized as Americans struggled to bring meaning to their lives after the great postwar crusades—against communism, North Vietnam, and poverty, and for the American dream, civil rights, racial equality, and the counterculture—had either failed or stalled. Much like Europe after World War I, the United States had seen its faith in progress shaken by images of bloodshed, waste, and corruption. The exposure of President Nixon's political spy ring during the Watergate affair of 1973–1974 provided the final major episode in the political turmoil of the sixties, but more government scandals, as well as the fall of Saigon, would follow. Rapidly increasing price inflation and unemployment presented America with its greatest economic difficulties since the 1940s. The student movement, Black Power, and other left-wing challenges had also collapsed due to suppression by authorities and zealous overreaching. Violence and the devastating effect of drugs took the reformist zeal out of most of these movements.

America's postwar myths of affluence, righteousness, and

liberal progress seemed thwarted, and its institutions now were viewed with a new cynicism and suspicion. In the seventies, many observers noted, Americans responded by turning inward. Solitary sports such as running and skiing, the increasing frequency of unmarried cohabitation, and a rising divorce rate were evidence of a "Me Decade." Music, appropriately, became a vehicle for individuals' search for satisfaction. Even more than in previous decades, musical styles reflected subcultures' separate, intensely private preferences, apart from shared mass public experience. Commercial radio stations, guided by market research, targeted particular age, ethnic, and socioeconomic groups and specialized in the musical styles that these groups allegedly preferred. While concerts by the most popular rock bands attracted tens of thousands to stadiums, the exacting calculations that corporations made to lure those audiences to particular bands—and the wide criticism they drew from nonfans—showed the splintering and conflict of tastes even in the white suburban majority.

In the 1940s jazz had been perhaps the first victim of audience splintering; in the seventies some jazz subgroups found themselves with extremely limited publics. The avant-garde, based in Chicago's AACM and New York's various cliques, became more dependent on international concert bookings and European record companies such as Black Saint and ECM. An individual avant-garde album's sales rarely reached twenty thousand, too low to provide a living income for artists. The large New York scene increasingly relied on a network of "lofts," usually run by musicians themselves at minimal expense, which nurtured a small and dedicated audience. Sam and Bea Rivers's Studio Rivbea in SoHo was a major loft site. By the late seventies, though, most lofts closed as musicians went off on their own career paths. Muhal Richard Abrams, Anthony Davis, George Lewis, and Ricky Ford found that only by living in the same Manhattan high rise

could they link their creative efforts. To many, the avant-
garde "outside" jazz scene seemed irrelevant and tired. As the
drummer and New York stalwart Milford Graves recalled,
the sixties "was a period when everyone was up and the music
was hot and burning. But the 1970s is like everyone went to
sleep. Everyone got split up."

If there were "hot and burning" sounds in the seventies,
they came from funk, a variant of soul and R and B, the music
of the turbulent black cities of the previous decade. Funk's in-
strumental complexity showed a debt to jazz improvisation
but especially represented a denser orchestration of R and B
harmonies. Brass players joined heavily electrified keyboards
and guitars to amplify the propulsive R and B beats, and lead
vocalists both shouted and sang in menacing or seductive
whispers; female backup singers also became a fixture. Vocal-
ists such as George Clinton and Al Green and the arranger
Isaac Hayes, emerging from such record studios as Stax's in
Memphis, propelled the style to fame. Hayes's score for the
film *Shaft* (1972), the first by a black composer to win an
Academy Award, and his lucrative tours and contracts repre-
sented notable triumphs of the post–Jim Crow era; but they
also showed how funk—and other aspects of black music and
culture—continued to be controlled by the white-run enter-
tainment industry. Hayes's music and his "bad" performing
persona, like *Shaft* and other 1970s "blaxploitation" films,
were promoted as expressions of Afro-American militancy. In
reality they enforced stereotypes of bestial urban black life that
whites had revived during the riot-torn sixties.

As Nelson George first observed, funk stars in the early
seventies fell into dilemmas that future black musicians would
also face: achieving unprecedented wealth and exposure, they
also lost control of their music and public images to white-
dominated entertainment conglomerates. Late in the seven-
ties, for example, European producers and white dance-club

managers packaged the black "disco" dance style into forms acceptable to young whites. Such manipulation for the mass market, of course, had confronted jazz musicians since the twenties. The "fusion" phenomenon produced new heights of popularity for jazz and greater volumes of critical condemnation. Capable improvisers in the Mahavishnu Orchestra and Weather Report gained some critics' respect—players such as saxophonist Wayne Shorter, a founder of the latter group, had been young combo stars in the sixties. Still, the glibness of Weather Report's biggest hit, "Birdland" (1976), and of pianist Keith Jarrett's rambling (and wildly popular) solo recitals disturbed traditionalists. The gold-record successes of Chuck Mangione, Stanley Turrentine, Grover Washington, Jr., George Benson, Bob James, and Earl Klugh—all veteran jazz musicians—seemed to some to be the triumph of "Jazz Lite." The easygoing rhythms and harmonies of fusion were a distillation of the "cool," West Coast, and modal innovations of earlier years into accessible and therapeutic pop formats. It was easy to associate these sounds with the uncommitted, private, detached "life styles" of the splintered seventies mass public.

While new cultural trends tended to take the urgency and protest out of popular music and allowed mass marketing to dominate public consumption, to a great degree the social revolutions of the 1960s were also continued and realized. Despite the exhaustion of social movements and backlashes against them, real gains had been made, and they were consolidated in the seventies. Public segregation had vanished, and black voters and elected officials quickly transformed the face of political power. Black men became mayors of large cities, and educational and career opportunities for African Americans expanded. By 1980 the black college student population reached one million. Private and public affirmative action policies helped to increase dramatically the number of black professionals and families earning comfortable middle-class

incomes. Millions of blacks were integrated into the social mainstream for the first time, and Americans recognized the moment's significance. Black history and culture gained unprecedented attention in the 1970s. *Roots,* Alex Haley's story of his ancestors' centuries-long struggles, became the highest-rated television special in history, and scholarly works revolutionized the appreciation of black song and folklore.

As a byproduct of this recognition, the jazz tradition belatedly received official recognition as a major American art form, even gaining private and public patronage. In the years before his death in 1974, Duke Ellington received honorary degrees and many other tokens of academic and official esteem. The National Endowment for the Arts, founded in 1965, began to fund a jazz oral-history project and grants to musicians. (In the 1980s Jazz Masters grants of $30,000 were awarded annually to established musicians for their own projects.) Ornette Coleman received commissions to compose for symphony orchestras.

Jazz studies programs proliferated in the seventies. Archie Shepp became a professor of music at the University of Massachusetts at Amherst, one of the centers of black academic militancy; Bill Dixon founded a department of black music at Bennington College; Roscoe Mitchell continued to experiment at the University of Wisconsin, where Cecil Taylor also taught; and Bobby Bradford worked at Pomona College. Taylor also took part in the ultimate official recognition, an outdoor jazz concert at the White House on June 18, 1978, which also featured Eubie Blake, Lionel Hampton, Mary Lou Williams, Dizzy Gillespie, Jo Jones, Stan Getz, Herbie Hancock, Sonny Rollins, and Ornette Coleman in performance and Billy Taylor, Gerry Mulligan, John Lewis, and Charles Mingus in the audience. President Jimmy Carter praised jazz as the embodiment of two American virtues, "individuality

and a free expression of one's inner spirit." Carter, a Southern advocate of racial conciliation, worked as president (not always successfully) to ease the leftover tensions of the sixties with a spirit of inclusion and recognition of the achievements of ethnic groups. The recognition of jazz certainly fit this moderate political agenda.

The major social revolution of the seventies affected the status of women. Discriminatory laws were eliminated; affirmative action benefited female students and career women; and abortion rights were proclaimed by the Supreme Court. American assumptions about women's roles and opportunities changed more drastically than they had in the 1920s or 1940s. Jazz was conspicuously affected by this trend. Veteran performers such as Mary Lou Williams, Melba Liston, Marian McPartland, Patti Brown, Betty Carter, and Carla Bley found it easier to obtain bookings and recording dates, and to gain business control within the traditionally male-dominated jazz subculture. The bandleader Toshiko Akiyoshi, the pianist JoAnne Brackeen, and the singer Lillian Boutté gained prominence. The transition in jazz was not dramatic, but the changing social climate made the increasing abundance of relatively well-known jazzwomen more acceptable to promoters and audiences. In terms of gender, jazz had been less than revolutionary—and the dominant names in jazz continued to be male—but new opportunities for women did emerge.

To an extent, therefore, jazz in the 1970s was resuscitated as popular music in the form of lighter, more optimistic styles. These styles reflected the lingering energy and optimism of sixties liberalism, the "time for healing" that followed Watergate, and real progress for African Americans and women. Some Americans, though, were distressed by features of the seventies cultural scene. African-American writers such as Michele Wallace and Albert Murray noted that the stereotyp-

ing of ghetto life in the marketing of funk music and "blax-ploitation" movies scarcely represented a stride toward progress.

For very different reasons, cultural traditionalists were convinced that the nation was in an unhealthy state. The rise of career women, coupled with the prevalence of divorce and unmarried cohabitation, provoked anger and concern among evangelical Protestants. Conservative Christians launched a political crusade against post-1960s cultural tolerance. The defeat of the proposed equal-rights amendment to the Constitution showed that the "religious right" was a highly organized political force. It soon allied with worried cold warriors who demanded a new vigilance against a heavily armed, atheistic Soviet Union. The white backlash against welfare programs and affirmative action, meanwhile, slowly gained strength. Battles over the use of student busing for school integration split cities along racial lines, and opponents of affirmative action filed court challenges to racial quotas.

In popular culture the white backlash became apparent in various ways. Movie stereotypes of blacks were indicative, as was the tremendous popularity of the film *Rocky* (1976), which depicted a working-class white boxer who nearly defeats the arrogant, wealthy—and black—world heavyweight champion. Rocky Balboa, many noted then, was a symbol of white industrial workers triumphing against economic hard times, but he was perceived as a racial symbol as well. Country and western music, now a prosperous industry with wide appeal, became even more popular in the seventies. "Country" attracted listeners of all political persuasions—Jimmy Carter, a lifelong fan, invited many leading singers to the White House, and some of them were Democratic activists. Richard Nixon, though, had politicized country music by championing song that defended traditional values. The historian Bill Malone notes that "the Nixon–country music linkage seemed

ominous to some liberal observers. . . . One writer was moved to describe the music as 'the perfect musical extension of the Nixon Administration.'" The filmmaker Robert Altman agreed. His 1975 film *Nashville* portrayed the country music industry as reactionary, feeding a mysterious millionaire's cynical "Replacement Party" presidential campaign. In fact, Ronald Reagan, George Bush, Lamar Alexander, and other Republicans recruited country music in their efforts to win over white Southern Democrats.

More generally, country music was marketed as a symbolic refuge from proliferating black musical styles. Nashville's Grand Ole Opry and clubs in Branson, Missouri, promoted country's "heritage" and "family traditions" in a manner that spoke only to white listeners. Whereas recent popular music, such as jazz, rhythm and blues, and rock and roll, had at least begun to draw blacks and whites closer together, country's rise reflected the revival of racial suspicion and cultural separation. As the rock critic Dave Marsh noted in 1992, when country music's popularity reached new heights, "For much of today's [white] pop music audience, the liberation symbolized by sounds derived from rhythm-and-blues and rap perhaps inspires more anxiety than ambition, while country's reassertion of social and musical limits seems reassuring, not restrictive."

The 1980 election brought the triumph of political conservatism. President Ronald Reagan strongly advocated deep cuts in government social spending, a defense buildup and a tough anti-Soviet stance, and a reversal of federal support for affirmative action and strong civil rights policies. More generally, conservative laissez-faire government encouraged Americans to pursue entrepreneurial individualism rather than the therapeutic introspection popular in the seventies. Daring stock and bond traders, creators of billions in new wealth for

their clients by means of innovative new market machinations, became heroes, as did such computer entrepreneurs as Steve Jobs of Apple and Bill Gates of Microsoft. The $4 trillion Reagan defense buildup and heavy investment from booming East Asian banks also helped the wealthiest 5 percent of Americans gain their greatest share of national income since the 1920s. As in the twenties, unfettered capitalism inspired a culture of free-spending leisure. As First Lady Nancy Reagan lavishly redecorated the White House, consumption of luxury items such as yachts and artworks increased dramatically. Social events in opulent settings—pioneered by the Reagans at their 1981 inaugural festivities—became highly popularized in the news media. The symphony and opera, recently under attack as elitist and outmoded, enjoyed a financial (if not an artistic) revival. Champagne flowed, and in other circles cocaine was plentiful—although the 1980s generally frowned on such daring behavior as the 1960s counterculture was condemned and concern about sexually transmitted diseases increased.

Popular music vividly reflected the conservative and materialistic trends of the eighties. *Rolling Stone,* which began as a 1960s "underground" rock magazine, launched a campaign for large corporate advertisers which emphatically renounced its earlier disdain for commerce. Most musical styles embraced what Nelson George called a new "pseudosophistication"; the soul singer Barry White, for example, became a "disco hero because he realized that a large part of the American public sought nostalgic elegance in reaction to the dirty jeans and back-to-the-earthiness of the sixties and early seventies." Cher and other white stars followed his lead, making glamour, as well as muscular physiques, popular attributes of musical icons. The rock singer Bruce Springsteen's new "buffed" look and patriotic anthem "Born in the USA" gave him a new image and a larger mass following. Madonna built her career

on an alluring body and image, and her song "Material Girl" was among many in the 1980s which celebrated lavish consumption. MTV, the music video channel that debuted in 1981, specialized in glorifying musical celebrities, glitter, and a narcissistic sexuality. Country music had its own cable channel as well, The Nashville Network, and stars such as Dolly Parton and Lee Greenwood brought doses of 1980s glitter and patriotism to that musical genre.

To the surprise of many observers, jazz made a remarkable comeback in the eighties. Fusion had kept jazz improvisation in the forefront of popular music, and sounds such as Chick Corea's bouncy keyboard rhythms, Al Jarreau's versatile vocals, and David Sanborn's and Tom Scott's soulful saxophone "licks" were familiar parts of many instrumental pop "mixes." Viewers often heard sensuous jazz-rock sounds in the background of a popular new genre of movies and television programs, the "adult thriller." *Body Heat, Miami Vice, 9½ Weeks, Jagged Edge,* and similar titles glorified beautiful, well-toned characters and the brazen risks they took amid affluent surroundings; they mixed sex, intrigue, and action with sinuous saxophone and synthesizer music and a glittering 1980s urban backdrop. (Gleaming new "postmodern" downtown spaces, the product of massive urban redesign and corporate investment, were also hallmarks of the decade.) Elements of funk and disco contributed to this instrumental jazz sound, which in many ways became the generic background music of the eighties, programmed by dozens of successful "smooth jazz" radio stations. Performers such as Spyro Gyra and Kenny G. played in smooth, extremely simple improvisational styles which delighted casual listeners and horrified traditional jazz fans.

Within the jazz "mainstream" new stars emerged. Talented young saxophonists such as Clarence Clemons and Branford Marsalis solidified jazz's presence in rock ensembles that ac-

companied Bruce Springsteen and Sting, respectively. Marsalis also proved to be a capable bebop and avant-garde improviser, as his diverse albums show, and during his brief time as bandleader on television's *Tonight Show* he broadcast new jazz styles to millions of new listeners. His younger brother, the trumpeter Wynton Marsalis, gained even more attention by leading a revival of the clean, forceful improvisation on chord progressions that hard bop had last championed in the early 1960s. Twenty years later it sounded like a fresh new language to many young listeners. Wynton Marsalis, the product of a large musical family in New Orleans, emerged from the Juilliard School and the Art Blakey and Herbie Hancock groups in his early twenties, gained a Columbia contract, and almost instantly became America's best-known jazz *and* classical trumpeter. His extraordinary facility, knowledge of the jazz tradition, and articulate public presence aided his rapid rise in all media.

"Gentrification" in the 1980s referred to the resettlement of handsome old housing in depressed urban (usually black) areas by newly affluent (usually white) young professionals. The new wealthy urban scene was the backdrop for adult thriller films as well as the highly publicized deal-making of entrepreneurs such as Donald Trump and the video tours featured in the popular 1980s television program *Lifestyles of the Rich and Famous*. It was also the stage across which Wynton Marsalis seemed to glide as he helped to create a new interest in small-combo jazz. Marsalis, along with the pianist Marcus Roberts, the trumpeter Terence Blanchard, and the drummer Kenny Washington, moved from such training groups as Art Blakey's Jazz Messengers into concert halls and newly remodeled and revived jazz clubs. Their expensive suits, polished and educated manner, and reverence for tradition—especially Wynton Marsalis's—seemed to some veterans of the 1960s to represent the new gentrification of jazz. The critic Francis

Davis saw "certain nouveaux riches pop stars" as the gentrifiers who were "pricing the original tenants [of jazz] out." Davis argued in 1983 that Marsalis, like Reagan's supporters, "rebel[led] against . . . nonconformity. . . . According to Marsalis, jazz went crazy in the 1960s for the same reason the rest of the world did: no one was tough enough, dedicated enough, *man* enough, to live up to their responsibilities."

The trumpeter's own words suggested that he felt avant-garde or "outside" jazz and fusion had been musical mistakes. He attributed his success to the fact that avant-garde players were "bullshittin' [and] wearing dresses [African robes]," and fusionists were "trying to act like rock stars" and nearly ruined jazz. He disparaged contemporary black pop music and called Miles Davis's continuing electronic experiments "crap." Marsalis's knowledge of "classic" swing and bop "intimidate[s] people because I know what I'm talking about." To some older observers, the young players led by Marsalis seemed to be coddled, well-paid members of the new black middle class who scolded the previous jazz generation unfairly, with little understanding of its courageous and painful artistic struggles.

Wynton Marsalis's outspoken defense of "tradition" and attack on avant-garde jazz and pop music stimulated a debate about jazz that also embraced larger controversies in 1980s black America. Branford Marsalis was more eager than his brother to engage in avant-garde experimentation and popular music, and he carefully avoided the controversies in which Wynton became engaged. "Outside jazz" pioneers unsupported by academic positions, such as Ornette Coleman, Don Cherry, Muhal Richard Abrams, and Cecil Taylor, resented Marsalis's denigration of their work and believed that he helped devalue it in the marketplace for grants, club dates, and concert-hall bookings. More generally, though, the public response to the "new classic jazz" represented a characteristic 1980s rejection of the innovation of the previous two decades;

it showed public scorn for the militant artistic perspective that had emerged in the ghettos under the duress of violence and poverty. The image of young members of the new black middle class—the beneficiaries of 1960s struggles—heaping scorn on sixties music seemed particularly wounding.

America embraced "classic" jazz anew in other ways too. While festivals showcasing jazz innovators fell on hard times in the 1980s, retrospective and amateur gatherings became major tourist attractions. The Sacramento Dixieland Jubilee, begun in 1974, became an enormous celebration of the earliest jazz style, featuring hundreds of bands from across the world. The New Orleans Jazz and Heritage Festival, featuring many jazz styles but marketed as a celebration of Dixieland heritage, soon attracted 100,000 tourists annually. The young musicians Scott Hamilton and Warren Vaché led a small revival of swing-band music, while swing veterans such as Mercer Ellington, Woody Herman, and Lionel Hampton continued to tour with bands.

The bulk of the media attention, however, was fixed on new faces such as Wynton Marsalis and on veterans—largely black—who played fifties-style bebop. Dexter Gordon returned to America, played often, and gave a brilliant performance as an aging, troubled jazzman in the 1986 French film *Round Midnight*. Third-Stream advocate John Lewis had languished in obscurity and the Modern Jazz Quartet had disbanded in 1974, but in the eighties Lewis, the MJQ, and their polite, elite sound made a major comeback. "Repertory jazz" programs sponsored by the government and corporations became elite fare. Martin Williams and Gunther Schuller organized the Smithsonian Jazz Masterworks Orchestra, an extension of the institution's popular record reissues and exhibits. In 1990 Wynton Marsalis became director of Jazz at Lincoln Center, an ambitious program of concerts, education, and community relations which promoted the "classic" jazz

tradition. Collaborating with Schuller, Marsalis sponsored the first performance and recording of Charles Mingus's two-hour work *Epitaph,* and each year the trumpeter composes a similarly lengthy work for the Lincoln Center program.

The jazz avant-garde, while overshadowed by the prestige and corporate generosity flowing to the revived "mainstream," was also producing large and dynamic works. African-American composers built on the examples of Ellington and Mingus and continued to write extended pieces that drew on a vast range of musical expressions. Anthony Braxton, now in academe, remained prolific. Anthony Davis, son of a Yale professor and active in New Haven and Manhattan music circles, wrote challenging works such as *Episteme* (a ballet score) and *Hemispheres* that contained very little traditional improvisation. Davis made his most ambitious contribution in 1985 with the opera *X,* based on the life of Malcolm X. This eclectic and highly sophisticated score (like other works by Davis and his colleagues Leo Smith, Dwight Andrews, and George Lewis) never attracted a large audience, but its subject matter and use of contemporary urban pop styles showed Davis's attention to current inner-city music.

This sympathy, borne of the social advocacy that had moved black musicians so deeply during the sixties, differentiated the persisting avant-garde from many of the popular new jazz stars. Ornette Coleman and former loft managers such as Sam Rivers maintained precarious existences in marginal Manhattan neighborhoods, mostly to stay near the black city folk they valued. Coleman suffered from burglary and beatings in his high-crime neighborhood. By the eighties Coleman had fully articulated his concept of harmolodics, the idea that musicians trained in African-American styles can improvise fruitfully in multiple keys and meters if they nurture "social peace" in their performance settings. In 1978 he formed the Prime Time ensemble, a heavily electrified group that worked

funk sounds into its basic style. At the same time, though, Coleman became even less trusting of record companies and promoters outside the ghetto, and remained an embittered avant-garde veteran.

Avant-garde jazz had a minor impact on the political consciousness of 1980s Americans. After 1980 other music publicized the worsening plight of the inner cities. While the rich grew richer and the black middle class became more comfortably situated, the urban poor lost ground as jobs, industries, and tax revenues fled their neighborhoods and federal budget cuts deleted many social services. In the late seventies social scientists had begun to write of a multi-ethnic "urban underclass" which was becoming the chronic victim of America's postindustrial economic restructuring. Unskilled inner-city workers had no work opportunities except minimum-wage service jobs or high-paying, illegal, and dangerous work in the drug trade. Homelessness escalated in America for the first time since the 1930s. The exploding cocaine trade and the spread of cheap "crack" crystals to ghetto users fed the despair and addictions of many poor people and provided dangerous but lucrative employment for youth gangs. These urban calamities gained much publicity and inspired political rhetoric, but the nation's general reaction during the 1980s was largely to build more prisons, increase drug crime penalties, and double the population of black men behind bars.

1980s popular music drew energy from the anger of the inner cities and their musicians' hunger for success and new lives. Rap, or hip-hop, grew out of the fast-talking skills of black disk jockeys and record-party "MCs," and became a highly stylized commentary on black gang and ghetto life. Break-dancing and "techno-funk" dance music enjoyed brief vogues as well. Most prominently, though, mainstream pop performers such as Michael Jackson and Prince borrowed musical and verbal styles and imagery from rap and techno-funk.

In Jackson's case the versatile producer Quincy Jones—who had begun his career in the 1950s as an arranger for Count Basie and other big-bandleaders—gathered thirty years' worth of black musical devices, especially current urban innovations, for the epochal album *Thriller* (1984), which became the biggest-selling record in history. As the veteran jazz theorist George Russell proudly noted, the tune of Jackson's "Wanna Be Startin' Somethin'" from *Thriller* was in the Lydian mode (perhaps a clever contribution by Quincy Jones), and the rest of the album contains progressions and instrumentation drawn from various "cool" and avant-garde jazz styles.

In such ways, echoes of important jazz innovations became part of Jackson's and other popular music of the eighties, which earned tens of billions of dollars internationally every year, dwarfing films and all other entertainment industries. For the most part, however, jazz was an almost indistinguishable part of "the mix," as sampler-rappers called their music. Enterprising musicians tried to raise jazz's profile with new varieties of fusion—Herbie Hancock produced the much-maligned video single "Rockit" in 1985, featuring break-dancing robots—but such experiments obscured jazz's basic identity as an improvisational blues music.

In a different way, anxieties about the underclass—particularly among members of the growing black middle class—generated new interest in black cultural identity, which gradually kindled new interpretations of the meaning of jazz. Black Studies, the academic product of the Black Power movement of the sixties, reached a new level of sophistication in the eighties. Robert Farris Thompson traced African influences in New World dance, religion, and music. Houston Baker, Jr., identified the fundamental role of the blues in the content and form of African-American poetry and prose. As if to prove Baker right, the playwright August Wilson and the

writer Toni Morrison wrote works that dramatized the vital role of the blues and jazz in black family and community life. Wilson's *Joe Turner's Come and Gone,* for example, showed how the blues both kept the memory of slavery alive and eased the pain of that memory, while *Ma Rainey's Black Bottom* showed how the blues helped 1920s blacks cope with urban migration, technology, and the battle between the sexes. Professor Henry Louis Gates, Jr.'s theory of black literature, published in *The Signifying Monkey* (1988), provided the strongest intellectual support for the concept that jazz was a pillar of modern black culture. Jazz improvisation, Gates argued, was a key product of the core African-American skill of verbal elaboration on themes—the "signifying" skill of black preachers, comedians, novelists, and politicians as well as musicians—inherited from West African storytelling traditions.

The "new Black Studies" gave jazz a new importance as *the* black classical music. (Cecil Taylor, Archie Shepp, and other militants had advocated this concept since the sixties, but they did not have as wide an impact as public intellectuals.) The new concept celebrated jazz as an expression of African-American aesthetics and social values, and a foundation for the most meaningful black music of the twentieth century. New black cultural critics saw jazz as a discipline that demonstrated black achievement and promise in the post–Jim Crow era. Wynton Marsalis, echoing Gates's theory, told *Ebony* in 1994 that "Jazz music, and most Afro-American music, is about the dialogue, the quality of conversation, the process of negotiation." Similarly Stanley Crouch, a drummer, composer, critic, and consultant to Marsalis at Lincoln Center, has perceived jazz as a triumph of black aesthetics, a bulwark of tradition against the "spiritual rot" of contemporary pop music.

Other African Americans, however, have associated jazz and the new cultural pride more closely with a revival of black

separatism and nationalism. The agony of the ghettos, as well as the low-level alienation of middle-class blacks in white-dominated universities and offices, made Malcolm X's thought popular again. The young filmmaker Spike Lee dramatized the life of Malcolm X in a major 1992 production. Lee also popularized jazz's nationalistic new role. His father, the avant-garde jazz bassist Bill Lee, wrote the music for and acted in his first film, *She's Gotta Have It* (1986). Lee's fourth film, *Mo' Better Blues* (1990), brought the Black Studies image of jazz to dramatic life, focusing on competitive, affluent male musicians, their relationships with educated and proud women, and the predatory white-controlled music business against which they all struggled. Jazz appears here as the music of a proud, sophisticated, and quietly militant black middle class. Jazz was portrayed similarly (but much more cautiously) on *The Cosby Show*, comedian Bill Cosby's network comedy about an affluent black family, the most popular television program of the eighties. Dizzy Gillespie, the singer Joe Williams, and other musicians appeared to instruct the characters and the audience about jazz and black heritage.

This portrayal of jazz, designed to define and reinforce the cultural and social status of African Americans, played down the important presence of whites and others in the history of the music. To one white jazz historian, the prolific and controversial James Lincoln Collier, this was an outrageous distortion of the historical record. In his book *Jazz: The American Theme Song* (1993), Collier attacked recent jazz histories for their allegations that black culture was the fount of jazz and that the most crucial jazz innovators were black. While he did not really refute these arguments, Collier reminded readers that white musicians had been crucially important as well. He then directed his anger at Jazz at Lincoln Center, attacking Wynton Marsalis's alleged slighting of white jazz composers and musicians. Much of the New York press rallied to Col-

lier's cause. Collier and Marsalis debated the existence of "reverse racism" in jazz in print and before an audience at Lincoln Center.

As Marsalis's factual rebuttals showed, Collier's charges against Jazz at Lincoln Center were exaggerated. (They were also incomplete; as we have seen, others criticize Marsalis for ignoring the jazz avant-garde.) But they reflected a larger perception by nonblacks of a growing black protectiveness toward jazz and the cultural heritage it has come to symbolize. The Collier-Marsalis debate also reiterated how the sizeable African-American middle class—articulate, educated, and affluent—will turn to jazz and other creative traditions in its fight for proper recognition for black people and their culture.

In the 1990s, the last years of "the American century" and the jazz century, the agony and pleasures of the black experience and the continued vitality of jazz and popular music shared the spotlight with momentous world events. The United States "won" the cold war. Presidents Reagan and Bush justifiably boasted that American wealth and democratic principles helped to speed the collapse of the stagnant Soviet bloc. The 1991 Persian Gulf War showed a dominant American military making short work of Iraq's large defense forces—though the United States had to "pass the hat" among its allies to pay for Operation Desert Storm, since the nation's economy was staggered by huge federal budget and trade deficits. Each year Japan, China, and Hong Kong exported tens of billions of dollars' worth of products more to America than America exported to them; Japan, flush with dollars, purchased American companies and vast amounts of real estate. A 1992 recession drove George Bush from office, and the new president, Bill Clinton, made aggressive economic diplomacy the foundation of his foreign policy.

In popular culture Japan's Sony purchased Columbia

Records, the world's major jazz and pop label, and Matsushita gained control of MCA, which owned Universal Studios and the rights to thousands of jazz compositions. This did not lead to a Japanese dictatorship of music and movies—in fact, it only boosted America's role as the source of the world's most desired popular entertainment. But it did indicate that American show business, like other industries, was internationalizing at an unprecedented rate. The explosion in East Asian and Latin American populations in the United States, due mostly to immigration, also showed this, as did the spread of worldwide computer communications across the Internet.

The agony of the ghetto reemerged in 1992 when poor residents of Los Angeles rose up to protest the acquittal of police officers charged with the videotaped beating of a black man, Rodney King. Attacks on Koreatown by city youth of various ethnicities and clashes with the police led to $700 million in damage and 52 deaths, the worst casualties in a U.S. riot in 129 years. Like the 1991 Anita Hill–Clarence Thomas clash over sexual harassment at the Senate hearings on Thomas's Supreme Court nomination, the Los Angeles riot brought lingering issues of racism and racial identity before post–cold war America. Later, in 1995, another Los Angeles acquittal—of the black sports celebrity O. J. Simpson, tried for the murder of his white ex-wife—inspired dramatically differing reactions from whites and blacks, and a new national discussion about the nature of America's racial divide. Meanwhile 1 of 13 black males between the ages of 16 and 35 resided in prison; older black men died an average of 12 years before their white counterparts; the average black family had 13 percent of the net worth of the average white family; and half of all families (white and black) kept firearms to ward off shadowy criminal threats they perceived outside their homes at night.

Popular musicians, enmeshed in multinational tours and

record contracts, have had little to contribute to the urgent new debate on race relations and conflicts. Socially engaged performers are highly marginal figures in 1990s mass culture. Prominent rap artists, while often close to the agony of the ghettos, also tend to caricature the experience by means of the popular "gangsta" image (an echo of 1970s "blaxploitation"), and some of them become distracted by threats of censorship and their own legal troubles. Jazz gained minor new popularity in the early nineties; the rap group Jazzmatazz pioneered the use of jazz instrumentals behind rap lyrics, and "acid jazz" became a heavily synthesized favorite at "alternative" dance clubs. Within the classic-jazz mainstream championed by Marsalis, despite the continuing emergence of outstanding young talent, little major innovation has generally occurred, and its popularity remains small. In 1995 not a single commercially supported jazz radio station operated in the United States. Country music, by contrast, has doubled its sales since 1985, and the multinational entertainment conglomerates have begun to market it in Europe as "American" music. As the century neared its end, it was unclear who the new jazz innovators would be, or what they might do to harness a great musical tradition and provide Americans with spiritual and cultural guidance.

Epilogue

THE STORY OF JAZZ tells us a great deal about the ideas, feelings, and activities of Americans in this century. It is hazardous to generalize about such aspects of the human experience, especially when the focus is on a relatively small feature of the national scene such as jazz music. Biography and experience teach us that individuals have special relationships with their culture and the music they hear. Americans pride themselves on their individualism, and as persons as dissimilar as Wynton Marsalis and Jimmy Carter have argued, jazz improvisation almost epitomizes the American ideal of individual expression. One of the supreme joys of listening to jazz is to acquaint oneself with the unique creative sensibilities of master soloists; it is equally satisfying to explore their life stories and to associate those stories with the music they produce. A "culture," though, gains its identity by providing behavior that is shared by the members of a society, and by creating a certain level of regularity in how they think, listen, and act. Even individualistic jazz can give us a sharp collective picture of cultural conditions and change in twentieth-century America.

Jazz's importance to American *musical* culture is perhaps most obvious. While minstrelsy, the blues, ragtime, and other forms preceded jazz, they belonged to earlier eras; minstrel songs, for example, gave voice to nineteenth-century Victorian morality and racism. Jazz was a blend of these and many other styles, the statement of a new generation of young people in the 1910s who had new emotions and experiences and

developed new ways of expressing them. Ragtime inspired stride pianists in New York and musicians in New Orleans, and French music deeply influenced the latter; but jazz was something new, reflecting the players' accelerating style of life and urge to express their sense of difference from more sedate earlier generations. The body of new performance conventions, musicians' practices, jazz slang, instrumental techniques, touring habits, and training regimens translated their youthful perspectives into a coherent musical form. The rapid evolution of styles—from Dixieland to symphonic jazz to hot jazz to swing to bebop—showed the jazz "guild" reinventing itself, testing, abandoning, and adopting musical ideas at a furious rate. The pace of experimentation ensured that jazz would eventually become an avant-garde art, evolving too quickly for most listeners to appreciate and holding the interest of only a small group of sophisticated enthusiasts. In this way the music of New Orleans longshoremen and hack drivers became the difficult *objet d'art* of a highly cultivated international elite. The twentieth century moved that quickly.

As a result, the jazz story raises some interesting questions about the role of the arts in recent history. As jazz musicians became more accomplished and began to create for themselves—rather than to satisfy audience tastes—did they become irresponsible "elitists"? Should performers originally nurtured *by* the people continue to *serve* the people? Stan Kenton, the "progressive" jazz bandleader, thought he was doing so, though many jazz fans rejected him. The players active in 1960s black communities tried to connect with average listeners by playing simple melodies and incorporating soul and funk elements into their sounds, but their complex styles kept them from gaining wide followings.

On the other hand, jazz's occasional mass popularity raises a separate set of concerns. Did the rages for 1920s "happy"

jazz, 1930s swing, and 1970s "fusion" occur because players and promoters were simplifying jazz and pandering to the "lowest common denominator" of public taste? Artie Shaw felt that way about swing, and in the 1940s more than once he "retired" from bandleading in disgust. Even Duke Ellington, who straddled popular success and avant-garde innovation more successfully than any other figure in jazz, was accused at various times either of "losing his audience" or shamelessly seeking the leisure dollars of the musically ignorant masses. Ironically jazz ultimately became a victim of the mass media and the worldwide promotion it had helped to create, as rhythm and blues and rock and roll overwhelmed it in the 1950s and 1960s. The American audience's tastes, in short, changed as rapidly as jazz music, but in noticeably different directions. As a result, jazz is now an honored, much studied, and widely known music, but only one of many "niche" musics in a vast terrain of diverse popular tastes.

The division, uniting, and redivision of the popular audience into new "taste cultures" over the years and decades alerts us to changes in modern American culture as a whole. Not just music but family life, gender roles, leisure habits, living arrangements, work, politics, spirituality, and other aspects of daily life have evolved rapidly. Industrialization, urbanization, world wars, and mass media—followed in turn by deindustrialization, suburbanization, the cold war, and the counterculture—have shaped and reshaped average Americans' lives and tastes. From its beginnings to the present, jazz has reflected the modernizing spirit in the lives of many Americans. In the 1920s youth and some elders used jazz to experiment with new sexual, gender, and leisure attitudes in urbanizing settings; in the thirties swing became a mouthpiece for the common-man liberalism of the New Deal; bop and progressive jazz illustrated post–World War II militancy and

existentialism, respectively; fifties cool jazz expressed suburbanization; and sixties "outside" experiments voiced the angry demands of Black Power.

Jazz's story furthermore shows how adolescent Americans have largely led the way for their elders, using music to explore their emotions and desires in the midst of constant social innovation. Beginning with ragtime, modern popular music has been a young person's domain, an art for energetic people with little to lose and brave (or reckless) enough to express their emotions with relentless honesty. Jazz's energy initially came from the wild children playing in the streets of New Orleans, Ferdinand Lemott and Jack Laine in the 1880s and 1890s, hungrily consuming French and ragtime sounds and regurgitating them as amateurish, vulgar "noise" that captured their experience of youth and city life. The musical youth movement of the twentieth century first shone brightly during the Jazz Age of the 1920s. Less likely than their elders to revere tradition, teenagers in every decade built new music, and behavior that supplemented it, out of the novel aspects of life that kept rushing in to meet them. War, technology, money, cities, automobiles, "strange" ethnic groups, radical college professors, and mood-altering chemicals fed new popular music and made rough-hewn amateurs such as Louis Armstrong, Charlie Parker, Elvis Presley, and John Lennon into improbable new leaders of world taste and opinion. Politics, clothing, philosophies, and social customs changed with the music.

As jazz's generational history indicates, youth rebellions rarely continue after the youths enter their late twenties. Still, each rebellion has allowed the next one to become even more daring, and as a result the America of 1900 that first created jazz is almost alien to us today. While jazz has been a victim of this change ever since youth embraced R and B and rock (and swing and bebop musicians and fans grew older), its "hot" and

"cool" emotions and specific musical gestures remain embedded in our complex culture, which resembles a colorful, wild, and overgrown musical garden. In this way and others, jazz was the first, and perhaps the most important, cultural youth rebellion of twentieth-century mass society.

We should not view the jazz story too idealistically, though. Since 1900 promoters and commercializers of popular music—driven by the profit motive and often totally lacking in musical taste—have exploited the creativity of rebellious adolescents. Young musicians had to make a living, but while a few jazz players profited healthily and happily with the help of appreciative and capable promoters, most of them suffered economically or artistically at the hands of managers, record companies, and other hucksters.

The haphazard process of trying to bring honest musical expression to a large audience is a major aspect of twentieth-century music history in itself. 1930s swing declined largely because the music business broke into turf wars (between broadcasters, songwriters, and the union) over profits, overexposed the big-band sound, and then diluted it with totally alien popular styles. The "race records" mentality of the major labels and discrimination in radio hid black musicians from most white listeners for decades. In the 1960s rock's overwhelming popularity encouraged all media virtually to ignore jazz and other traditional sounds. Fortunately jazz history also shows generations of resourceful "independent" producers and promoters—from the Gennett label in the twenties to Black Saint in the seventies—coming to the rescue of jazz musicians and listeners, preserving the music and nurturing a small but dedicated audience. The revival of historic independent labels such as Impulse! and Blue Note was a pleasant 1990s development.

The tumult of cultural change and commerce hurt jazz in many ways, but many Americans' resistance to change may

have stifled the music more deeply. Despite decades of general change, jazz has remained a symbol of modernization, city life, sexual freedom, and interracial activity, and for this reason culturally conservative whites and blacks continue to denounce it. Even within the jazz subculture itself, the Dixieland revival of the late thirties, the condemnation of bebop in the 1940s, and the popularity of the "classicism" of Wynton Marsalis have shown some players' and fans' resistance to change and their nostalgia. Like the heroin that some bebop musicians took to escape the pain of the present, nostalgia has been a narcotic of choice for people terrified by the unfamiliarity of the ever-changing present. Almost regularly in the twentieth century, Americans have expressed disgust with the present and yearned for the imagined "normalcy" of yesteryear.

While older jazz styles allowed veteran fans to reminisce about the good old days of their youth, jazz never really captured the general American imagination as the music of traditionalism. That mantle has been worn more successfully by country and western music, which became a popular sensation almost at the same time as jazz in the early 1920s, grew dramatically in later decades, and has now overtaken jazz in popularity. Despite the enormous ideological and stylistic diversity of country music, politicians, promoters, and some musicians have helped to make it a symbol of white America's resistance to cities, suburbs, political liberalism, racial integration, and women's liberation. It is remarkable how jazz and country, two Southern musics with common taproots, have symbolically diverged in recent American culture—even though both contributed directly to the sound of rock and roll, the most antinostalgic and radical musical innovation of them all. Perhaps we can only tentatively conclude that innovation and nostalgia are fundamentally interrelated in modern popular music and culture.

Much clearer is that jazz has been closely tied to the African-American struggle for equality. Ragtime and the blues expressed black subordination to white culture and white power, before World War I gave them hope; rhythm and blues, soul, funk, and rap gave voice to blacks' deferred dreams and angry sense of betrayal after World War II. Black jazz came between these two trends. It arose during the crucial 1910s and 1920s, when nationalism and civil rights activism took hold. Jazz was the music of the newly optimistic black masses that had fled Jim Crow. The urban black, like the jazz improviser, struggled with the present in order to achieve victory in the immediate future, and the spirit of Harlem and other communities rallied behind the individual's cause. That spirit was the essence of Garveyism, the Harlem Renaissance, King's civil rights movement, and Black Power—and it brought energy to jazz in nightclubs and dance halls. That energy, as well as growing bitterness and doubt, fueled the innovation of bebop, but the revitalized "soul" spirit of the 1950s enlivened hard bop and free jazz. While the aptly named Paul Whiteman had begun the major white presence in jazz, the ghetto long supplied the creative core of the music; white innovators kept coming back to it to learn more.

Even though jazz critics and promoters have rarely been black, black musicians have defined the essence of jazz and many of its styles. The fragmentation of the African-American community after 1960 was reflected in the breakup of the jazz mainstream. Just as the civil rights movement broke into various conflicting groups, so did jazz—fragmented into modal, "free," and "outside" styles—face a crisis of identity and lose its revolutionary fervor. Since 1970 black avant-gardists have thrived in healthy and vibrant oases, and they have benefited from the occasional spurts of black political and nationalistic rebellion that continue to remind the world

of the existence of racism and the underclass. While these problems remain in the 1990s, the traditions of black activism and the jazz spirit also remain and thrive, waiting to be tapped by the next Martin Luther King or Malcolm X.

Black equality and nostalgia, cities and suburbs, art and commerce, mass culture and the avant-garde—jazz embodies all of these major qualities of the twentieth century, and many more. They are the elements out of which Americans—and those around the world who share American culture—will build new sounds, new leisure, and new concepts of community and social identification. In mysterious ways, music-making and listening bring all these complex cultural changes into focus and encourage publics to create forces of change and to preserve their heritages. This is one of the major lessons of jazz as history.

Suggested Reading

THE OUTSTANDING jazz history textbook is Lewis Porter, *Jazz: From Its Origins to the Present* (Englewood Cliffs, N.J., 1992), also available as a multimedia CD-ROM. Marshall Stearns, *The Story of Jazz* (New York, 1970) and Charles Nanry and Edward Berger, *The Jazz Text* (New York, 1979) remain useful overviews. Albert Murray, *Stomping the Blues* (New York, 1976) is an eloquent survey of modern black popular music.

A few fine studies cover special topics in jazz history. Katrina Hazzard-Gordon, *Jookin': The Rise of Social Dance Formations in African-American Culture* (Philadelphia, 1990) is a concise history of jazz dance, and Linda Dahl, *Stormy Weather: The Music and Lives of a Century of Jazzwomen* (New York, 1984) surveys a previously neglected topic. Russell Sanjek, *American Popular Music and Its Business: The First Four Hundred Years,* vol. 3, *1900–1984* (New York, 1988) is an incredibly detailed, at times impenetrable chronicle of the music business. Students with training in music theory will revel in Gunther Schuller's rich, pioneering studies, *Early Jazz: Its Roots and Musical Development* (New York, 1968) and *The Swing Era* (New York, 1989), and Paul F. Berliner's brilliant *Thinking in Jazz: The Infinite Art of Improvisation* (Chicago, 1994), perhaps the most important scholarly work on jazz yet to appear.

Rudi Blesh and Harriet Janis, *They All Played Ragtime,* 4th ed. (New York, 1971) remains a classic study of ragtime and should be supplemented by Edward A. Berlin, *Ragtime: A Musical and Cultural History* (Berkeley, 1980). Reid Badger, *A Life in Ragtime: A Biography of James Reese Europe* (New York, 1995) does justice to a crucial figure. The Broadway milieu is analyzed in Lewis A. Erenberg's influential *Steppin' Out: New York Nightlife and the*

Transformation of American Culture, 1890–1930 (Westport, Conn., 1981). Regarding early New Orleans jazz, see William J. Schafer, *Brass Bands and New Orleans Jazz* (Baton Rouge, 1986); Donald M. Marquis, *In Search of Buddy Bolden: First Man of Jazz* (Baton Rouge, 1978); and H. O. Brunn, *The Story of the Original Dixieland Jazz Band* (Baton Rouge, 1960). A fine history of the 1910s is David M. Kennedy, *Over Here: The First World War and American Society* (New York, 1980).

James Lincoln Collier, *Louis Armstrong: An American Genius* (New York, 1983) is still the best biography of its subject. Thomas A. DeLong, *Pops: Paul Whiteman, King of Jazz* (Piscataway, N.J., 1983) is satisfactory, and Richard M. Sudhalter and Philip R. Evans, *Bix: Man and Legend* (New Rochelle, N.Y., 1974) is filled with interesting detail. Thomas J. Hennessey, *From Jazz to Swing: African-American Jazz Musicians and Their Music, 1890–1935* (Detroit, 1994) is the best cultural history of jazz bands. Kathy J. Ogren, *The Jazz Revolution: Twenties America and the Meaning of Jazz* (New York, 1989) has become the standard study of its topic. Nathan Irvin Huggins's *Harlem Renaissance* (New York, 1971) remains an invaluable treatment. Ann Douglas, *Terrible Honesty: Mongrel Manhattan in the 1920s* (New York, 1995) is a vast study of twenties urban cultural trends, while Burton W. Peretti, *The Creation of Jazz: Music, Race, and Culture in Urban America* (Urbana, Ill., 1992) concentrates on the 1920s (and 1930s) jazz scene. Warren I. Susman, *Culture as History* (New York, 1984) contains landmark essays on American attitudes in the 1920s and 1930s. Dempsey Travis, *An Autobiography of Black Jazz* (Chicago, 1983) and William Howland Kenney III, *Chicago Jazz: A Cultural History, 1904–1930* (New York, 1993) provide lively and detailed coverage of jazz in interwar Chicago. Leroy Ostransky, *Jazz City: The Impact of Our Cities on the Development of Jazz* (Englewood Cliffs, N.J., 1978) covers 1920s city life particularly well.

Mark Tucker, *Ellington: The Early Years* (Urbana, Ill., 1991) is the best detailed study of the composer. His entire life is covered effectively in John E. Hasse, Jr., *Beyond Category: The Life and*

Genius of Duke Ellington (New York, 1993). *Good Morning Blues: The Autobiography of Count Basie* as told to Albert Murray (New York, 1985) is detailed and well researched, especially on the 1930s. Ross Firestone, *Swing, Swing, Swing: The Life and Times of Benny Goodman* (New York, 1993) is helpful. David W. Stowe, *Swing Changes: Big-Band Jazz in New Deal America* (Cambridge, Mass., 1994) is a pioneering study. New Deal–era American culture is probed in essays by Lawrence W. Levine in *The Unpredictable Past: Explorations in American Cultural History* (New York, 1993); Barbara Melosh, *Engendering Culture: Manhood and Womanhood in New Deal Public Art and Theater* (Washington, D.C., 1991); and Carol J. Martin, *Dance Marathons: Performing American Culture in the 1920s and 1930s* (Jackson, Miss., 1994). Bill C. Malone, *Country Music, U.S.A.,* 2nd ed. (Austin, Tex., 1985) and Robert Cantwell, *Bluegrass Breakdown: The Making of the Old Southern Sound* (Urbana, Ill., 1984) are excellent histories of their subjects.

Cultural histories of America during World War II include John Morton Blum, *V Was for Victory: Politics and American Culture During World War II* (New York, 1977) and William M. Tuttle, Jr., *"Daddy's Gone to War": The Second World War in the Lives of America's Children* (New York, 1993). George T. Simon, *The Big Bands,* rev. ed. (New York, 1971) and Max Kaminsky with V. E. Hughes, *Jazz Band: My Life in Jazz* (New York, 1963) are useful sources by swing eyewitnesses. Thomas Owens, *Bebop: The Music and Its Players* (New York, 1995) is a detailed study of that jazz style. Dizzy Gillespie and Al Fraser, *To Be, or Not . . . To Bop: Memoirs* (Garden City, N.Y., 1979) is perhaps the richest autobiography of a jazz musician. Ross Russell, *Bird Lives: The High Life and Hard Times of Charlie Parker* (New York, 1973) is stimulating, but we still lack a strong Parker biography. Lewis Porter, *Lester Young* (Boston, 1985) is an effective short study. Paul Chevigny, *Gigs: Jazz and the Cabaret Laws in New York City* (London, 1991) is a unique case study in jazz labor history. Leonard Feather, *The Jazz Years: Earwitness to an Era* (New York, 1987) offers detail on the critics' wars of the 1940s.

Paul Boyer, *By the Bomb's Early Light: American Thought and Culture at the Dawn of the Atomic Age* (New York, 1985) and Elaine Tyler May, *Homeward Bound: American Families in the Cold War Era* (New York, 1988) are strong cultural histories. Peter Stearns, *American Cool: Constructing a 20th-Century Emotional Style* (New York, 1994) is pioneering but says nothing about "cool" jazz. No biography of Stan Kenton has yet appeared, though his activities are related in Ted Gioia's excellent *West Coast Jazz: Modern Jazz in California, 1945–1960* (New York, 1992). Jack Chambers, *Milestones,* vols. 1 and 2 (Toronto, 1983 and 1985) offer the best examination of Miles Davis's complex career; Davis's *Autobiography* (New York, 1989), written with Quincy Troupe, is interesting but factually flawed. Art Pepper and Laurie Pepper, *Straight I fe: The Life of Art Pepper* (New York, 1979) is one of the best jazz memoirs. Ben Sidran, *Black Talk* (New York, 1971) is a provocative early study of jazz and 1950s ghetto culture but should be supplemented by David H. Rosenthal, *Hard Bop: Jazz and Black Music, 1955–1965* (New York, 1992).

Todd Gitlin, *The Sixties: Years of Hope, Days of Rage* (Toronto, 1987) and William L. O'Neill, *Coming Apart: An Informal History of America in the 1960s* (Chicago, 1971) are detailed and valuable. Recent popular music is well covered in Charlie Gillett, *The Sound of the City: The Rise of Rock and Roll,* rev. ed. (New York, 1984) and Nelson George, *The Death of Rhythm and Blues* (New York, 1988). There are many fine works on 1960s jazz, including John Litweiler, *The Freedom Principle: Jazz After 1958* (New York, 1984); David G. Such, *Avant-Garde Jazz Musicians: Performing "Out There"* (Iowa City, Ia., 1993); Ekkehard Jost, *Free Jazz* (Graz, Austria, 1974); and Eric Nisenson, *Ascension: John Coltrane and His Quest* (New York, 1993). A. B. Spellman, *Black Music: Four Lives in the Bebop Business* (New York, 1970) contains excellent portraits of Cecil Taylor, Ornette Coleman, and Jackie McLean (who deserve full-length biographies or autobiographies).

On recent American culture, see Peter N. Carroll, *It Seemed*

Like Nothing Happened: The Tragedy and Promise of America in the 1970s (New York, 1982); John Taylor, *Carnival of Ambition* (New York, 1990); Robert Walser, *Running with the Devil: Power, Gender, and Madness in Heavy Metal Music* (Hanover, N.H., 1993); and Mike Davis, *City of Quartz: Excavating the Future in Los Angeles* (New York, 1991). Ronald M. Radano, *New Musical Figurations: Anthony Braxton's Cultural Critique* (Chicago, 1993) is a complex and stimulating portrait of a major avant-garde musician. Interesting critical analyses of recent jazz developments include Gary Giddins, *Rhythm-a-ning: Jazz Tradition and Innovation in the '80s* (New York, 1985); Francis Davis, *In the Moment: Jazz in the 1980s* (New York, 1986); and Stuart Nicholson, *Jazz: The 1980s Resurgence* (New York, 1995). James Lincoln Collier's controversial statements on jazz and race can be found in *Jazz: The American Theme Song* (New York, 1993), and Wynton Marsalis has published an occasionally informative book about his touring career, *Sweet Sing Blues on the Road* (New York, 1994). Stanley Crouch's collected writings on jazz and American culture, *Notes of a Hanging Judge* (New York, 1990) and *The All-American Skin Game: The Decoy of Race* (New York, 1995), are fascinating.

Index

A NOTE ON THE AUTHOR

Burton W. Peretti is assistant professor of humanities at Pellissippi State Technical Community College in Knoxville, Tennessee. He studied at Pomona College and received M.A. and Ph.D. degrees from the University of California, Berkeley. His articles on the cultural aspects of jazz have appeared in a variety of magazines and journals, and he has also written *The Creation of Jazz: Music, Race, and Culture in Urban America.*